D1221582

Film Nation

Film Nation

Hollywood Looks at U.S. History

Revised Edition

Robert Burgoyne

University of Minnesota Press
Minneapolis
London

An earlier version of chapter 3 was published in *Screen* 35, no. 3 (Autumn 1994): 211–34; reprinted by permission of Oxford University Press. Chapter 4 was originally published as "Modernism and the Narrative of Nation in *JFK*," in *The Persistence of History*, ed. Vivian Sobchack (New York and London: Routledge, 1995), 113–25; reprinted by permission of the publisher. An earlier version of chapter 6 was published in the online journal *Screening the Past* 25 (September 2009). An earlier version of chapter 9 was published as "The Topical Film: *United 93* and *World Trade Center*," in *The Hollywood Historical Film* (London and Malden: Wiley-Blackwell, 2008), 148–69.

Illustrations courtesy of Photofest

Published by the University of Minnesota Press
111 Third Avenue South, Suite 290
Minneapolis, MN 55401-2520
http://www.upress.umn.edu

Library of Congress Cataloging-in-Publication Data

Burgoyne, Robert
 Film nation : Hollywood looks at U.S. history / Robert Burgoyne. — Rev. ed.
 p. cm.
 Includes bibliographical references and index.
 ISBN 978-0-8166-4291-5 (hc : alk. paper)—ISBN 978-0-8166-4292-2 (pb : alk. paper)
 1. Historical films—United States—History and criticism. 2. United States—In motion pictures. 3. Motion pictures and history. I. Title.
 PN1995.9.H5B87 2010
 791.43'658—dc22 2009017764

Printed in the United States of America on acid-free paper

The University of Minnesota is an equal-opportunity educator and employer.

17 16 15 14 13 12 11 10 10 9 8 7 6 5 4 3 2 1

This book is dedicated to the memory of my father,
Robert Alexander Burgoyne

Contents

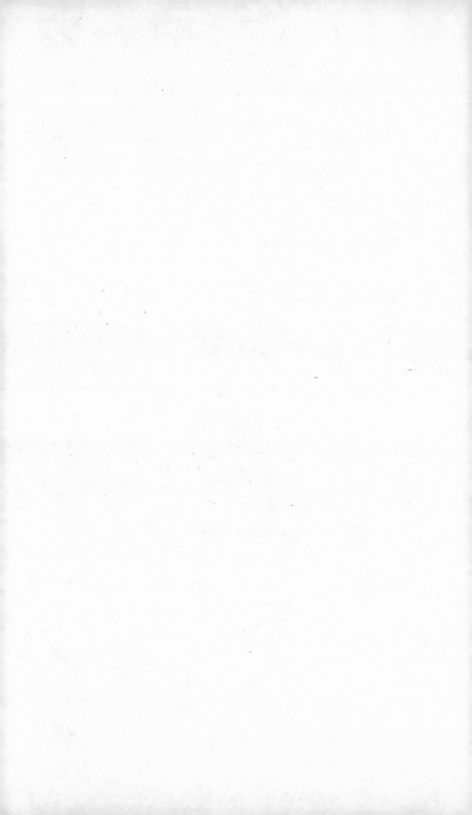

Preface to the Revised Edition

Since the initial publication of *Film Nation* in 1997, the American national narrative has become the most open and undecidable of texts, with sudden reversals giving way to spectacular rebounds, and with forces once conceived as operating on parallel or secondary tracks suddenly erupting into the main story. The extraordinary historical events of the past decade would seem to defy any attempt to find a linking theme or common quality; a previously invisible world of purposes, emotions, and memories has been exposed by the compound events of the new century, reordering the story line and blurring the outlines of the national text. In fact, neither "nation" nor "narrative" conveys the kind of authority that could be taken for granted a short while ago. Both terms now suggest something like an illegitimate conceit, a controlling perspective where no controls can be discerned, a retrograde attempt to police the borders and bind up the plural possibilities of transitory protagonists who operate outside singular narrative or political worlds.

The world dramas now unfolding across the national space challenge our understanding of the nation's past as well. Events of the past decade have brought to light a different history of nation, one marked from the beginning by competing geopolitical interests, by mobility and migration, and by contending ethnic and racial groups. The films I consider here are early, powerful examples of this revisioning. Like an

X-ray of a canvas that has been altered many times, recent historical films such as *The New World* or *Gangs of New York* reveal the under-layers of nation, the encounters and conflicts of dramatically different peoples, and the competing concepts of collective destiny. What comes through is a powerful sense of a nation continuously being remade and reshaped, a nation that, in the words of Homi K. Bhabha, "is internally marked by the discourses of minorities, the heterogeneous histories of contending peoples . . . and tense locations of cultural difference."[1] By making visible the "split selfhood" of nation, the films analyzed here convey a sense of the pentimento of national identity—the marks and erasures left on the national canvas by radically different cultures thrown together into a single, charged space.

This revised edition includes four new chapters on six films: *The New World, Gangs of New York, Flags of Our Fathers, Letters from Iwo Jima, United 93,* and *World Trade Center.* My thesis in the first edition—that historical films are creating a counternarrative of nation, one articulated through what Bakhtin calls "genre memory"—is con-firmed and reinforced in these new films. Events that have acquired a deep patina of myth and romance are subjected to a full historiographic scrutiny in these works, and they are reconceived for the contempo-rary period. The heroic aura that seems to surround such privileged events as the founding of the first English colony in Jamestown, the "making of Americans" during the first great wave of immigration in New York, the Marine flag-raising on Iwo Jima, and the hallowed si-lence that has set the representation of the terrorist attacks of 9/11 as culturally "off limits" is questioned in ways that open the past to the present and that connect the past to the particular cross-currents of the contemporary moment.

The critical models I employ may seem far from the usual frames of analysis for historical films. Drawing on the discourses of ecocriti-cism, trauma theory, ethnosymbolism, and "hauntology," my approach to these works incorporates new critical ideas that have proved to be remarkably salient. For example, the ecohistorical concept of the "Co-lumbian Exchange" is the lens through which I read Terence Malick's cinematic tone poem, *The New World.* As the eminent ecohistorian Alfred Crosby writes, the transit between the Old World and the New that commenced with Columbus's voyage was unprecedented, perhaps

the most important event in the history of life, an event that "knit together the torn seams of Pangaea."[2] Departing from the typical frames of reference in its historical recounting of the story of Jamestown, *The New World* visualizes the encounter of the two worlds as a profoundly disorienting experience; as Tom Conley wrote in another context, our "locational machinery" is suspended, and the visual and acoustic style of the film induces a feeling of weightless disorientation in the spectator.[3] Emphasizing the sensual, almost vertiginous experience of seeing a familiar geography with new eyes, *The New World* shapes the visual and sonic textures of the medium in such a way that the extraordinary "otherness" of the past is highlighted. Although the ecological devastation brought by the settlers comes through strongly, the film's emphasis falls equally on the global crossings and transits, the migrations and cultural borrowings, and the passages across continents and cultures that defined the seventeenth century. Expressed principally through the retelling of the story of Pocahontas, the "Indian Princess" of mythology, *The New World* describes both the destruction of an ancient and flourishing civilization as well as the emergence of a new world-in-motion.

Gangs of New York considers the concept of nation from a similarly defamiliarizing perspective, as a competition among violently antagonistic collectivities. Stressing the fullness of ethnic identity in its lived reality, the film emphasizes the potent emotions associated with shared memories, a legacy of heroic figures, and a relationship to place—a combination that Anthony D. Smith sets forth as an "ethnosymbolic" understanding of nation-formation. Rather than seeing nation as the apotheosis of ethnic conflict, or providing an immigrant narrative where the ethnic other is absorbed into the national body, the film presents the ethnic gangs of New York as a more powerful source of identity and emotional purpose than the fledgling nation-state. Indeed, the state is portrayed as a contending gang in its own right, with no greater claim to allegiance than the Dead Rabbits or the Native Americans. The ethnic narratives and the local patriotisms of early New York are depicted as antagonistic to the larger national ideal first articulated by Lincoln in the form of the Emancipation Proclamation and then with force in the Conscription Act and the bombardment and military occupation of New York City.

In my discussion of *Flags of Our Fathers* and *Letters from Iwo Jima*, I explore a new critical approach to the war film, considering it an example of cultural haunting—the "possession" of the present by the past. Although realism and verisimilitude have provided a touchstone for most critical work on the war film, films such as *All Quiet on the Western Front, Apocalypse Now,* and most recently *Letters from Iwo Jima* and *Flags of Our Fathers* are defined as much by their ghostly, spectral encounters as by their faithful reproduction of wartime experience. Sonic and visual realism has been critically and popularly celebrated as the war film's particular contribution to the history of the cinema. Many war films, however (even those most celebrated for their realism), convey a powerful sense of the obligation that the past imposes on the present. Expressed in the form of nightmares and hallucinations, unlocatable voices, and traumatic memories, these films touch on the deepest zones of uncanny experience. In *Flags of Our Fathers,* the famous photograph becomes a kind of haunted medium, seeming to follow the characters wherever they go. In *Letters from Iwo Jima,* the spectral setting of the caves, the sense of an external, phantom force driving the characters' actions, and the deep awareness that suicide or death in battle is the only outcome that awaits are expressed as a kind of malignant shadow-self controlling the characters' lives.

In the closing chapter, I examine the critical discourses associated with representations of trauma as a way of gauging the continuing impact of 9/11 on American national identity. Amplified by the saturation media coverage of the attacks—the attacks on the World Trade Center were viewed by approximately one third of the world's human population—the effects of 9/11 would seem to be indelible.[4] Yet few films take 9/11 as their subject. The amnesia (or insomnia) that has prevented 9/11 from being sorted into a coherent narrative has created a blank spot, like an antique map with a vacant area marked by a warning inscription: "here there be monsters." I analyze two major films that entered this more or less blank cultural zone, providing a point of reference for future work. *United 93* conveys the panicked anxiety of the hijacking in an adrenalized style, full of rapid parallel edits, jittery hand-held camera shots, and shock cuts between different locales. *World Trade Center,* in contrast, depicts the events in a

series of stunned, slowed down, static sequences, in which the paralysis of nonaction is as powerfully expressive as the frantic pacing of *United 93*.

The films I study in this book give shape to an emerging story of nation, one that can be characterized as an open, multiprotagonist narrative defined by multiple lines of interaction. Certain themes (the ecological impact of even the earliest encounter of European and Native cultures, the significance of ethnic modes of belonging within the overarching national form, the haunting of the present by the past, and the effects of traumatic historical events on national identity) have proved compelling lines of argument. These themes, almost invisible in earlier constructions of the national narrative, are placed in relief in the films I treat here and will continue to shape concepts of national identity going forward. Each film represents an encounter, and each constitutes an almost carnal remapping of the place of nation in a broader network of emotion and belonging.

Acknowledgments

I would like to acknowledge the continuing friendship and support of my two mentors, Tom Conley and Robert Rosenstone, who have encouraged and inspired me throughout my career and whose own scholarly work serves as a model. Both have created exceptional, original bodies of scholarship, and they have succeeded in swimming against the current. I also acknowledge the more recent but equally formative influence of my two colleagues at Wayne State University, Steve Shaviro and Ken Jackson, whose vanguard positions in critical theory found a way into my own work. Steve and Ken's generosity and willingness to share their sophisticated critical understanding have been the source of some of the happiest discoveries in these pages. The friendship I recently established with Rikke Schubart at the University of Southern Denmark produced a significant scholarly assignment as a Fulbright Senior Scholar, during which I completed the chapter on *Flags of Our Fathers* and *Letters from Iwo Jima*. The symposium hosted by Rikke on the two Clint Eastwood films ranks as one of the most exciting intellectual exchanges I have had yet in academia. My long-standing friendship with Dina Iordanova at the University of St. Andrews led to a visit that has become a key event in my life, and I thank her for her encouragement and generosity. For the emotional spark that energized and buoyed me during the past two years of writing, I thank my students, whose youth is contagious. And above all,

thanks to Doug Armato at the University of Minnesota Press, who has been a steadfast and faithful champion through the years.

I acknowledge the generous support of The Humanities Center at Wayne State University, which facilitated the writing of chapter 8, and I thank Wayne State University for the sabbatical support in 2008 to complete this project.

Introduction

With questions of national, racial, and cultural identity emerging as a central topic of debate in the United States, the American past has become a contested domain in which narratives of people excluded from traditional accounts have begun to be articulated in a complex dialogue with the dominant tradition. One of the most visible manifestations of this changing narrative of nation, a change that is evident throughout the spectrum of contemporary life, can be found in the resurgence of films that take the American past as their subject. Recent films such as *Glory, Thunderheart, JFK, Born on the Fourth of July, Malcolm X, Jefferson in Paris,* and *Forrest Gump* bring into relief the striking degree to which the national narrative is currently being reshaped by stories that explore the meaning of nation "from below." Although occasionally flawed by nostalgia and by a somewhat glancing relation to the historical record, these films illuminate what I think is a pervasive and growing tendency in contemporary American culture: the desire to remake what the sociologist Jacques Rancière has called the "dominant fiction," the ideological reality or "image of social consensus" within which members of a society are asked to identify themselves.[1] This impulse permeates present-day culture; even Disney's plans for a theme park on American history, for example, emphasize the importance of representing the experiences of racial and ethnic minorities, including slavery and industrial exploitation, as central aspects of the American past. But the leading edge of this impulse, in my

1

view, is the cinematic rewriting of history currently taking shape, which stands as a particularly conspicuous attempt to rearticulate the cultural narratives that define the American nation. By interrogating the reserve of images and stories that constitute the dominant fiction, these films set forth a counternarrative of American history that ultimately attempts to reinforce social belief.

In describing the concept of the dominant fiction, Rancière emphasizes the importance of narrative and pictorial forms, particularly films, in fostering a sense of national identity, arguing that they create an "image of society immediately readable by all classes."[2] In this regard, his discussion, dating from 1977, anticipates many of the most recent analyses of nationalism, which typically emphasize the importance of narrative forms in creating concepts of nation; as Timothy Brennan writes, the idea of nation depends on "an apparatus of cultural fictions."[3] The link between national identity and narrative is especially apparent in the American cinema, Rancière suggests, in which the dominant fiction of "the birth of the nation" is replayed in different ways: "whites versus Indians; North versus South; Law versus outlaw, etc." In my view, however, what Rancière admiringly calls "the legend of the formation of the code" is in the process of being transformed. Rather than rehearsing the foundational narrative that Rancière summarizes as "this is where we come from," contemporary historical films seek, on the whole, to recover a different message from the past, a message that will validate the increasingly hybrid and polycultural reality of American life and bind it to an image of nation that expresses a sense of "this is how we are."[4]

In combining the viewpoints of dominant and nondominant peoples, however, these films also register another more difficult and disturbing theme, which I will call "identity from across." The films I treat in this study insistently return to a certain hard kernel of historical truth—that social identities in the United States have largely been shaped by relations of opposition and antagonism, and that fear and hatred of the other have exerted just as powerful an influence on the molding of ethnic and racial identity as the positive and organic traits that supposedly distinguish one group from another. The stories of nation that these films unfold convey a strong sense of the way white identity, for example, has shaped itself in contrast to its perceptions of black identity, or the way American "civilization" has defined itself in contrast to conceptions of Indian "savagery"—an oppositional logic

that works against the idea that nationalism can be reconceived and re-configured to express new forms of social coherence.[5]

I offer the concept of identity from across as a way of foreground-ing the agonistic, contestatory character of this rewriting of the dom-inant fiction. Far from viewing national identity in terms of what theorists have described as a "deep, horizontal comradeship," an "imag-ined community" characterized by social unisonance, recent films deal-ing with the American past frequently address the fundamental con-tradiction at the center of the narrative of nation—the contradiction posed by race.[6] The stark inconsistency between national ideals of a deep, horizontal comradeship and the actuality of racial hierarchy and oppression, what Virginia Wright Wexman calls the tension between "the ideal of a community of equals and the drive for domination by groups within the culture," has been explored with surprising direct-ness in certain contemporary films.[7] Works such as *Thunderheart*, *Malcolm X*, and *Glory*, for example, throw into relief the subtle and complex antagonisms that structure identity in America—most evident in the way white and black American identities, for example, have been shaped in a relation of contrast and, in some cases, a relation of mimicry with each other. Social identity, as conceived in these films, originates neither from "above," in alignment with the nation-state, nor from below, with ethnicity or race, but rather from "across," through horizontal relations whose antagonistic and transitive character is best represented in terms of "inside" and "outside."[8] The mythology of na-tional identity in the United States, as recent films suggest, thus har-bors a double contradiction: not only is the ideal of deep, horizontal comradeship belied by the fact of racial hierarchy and domination, but the myth of nation is also contradicted by a kind of lateral caste sys-tem, in which identity is constructed in relations of opposition and, oc-casionally, imitation "from across."

Because these films confront what I feel are the most important and complex issues in American life today, the ongoing controversy over the legitimacy of cinematic interpretations of the past, a contro-versy that reached a critical flashpoint with *JFK* and *Malcolm X* and that flared again over *Jefferson in Paris* and *Nixon*, to my mind misses the point and at the same time reveals the significance of the stakes on the table. The argument over film's responsibility to the past encom-passes several distinct issues. Perhaps the most vexing concern, for many, is the preeminent role that film has assumed in interpreting the

past for contemporary society. The influence of film on present-day historical consciousness and understanding has often been described as debilitating; an important counterargument has been raised, however, in connection with the increasing absorption of mainstream films and television programs with the American past. Describing this phenomenon as a positive revitalization of "social memory," the historian Michael Kammen argues that the popularity of historical films and television movies, of historical theme parks and the rage for Americana in decorating and architecture—even the use of historical allusions in advertising—are part of a widespread trend that he calls "the emotional discovery of America."[9] Assessing both the limits and the strengths of this mass diffusion of interest, Kammen argues that the contemporary period is uniquely characterized by a dualistic relation to the past. The 1980s were especially noteworthy, in his view, as a time of "surging public interest in the past, but also a time when ignorance of United States history proved to be astounding; a time when spurious traditions were concocted and commercialized, but also a time when vernacular arts and folk culture flourished as never before."[10] Kammen views this paradox as a consequence of the split between history and memory in the contemporary United States. Memory and history, he writes, are peculiarly fractured and joined to one another in American culture—fractured because of the social diversity that gives us a multitude of memories, rather than a single, monolithic cultural memory; joined because the "genuine intermingling of cultures" that characterizes our contemporary reality gives us a history that "hinges on memory."[11] Unofficial forms of collective rememoration, including film and television programs based on historical subjects, have thus become increasingly important in the 1980s and 1990s in terms of their visibility and in terms of their influence on emerging and traditional concepts of collective identity.[12]

A similar argument for the persistence of collective memory in commercial, popular forms is offered by George Lipsitz, who sets forth an intriguing approach to social memory based on what he calls a "sedimented layer of historical knowledge and historical critique" in popular culture artifacts.[13] Commercial culture, he argues, can function as a site of opposition and resistance precisely insofar as it depends and draws upon actual historical experiences and traditions. Ethnic and class memories, for example, may be distorted and trivialized in commercial culture, but there are nonetheless historically spe-

cific elements within commercial culture that represent an expression of collective popular memory and the reworking of tradition that can be activated on behalf of social change. Popular culture—and his examples range from television programs of the 1950s to Mardi Gras songs and costumes—when viewed as an evocation of collective memory and tradition, however much transformed, conveys a form of contemporary social engagement with history that is usually overlooked: "The desire to connect to history, the impulse to pose present problems in historical terms, and the assertion of a temporal and social reality beyond one's immediate experience pervade popular culture."[14] Lipsitz offers the striking conclusion that popular memory, tradition, and knowledge exist not just in the fading memories of marginalized groups, but in the strongholds of the contemporary economy.

A second issue that often arises in these discussions is the interpenetration of history by fiction in contemporary films. The erosion of the presumed boundary between factual and fictional discourses has been the subject of much anguished commentary, with films that focus on the historical past sometimes held to standards of authenticity and verifiability that nearly equal the standards applied to scholarly historical texts. As Caryn James reminds us, however, in a powerful defense of the history film, "Such responses naively assume that an accumulation of facts equals truth. But a collection of facts is no more than an almanac. History is the interpretation of those facts."[15] The seemingly absolute border between imaginative and realistic discourses is necessarily permeable, for historical writing delivers not the "real" of the historical past but rather a mental conception of it, a system of discursive representations, in which speculation, hypothesis, and dramatic ordering and shaping closely inform the work of historical reconstruction and analysis. Moreover, dramatic license and a strong point of view are essential for these films to work as art, or to claim a share of the social power and influence that inheres in storytelling, both fictional and historical. James argues that social power and influence are in fact the real issue here, the one that is most troubling to critics of historical films; these films are controversial, she writes, not because of their intermingling of fiction and history, but because of their "use of fiction to challenge history's accepted views."[16]

Indeed, in works such as *Glory, JFK, Born on the Fourth of July, Thunderheart*, and *Forrest Gump*, the national past appears to be a story with distinctly tragic overtones; the narrative of nation these films

convey is at least partially a narrative of collective loss. Seen in the most positive light, they appear to be engaged in the task described by the anthropologist Victor Turner as "remaking cultural sense." Turner writes that "where historical life itself fails to make cultural sense in terms that formerly held good, narrative and cultural dramas may have the task of poesis, that is, of remaking cultural sense, even when they seem to be dismantling ancient edifices of meaning."[17] Joining a formidable quality of social criticism to a newly libidinalized national narrative, recent historical films can be seen as part of the ongoing revisionary enterprise of the late twentieth century; they reenact the narrative of nation in terms of its tributaries, in terms of stories of ethnic, racial, and gender struggles to reshape the national narrative, and to make the experiences of marginal groups a "formative and necessary part of the story."[18]

It is precisely the reshaping of our collective imaginary relation to history, and to nation, that I explore in this text. Issues such as cinema's ostensible distortion of historical reality or of the culture's willingness to substitute glossy images for historical understanding and insight are ultimately secondary to the more pointed challenge that recent historical films convey—their challenge to the traditional myths of the nation-state. The films I have chosen to examine bring into relief issues of power that underlie the idealized construction of nationhood, exposing the "fissures and faultlines" between national myths and the historical experiences of people excluded from dominant accounts.[19] Debates about film and its responsibility to the past largely obscure what I think are more significant issues—the central position occupied by film in the articulation of national identity and film's ability to hold up to scrutiny and drive home the emotional meaning of the imagined community of nation and its bruising inadequacies.

In its range and coverage of the field of national imaginings, the Hollywood cinema is in many ways an unparalleled expression of national culture, one that has molded the self-image of the nation in pervasive and explicit ways. Presumably because it functions independently of state support or government guidelines, however, the Hollywood cinema is generally not considered under the rubric of national cinema; nevertheless, it unambiguously articulates an imaginary field in which the figures of national identification are deployed and projected. Concepts of social reality constructed in Hollywood films clearly serve as legitimating discourses in the life of the nation, a func-

tion that is particularly visible in the way the national past is represented in mainstream American films.[20]

In the contemporary period, however, many of the most hallowed myths of nation have been challenged and criticized in feature films that contest the basic premises of American ideology—the myth of manifest destiny, for example, or of the progressive extension of liberty to ever-increasing numbers of people, or of the power of national belonging to displace the lived identity of race, or of the existence of a single, homogeneous nation extending from "sea to shining sea." Even within mainstream Hollywood filmmaking, the foundational narratives of nation are increasingly being contested by films that open up the locked doors of the national past and that emphasize the histories forgotten or excluded from dominant accounts.

Nevertheless, the cinematic rewriting of history that is currently unfolding retains elements of what one writer aptly calls "the relic imaginary of the past."[21] Despite highly critical messages concerning the national past, the films that form the core of this study preserve and revivify some of the basic tropes of traditional narratives of nation—the image of a mystic nationhood that is revealed only on the battlefield, for example, or the importance of warfare in molding a sense of ethnic and national community. The discourse of national identity in the works I analyze, although radically reconfigured by their focus on the struggles of people outside the circuits of power, is nonetheless drawn from a filmic lexicon that is filled with powerful, emotionally charged images of martial conflict. Drawing on what Mikhail Bakhtin calls the "genre memory" of the western, the war film, and the melodrama, the texts I examine here set up a complex dialogue between the sedimented memories of history and nation preserved in these genre forms and the alternative narratives of historical experience they bring into relief.[22]

Bakhtin's concept of genre memory provides a way of approaching one of the most remarkable aspects of these films: the fact that their appeal to new forms of social coherence is to a large extent shaped by the rhetoric, imagery, and genre patterning of what might well be called the war myths of the national past. Although a great deal of recent scholarship on nationalism and national identity has emphasized the roles of the novel, the newspaper, and film in creating the imagined community of the modern nation, many of these influential approaches overlook what I take to be one of the most significant and obvious

forms of national mythology: the war stories of the nation-state.[23] In the twentieth-century United States, the narrative forms that have molded national identity most profoundly are arguably the western and the war film, genres that articulate an image of nation that, in the words of Anthony D. Smith, has been "beaten into national shape by the hammer of incessant wars."[24]

Now these genre forms, as Bakhtin argues, impose their own historical perspectives and systems of value on individual texts, even those that employ generic codes in nontraditional ways. Capable of both recalling past usages and responding to the present in a new way, genres serve as the principal vehicles for shaping and carrying social experience from one generation to another. Understood as crystallized forms of social and cultural memory, genres may be seen as "organs of memory" that embody the worldview of the period from which they originated while carrying with them "the layered record of their changing use." As Morson and Emerson write in their recent book on Bakhtin, "Genres are the residue of past behavior . . . the crystallization of earlier interactions . . . congealed events." They both "resume past usage . . . and redefine present experience in an additional way." They "remember the past, and make their resources and potentials available to the present."[25]

Born on the Fourth of July, Thunderheart, Glory, JFK, and *Forrest Gump* draw on the genre memory of the western, the war film, and the melodrama in ways that evoke what Smith calls "the fund of accumulated myths and images common to the community";[26] they do so, however, in a way that Bakhtin has described as "double-voicing"— the adapting of an older genre to a new context. Although these films appear to be reiterating positions that are fundamental to the most traditional forms of nationalism—setting forth the conditions "under which force or violence is justified in a people's defense"—the most salient and significant message that emerges from them is their call to defend a concept of nation that has all too often eschewed the power of what one writer calls "blood arguments."[27] In my efforts to come to grips with the seemingly contradictory messages of these films—their embrace of an expanded social vision and an enlarged sense of national community, together with their dramatic assertions of a kind of blood rhetoric that communicates a potent, even militant, national self-image—I have been led to consider the distinction between ethnic and

civic nationalism discussed by Michael Ignatieff in *Blood and Belonging* and by Anthony D. Smith in his recent book, *National Identity*.[28]

Civic nationalism, Ignatieff writes, "maintains that the nation should be composed of all those—regardless of race, color, creed, gender, language, or ethnicity—who subscribe to the nation's political creed. This nationalism is called civic because it envisages the nation as a community of equal, rights-bearing citizens, united in patriotic attachment to a shared set of political practices and values." Ethnic nationalism, on the other hand, maintains that what gives unity to the nation, what makes it a place of passionate attachment, is "not the cold contrivance of shared rights but the people's preexisting ethnic characteristics: their language, religion, customs and traditions. . . . that an individual's deepest attachments are inherited, not chosen."[29] Smith points out that conceptually, the nation is a blend of these two dimensions, "the one civic and territorial, the other ethnic and genealogical," in varying proportions in particular cases, and that it is this "very multidimensionality that has made national identity such a flexible and persistent force in modern life."[30]

In my view, *Thunderheart*, *Born on the Fourth of July*, *Glory*, and *JFK* are engaged in the project of defining a new form of civic nationalism, a kind of "polycentric" or "pluralistic" nationalism, which can be seen as an alternative to the virulent ethnic or ethnocentric nationalism so prevalent today—a reversion to a form of tribalism that has begun to assert itself in the United States in the form of the white militia movement.[31] Ignatieff underlines the need to defend this form of national identity: "Liberal civilization—the rule of laws, not men, of argument in place of force, of compromise in place of violence—runs deeply against the human grain and is achieved and sustained only by the most unremitting struggle against human nature. The liberal virtues—tolerance, compromise, reason—remain as valuable as ever, but they cannot be preached to those who are mad with fear or mad with vengeance. . . . We must be prepared to defend them by force."[32] In the films I consider here, the defense of nation, conceived more or less on the civic model described by Ignatieff, forms a central, unifying theme, offering a strong sense of the power of blood arguments to crystallize a sense of national purpose; as one writer says, to "force a social alignment, to force a decision about a social truth."[33]

The more inclusive, alternative social narratives set forth by these films are thus irrigated by the rhetoric of bloodshed and by stories of

"blood sacrifices for nation."[34] As Ignatieff reminds us, civic nationalism is the only effective antidote to ethnic nationalism; civic nationalism, however, appears also to require the "ennobling" rhetoric of blood myths. Thus, the narrative of nation survives in works such as *Born on the Fourth of July*, *Glory*, and *JFK*, but in a changed form; instead of the story of an original grandeur that has continued unbroken into the present, these films convey the social ruptures of the Vietnam decade and the Civil War as openings to another, emergent narrative, similar to what Homi Bhabha calls a "hybrid national narrative," constructed from histories that have been excluded from traditional accounts.[35] These films suggest that there are potentially many histories embedded in a given historical moment, histories that may be plural and conflicting, and that require different constructions of the national past. Out of these plural and conflicting histories, we may begin to glimpse the outline of the pluralistic or polycentric form of national identity defined by Smith and the Israeli writer Yael Tamir.

My approach to these films can also be seen as a kind of implicit argument against the presumption that the nation form is fading as a dominant focus of identification. Recently, several influential theorists have argued that the category of the nation has been superseded by the globalization of economies and by the spread of information technologies, that national boundaries have been effectively dissolved. Social, cultural, and economic life in the late twentieth century, the argument goes, is increasingly organized in transnational ways; real power is draining away from the nation-state, and it is only at the political level that the nation-state retains its identity. Yet the importance of the imagined community of nation in the cultural and emotional life of even the most cosmopolitan societies should not be dismissed. Ignatieff makes the case that our deepest allegiances and affiliations are hardly touched by the apparatuses and insignia of global systems:

> Our identities are based on the small symbols that differentiate us. Freud called this "the narcissism of minor difference." It does not matter how small the difference is; we can make it into the core of our identity. Cosmopolitans keep expecting Levi's and Benetton, McDonald's and IBM to erode these minor differences. All that happens is that people cling more tenaciously to the deeper differences that remain. Yugoslavia was filled with sophisticated Europeans, driving Mercedes cars and owning Swiss-style chalets. On the outside, one could not tell them apart. On the inside they remained Croats,

Serbs, and Bosnian Muslims. Yugoslavia shows how little modernization touches our deepest allegiances.[36]

Here I would like to defend the discourse of nation as a viable and strategic category of analysis—the nation seen not as the repository of a unitary, immutable, and essentialized identity, but rather as the basis of critique, the basis for interrogating and exposing the relations of power that lie at the heart of the idea of nation, and for making audible the oppositional voices that "cohabit the national space."[37] Although narratives of nation are traditionally chauvinist, narrow, and conservative, the category of nation, as Iain Chambers puts it, is not a closed history, something already achieved: rather, it can be seen as an open framework, as something continually in the making.[38] And, as the Australian critic Graeme Turner reminds us, "We should not assume that the battle for the discourses of the nation are over, or finalized."[39]

Despite the difficulty of conceiving nationalism in terms of polycentric or pluralistic modalities, I feel it is strategically unwise to shift the struggle onto less difficult terrain. In a period when armed militias in the United States have begun a campaign of white ethnic nationalism that threatens to rend the civic form of nationalism that has defined the American ideal for centuries, despite its limitations in practice, the power of mainstream films to articulate the more elusive and somewhat inchoate desire for new forms of social coherence, for a new national vision based on the polycultural reality of American life, should be recognized as a positive cultural force. The contemporary historical film is, in this sense, a privileged discursive site in which anxiety, ambivalence, and expectation about the nation, its history, and its future are played out in narrative form. What I try to stress in the chapters that follow is the way the cinematic rewriting of history currently unfolding articulates a counternarrative of nation that, paradoxically, throws into relief the power and importance of concepts of national belonging, a form of belonging conceived not on the narrow, ethnic model of blood and origins, but rather on the model of a civic pluralism that holds that "a nation should be a home to all, and race, color, religion and creed should be no bar to belonging."[40] As these films demonstrate, in the inherited language of genres such as the western, the war film, and the male melodrama, this concept has in the past been forcefully defended. In their coupling of pointed social criticism

with an overtly emotional appeal to the value of national conscious-
ness and national identity, these films reinforce Nathan Huggins's call
for a new national narrative that will be "vastly more coherent, logi-
cal, and inclusive" and that will "reflect upon our true condition . . . as
having a common story, and necessarily sharing the same fate."[41]

The five films this study comprises offer complex and sophisticated
treatments of the linked themes of nationhood and history. Each of
these texts interrogates the historical basis and the changing character
of national identity in the United States from a different perspective,
and together they offer a kind of "portrait in the round" of what can
be called the "national imaginary" in the contemporary period.[42] In
each, the nation is portrayed at a moment of historical crisis—the Civil
War in *Glory*, the Vietnam War in *Born on the Fourth of July*, the as-
sassination of John F. Kennedy in *JFK*, the centuries-old struggle be-
tween the state and Native America that *Thunderheart* revisits in the
context of the aftermath of the siege of Wounded Knee in the 1970s,
and the 1960s of *Forrest Gump*. The defining moments of American
history, these films suggest, are those that force the margins into the
center of the national text and that compel a new configuration of the
nation's self-image.

Although these five films could hardly be said to exhaust the range
of issues and contradictions circulating through and around the con-
cept of nation in the present day, the texts I have chosen represent sev-
eral points of an imaginary compass that allows for a fairly accurate
survey of the intellectual and historical field of national identity. The
cardinal concepts and ideas concerning nationalism in the contempo-
rary period are dramatized here in narratives replete with symbolism,
myth, history, and drama, in which the crises and conflicts of an in-
creasingly multicultural society are translated into the discourse of ver-
nacular and national mobilization. Each of these films allows me to
address different facets of the question of national identity, and each
brings into view previously unmarked areas of history, ideology, and
cultural life.

In chapter 1, I consider the Civil War film *Glory* in terms of the
competing forces of race and national construction. In articulating the
historical construction of racial identity at a moment when concepts of
nation are once again undergoing radical redefinition, *Glory* conveys
a particularly complex understanding of the way racial and cultural

identity is bound up with the national narrative. Drawing on the distinction Cornel West makes between identity from above (identification with the nation-state) and identity from below (racial and ethnic identity), I show how the struggle for racial visibility and recognition that culminates in the spectacular assault and massacre of the film's final sequence is complicated by another, competing message. In counterpoint to the ostensible subject matter and theme of the film, which might be defined in humanistic terms as the mutual reshaping and redefinition of identity from below and identity from above, the film also explores the more fractious subject of the failure of social movements to cut across racial identities, emphasizing the fear and hatred of the other as the constant feature of national experience. In its unusually direct examination of what I call identity from across—the particularities of white and black identity defined in relation to one another—the film makes evident the limits of its own nationalist solution to racial difference and antagonism, projecting in its closing images not a triumphal story of social progress but rather a national story that is in part a collective narrative of social loss.

Chapter 2 focuses on the film *Thunderheart* as an example of the changing image of Native Americans in the "national imaginary" of the nation-state. Here, I consider the way Native Americans have emerged in contemporary films as agents of a powerful counternarrative of nation, bearers of an alternative historical and national consciousness molded and shaped by centuries of incessant war. The theme of continuous struggle against the nation-state is expressed visually in the film's striking opening sequence, which fashions a reversal of the territorial imaginary of the state, calling into question the dominant metaphor of east-west "progress" and the basic model of history underpinning the master narrative of nation. However, I also note the ways *Thunderheart* draws on what Bakhtin calls the genre memory of the western, historically one of the nation-state's most important vehicles of nationalist ideology. The historical signals and cultural values associated with the western interpenetrate and affect the construction of new images in *Thunderheart* in ways that suggest an affinity between the two nations.

Chapter 3 looks at the film *Born on the Fourth of July* as a complicated variant of what Susan Jeffords calls "the remasculinization of America."[43] Linking the symbolism of nationalism to the iconography of gender in an overt way, the film anatomizes the failure of masculinist national ideals in the Vietnam period, offering in its closing scenes

an alternative image of nation based on the metaphor of a maternal, social body America, an "America who can embrace all her children." But while the film overturns myths of masculinity constructed on ideals of "punitive agency," it restores the privileged place of the male hero by appealing to another cultural paradigm, what Freud called "the rescue fantasy" in which the male hero gains authority by "rescuing" the nation, figured as a woman, from its own weakness. In its portrait of the Vietnam veteran as victim of patriarchy on the one hand and as savior of the nation on the other, *Born on the Fourth of July* solicits a more complex reading of masculine agency in the Vietnam film than has been given to date.

In chapter 4, I examine the film *JFK* in terms of the tension between the film's formal innovations and its explicit aim to articulate a narrative of national cohesion. Contrasting the film's fragmentary, atomized form to the sense of simultaneity and connectedness that Benedict Anderson maintains is crucial to the imagined community of the modern nation, I argue that the film's profusion of stylistic modes and idioms expresses the rupture of a once-unified national text. In its collagelike structure, *JFK* calls to mind the idea set forth recently by Hayden White—that modernist, antinarrative techniques, characterized by fragmentation, the exploding of the conventions of the traditional tale, and the dissociation or splitting of narrative functions, may be the most appropriate techniques for representing the historical reality of the contemporary period.[44]

In chapter 5, I consider *Forrest Gump* as an example of the powerful role that social memory plays in constructing concepts of nation. The film places in relief the power of memory and narratives of memory to create subjective connections to the national past, to call forth the sense of "I" and "we" that makes the national narrative compelling and meaningful. At the same time, however, the film repudiates the political movements of the 1960s, wiping the slate clean of blacks, women, and the counterculture in an effort to disengage cultural memory from public history. In severing history—understood as the register of public events outside the spectrum of individual experience—from what it envisions as the authentic texture of national life, the film creates a kind of prosthetic memory of the period, refunctioning the cultural memory of the sixties so that it can be integrated into the traditional narrative of nation. It thus imagines America as a kind of virtual

nation whose historical debts have been forgiven and whose disabilities have all been corrected.

Each of the films examined here defines national belonging in terms of a complex interplay between what Rancière calls the dominant fiction and local, vernacular memories of adversity and struggle. Each places in relief the wider significance of little-known strands of historical experience. But their most powerful and resonant appeal is their call to defend the concept of civic nationalism in a period when ethnic and racial conflict in the United States has again forced a re-evaluation of the meaning of national belonging. The past speaks to the present with extreme clarity on this particular subject; the films that constitute this study serve the exemplary role of making these lessons audible.

1 | Race and Nation in *Glory*

In resurrecting the forgotten story of a black Union Army regiment and its white leader, Colonel Robert Gould Shaw, *Glory* conveys a particularly complex understanding of the way racial and cultural identity is both bound up with and competes with the forces of national construction. Examining the historical construction of racial and national identity in the United States at a moment when concepts of nation were being fundamentally redefined, *Glory* emphasizes the tension between a civic ideal of nation conceived as a community of equals and the powerful appeal of ethnic and racial identities based on what Michael Ignatieff calls "blood and belonging."[1] Far from mediating or subduing ethnic concepts of nation, the Civil War, the film suggests, pulled potent structures of racial identification into visibility, promoting a sense of racial mobilization in white as well as in black America. *Glory* thus departs from the traditional themes of Civil War narratives, which typically focus on the emancipation of the slaves and the rebirth of national ideals of community and equality, to explore a subject that D. W. Griffith first considered from a rather different perspective: the struggle between competing ideals of nation, ethnic and civic, and their equally potent claims to recognition and belonging.

At first glance, *Glory* appears to be primarily concerned with the relation between what Cornel West has described as identity from above—identification with the nation-state—and identity from below—racial and ethnic identity. These two forms of identity, as West points

out, are both defined by the most elemental concerns; they are fundamentally about desire and death. The desire for affiliation, for recognition, for visibility, is one of the most significant and visceral forces shaping both national and racial identity. But the construction of identity also involves the recognition of death, being willing to die for that identity, or being willing to kill others for it.[2] In *Glory*, this concept is dramatized in a strikingly literal way, as the struggle for racial visibility and recognition culminates in the spectacular assault and massacre of the film's final sequence, foregrounding the almost suicidal costs of aligning identity from below and identity from above. Underlining the theme of collective martyrdom with the sounds of choral music, the film idealizes the sacrifice of the black soldiers as the price of national affiliation, as if identity from above were in some way a mystical compact, authorized and conferred only in death. By invoking what Paul Gilroy calls "a mystic nationhood that [is] only revealed on the battlefield," the film further suggests that racial difference is dissolved in warfare, valorizing war as the defining moment when racial and national self-realization coalesce.[3]

But this thesis, in which national identity is presumed to dominate and displace the lived identity of race, is complicated by another, competing message in *Glory*. In counterpoint to the ostensible subject matter and theme of the film, which might be summarized in humanistic terms as the mutual reshaping and redefinition of identity from below and identity from above, the film also explores the more fractious subject of the failure of social movements to cut across racial identities, emphasizing the fear and hatred of the other as the constant feature of national experience. Although the central importance of national identity is asserted strenuously in the closing moments of the film, the body of the text seems to be concerned mainly with what I am calling identity from across: the nonsymmetrical relationship between white identity and black identity that defines points of tension in *Glory* that have little to do with the unifying rhetoric of nation or the traditional Civil War topics of liberty, equality, and self-determination. And it is here that the film illuminates the hard kernel of historical truth that is slowly working its way through the various revisions of the dominant fiction that are currently being offered: the recognition that the achievement of new forms of collective coherence will require something other than an updated narrative of nation, and that only a historical narrative that, as the historian Peter Dimock writes, "is explicitly a collective

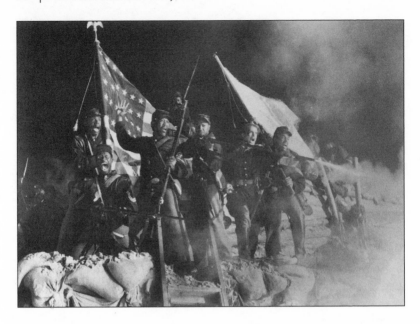

narrative of social loss" will be able to address the present crisis of so-
cial belief.[4]

This secondary theme is articulated chiefly through the story of the
white commanding officer, Colonel Robert Shaw, which serves in large
part as a means of registering the dissonance between white racial
identity and the imagined community implied by emancipation. Rather
than merging whiteness and nation into a single myth, the film sug-
gests that the historical coalescence of black identity during the Civil
War forced apart the formerly seamless narrative of white identity, sep-
arating it from its traditional one-to-one correspondence with the con-
cept of nation. With emancipation redefining the meaning of national
community, the voice of white racial privilege could no longer be heard
as the exclusive voice of national ideals. By inverted yet strangely simi-
lar paths, *Glory* comes to the same conclusion as D. W. Griffith's *Birth
of a Nation*: white identity is defined and clarified by black identity,
which forces "whiteness" into the open and compels it to speak in a
language of its own.

As Richard Dyer has explained, white identity is an exceptionally
elusive and difficult subject to analyze, for it represents itself not in
terms of particular characteristics and practices, but rather as a synthe-
sis of all the attributes of humanity. "The strength of white representa-

tion . . . [is] the sense that being white is coterminous with the endless plenitude of human diversity."[5] Just as the color itself is defined as a combination of all the other colors, white racial identity seems to have no substance of its own: "White power secures its dominance by seeming not to be anything in particular . . . as if it is the natural, inevitable, ordinary way of being human."[6] The invisibility of whiteness, its lack of specificity, masks it as a category; so thoroughly identified with the norm, white racial identity becomes difficult, especially for white people, to see and to represent.

One of the ways white identity does become visible, Dyer suggests, is in the contrast between white and nonwhite in narratives marked by ethnic or racial difference, narratives in which nonwhite characters play significant roles. In order to represent white identity, a "comparative element" seems to be required, for "only non-whiteness can give whiteness any substance." In such texts, the characteristics of whiteness can be inferred if not defined, understood by way of contrast with the stereotypes associated with nonwhite modes of behavior. In the films Dyer analyzes, the "presence of black people . . . allows one to see whiteness as whiteness." And the sense of whiteness is accentuated, Dyer notes, in films centering on situations where white domination is contested.[7]

These ideas offer an instructive approach to the representation of racial identity in *Glory*. The film uses the drama of the 54th Massachusetts Infantry, the first black regiment to be raised in the North, partly to pull white identity into visibility, detailing the practices and characteristics of the white Union military, emphasizing the "psychology" of whiteness, as seen through Shaw, and placing in relief the internal complacency and self-interest of the white establishment. The effective display of white identity, however, depends on a relation of rigid contrast with black identity, a contrast that recalls the absolute binarisms of racist thought. Stiff formality, an emphasis on individual agency and responsibility, and links to historical tradition are set out as clear markers of whiteness and explicitly set against the exuberance, collectivity, and sense of historical emergence that characterize the black soldiers. In keeping with the film's liberal themes and contemporary perspective, however, many of the features associated with whiteness are held up to scrutiny and subjected to criticism, partly through the voice-overs of Shaw himself. Ultimately, however, the traits

identified as white are restored to dominance as Shaw overcomes self-doubt and gains the approbation and respect of the black troops.

As Dyer observes, the ability to resolve this kind of crisis of identity can also be seen as one of the attributes of whiteness; here, the hero restores his own fading sense of authority by appropriating the emotional intensity associated with the black soldiers, displaying an uncharacteristic passion in a series of scenes in which Shaw ferociously confronts the military establishment, dresses down his own officers, and, in an expression of solidarity with his troops, rips up his pay voucher to protest the unequal pay the soldiers have received, taking his cue directly from the black soldier Trip. In a subtle way, however, the emotional intensity common to the black soldiers is recoded in these scenes as part of human nature, latent but still accessible to the white Colonel Shaw. In contrast, when the black soldiers take on the rigor and discipline associated with the whites, it is a cultural attitude, not nature, that is absorbed. Where Shaw seems to require an infusion of natural passion to complete his character, the black soldiers require, in the logic of the film, the armature of certain cultural values associated with whites. Here, the film appears to reiterate conventional notions of blacks possessing more "nature" than whites, whereas whites command the sphere of culture. Thus, despite the superficial impression the film gives of a fluid crossing over of characteristics, the overall marking of racial differences is such that the boundary between black and white appears to be more fixed than permeable, and where mutual reshaping of identities does occur, the traits that are exchanged often play into well-worn stereotypes of racial difference.

Glory provides an especially good map of contemporary liberal thinking about race. In stressing the ways that white identity has been historically conferred, the film displays with exceptional precision the traditions, psychology, and behavior and practices of the white establishment during the Civil War period, underscoring the different ways whiteness, in both its progressive and reactionary aspects, has been shaped by the reality of an emergent black racial identity. In contrast, however, the film offers a portrait of black identity that is affirmative, but resolutely ahistorical, as if black history had to be remade by white hands and according to white ideas in order to release its most powerful messages.[8] Despite the positive accent the story of the black troops receives, the film's erasure of its actual historical figures, compared with its detailed reconstruction of the milieu of

Colonel Shaw, ensures that the relations of racial identity here remain nonsymmetrical.

In general, the film uses two different paradigms to define racial identity, one of which is historical, the other folkloric and stereotypical, which are folded together or superimposed upon one another throughout the film. At several points in the narrative, the particularities of historical experience assert themselves in a powerful fashion, conveying a clear message that history has shaped racial identity in incommensurably different ways. For example, the film foregrounds the different meanings that blacks and whites assign to features of military life and specifically to the war against the Confederacy: military training and discipline, marching, and the climactic battle itself are viewed from a bifocal perspective that makes explicit the distinct optics that racial difference confers. At other points, however, this self-aware and careful dialogical principle gives way to a simple binarism in which racial difference is defined not in terms of historical experience but in terms of intrinsic differences, a tendency that rehearses essentialist patterns of racial representation. Seen in the most positive light, the film makes visible the way identity is constructed transitively, from across, using the binarisms of racial representation in a critical fashion and drawing from the dialogic encounter of black and white a reconsideration of the issues and traditions of national identity. But from another angle, the film hews uncomfortably close to old stereotypes, especially in its folkloric approach to black identity, which diminishes the actual historicity of black experience and identity.

In the pages that follow, I analyze the representation of racial identity in *Glory* from three different perspectives. First, I notice the contrast in the way the participants in the drama are defined and authenticated, a contrast that can be broadly described as historical versus folkloric. Second, I show how the film, despite its occasional lapses into stereotype, extends the dialogic principle discussed above—the foregrounding of the distinct viewpoints that racial difference entails—to encompass the historical process itself, represented in terms of two distinct historical trajectories, two competing narratives of history that are brought into conjunction in the imagery of the road and the march into the South. Third, I consider the messages the film conveys about racial identity and the national narrative from the perspective of the present, arguing that its seemingly traditional message of military valor

and sacrifice opening up the "iron gate" to equality is counteracted by another message, signified by the closing shot of bootless corpses, which projects, like a kind of afterimage, a narrative of a nation imprisoned by its past as much as empowered by it.[9]

History versus Folklore

By placing difference and conflict at the center of the national narrative, the film's approach to racial and national identity substantially changes the meaning of the story as it was known in the nineteenth century. Celebrated as one of the most renowned figures of the Civil War, Shaw, along with the 54th Infantry, had captured the imagination of the general public as well as the interest of the literary and political leaders of the period. Shaw's posthumous stature was such that Ralph Waldo Emerson and William James, among others, commemorated his "martyrdom" in verse and prose.[10] The recent treatment of the story, however, highlights Shaw in a different way, using him as a medium for registering the pointed racial animus of the Union military, as his idealism seems to bring into the open the underside of white racial identity, its basis in racial exclusion and fear. In large part, the text divides its affirmative and critical messages regarding racial identity in such a way that the Shaw narrative becomes the locus of a critical interrogation of white identity, now disjoined from its usual central position. The story of the black troops, on the other hand, who had been marginalized to such a degree that the "Shaw Memorial" in Boston had originally been designed with no black soldiers represented, is made the positive focus of the narrative, which treats the sacrifices of the 54th as the genesis of a black narrative of American history.[11]

In many respects, *Glory* reverses the usual codes of racial representation, portraying white identity for much of the narrative in an expressly critical way, while representing the narrative of the black soldiers as a drama of origins, the tracing of a heroic lineage. But in other ways, the film recapitulates many of the traditional stereotypes of race. Whereas the character of Shaw is heavily psychologized in a manner that emphasizes his self-consciousness and awareness, the black soldiers are portrayed in a resolutely nonpsychological fashion, and are associated instead, as if by way of compensation, with a kind of spirituality and resilience. Additionally, the historical dimensions and traditions of white identity are stressed: Shaw's actual historical existence is

underlined by specific references to his abolitionist family and to the political and military leaders of the day and through the use of his correspondence, rendered in the form of several first-person voice-overs scattered throughout the film. The black soldiers, on the other hand, are represented as bereft of historical tradition: the actual historical figures who served in the 54th, which included Frederick Douglass's two sons, are replaced by entirely fictional figures. Whereas the historical individuality of Shaw is underlined, the black soldiers are represented in the form of an ensemble of stereotypes in which the "Wild Tom," the "Uncle Tom," the "Buppie," and the rural hick are plainly represented.

Another striking difference in the way white identity and black identity are portrayed is in the dissimilar styles of language that characterize the two groups. In the voice-over that opens the text, for example, Shaw draws direct links among language, history, and national identity. Comparing the Civil War to the War of Independence, he says: "How grand it is to fight for the country, like the old fellows did in the Revolution. Only this time we must make it a whole country so that all can speak." The voice-over continues over images of life in the military camp and scenes of dispossessed blacks on the road, at which point we hear that the war is being fought "for a people whose poetry has not yet been written, but which will presently be as renowned and enviable as any." The character finishes the monologue with a quote from Emerson, whose words, he says, provide him with strength and comfort. These lines are typical of the discourse of the white officers. The refined speech of Shaw and his colleagues connotes class privilege, a sense of social obligation, and a long, stable, and unified tradition, one that assumes a perfect congruence of white racial identity and national identity.

In contrast to the unified tradition of Shaw, the black soldiers exhibit a range of dialects, verbal patterns, and rhetorical styles; the "poetry" to which Shaw alludes conveys a diverse sense of origins and a loose, patchwork form of connection. Thomas, for example, the eastern-educated black volunteer, must have the patois of a Sea Island black translated for him by another black soldier. Similarly, the exaggeration and deadpan humor of Trip proves incomprehensible to Jupiter, a rural black. Moreover, the motley regiment comes equipped with a mute drummer boy, whose practice and mastery of his instrument serves as a kind of synecdoche for the unit's growing sense of co-

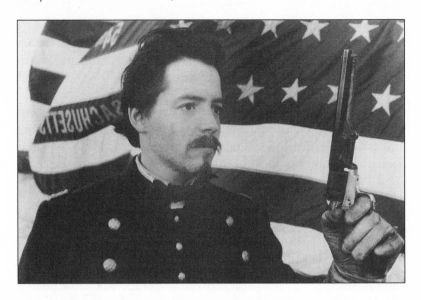

hesion. Whereas Shaw's voice-overs, together with the speech patterns of the white officers in general, are clearly marked as "historical," the black soldiers' speech patterns are marked as geographically diffuse, underlining the film's strategy of treating the story of the 54th as a narrative of emergence.

One of the consequences of this strategy, however, is the elimination of all but the most glancing references to black participation in the established political and social traditions of the period. A case in point is the portrayal of Frederick Douglass, who is depicted at the beginning of the film in a way that promises to counterbalance the traditional emphasis accorded Lincoln in stories of the Civil War. Contrary to expectation, however, Douglass appears only in the company of the white establishment, and is never mentioned by the black soldiers, who appear to be wholly unfamiliar with him. This aspect of the film contradicts the view of historians who aver that Douglass was widely known and revered among the black population of the Civil War period. The bracketing of Douglass from the portrait the film offers is compounded by its overlooking the fact that Douglass's two sons, Lewis and Charles, served in the 54th, with Lewis becoming sergeant major. Moreover, the film fails to indicate that the first black Medal of Honor winner was a member of the 54th.[12] Although it tries to make racial struggle a "formative and necessary part of the story" of Ameri-

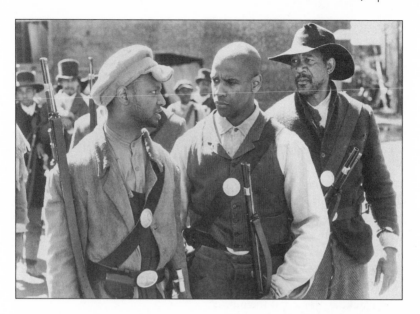

can history, to use the words of Nathan Huggins, the film provides only fictional "types" among the black soldiers, rather than the actual historical figures, whose presence would certainly lend its historical portrait a heightened degree of authority.[13] Another omission is the role played by the black intellectual Charlotte Forten, who worked as a teacher and nurse in the area where the 54th was encamped in South Carolina, and who had gained the admiration of Shaw. To some degree, the film treats the black soldiers and citizens of the period as bereft of historical tradition, understood in the conventional sense. The story of the 54th is instead constructed as the genesis, the mythic origin, of black historical consciousness.

But the history of black identity during the Civil War period that *Glory* suppresses with one hand it restores with the other; what Frederick Douglass called the "fleshly diploma" of slavery—the whip marks and other signs of physical abuse inflicted on the slave's or the ex-slave's body—comes to express another kind of tradition, another kind of history, one that functions in counterpoint to the dominant tradition.[14] Although the film erases much of the actual history of the 54th, it succeeds in creating a picture of a historical world that is shaped by radically different historical experiences, implying that there are potentially many histories embedded in a given historical moment. More-

over, the film suggests that black history and white history in the United States determine and shape one another. At certain points, it illuminates with surprising subtlety the deep, structural connections between the dominant tradition and the suppressed and marginalized history of racial domination, a theme that allows us to glimpse the outline of a more fundamental rewriting of the narrative of American history than we might have expected from this film, a rewriting that works against the convenient myth that, as Nathan Huggins puts it, "American history—its institutions, its values, its people—was one thing and that racial slavery and oppression were a different story."[15] By articulating these stories together, the film echoes the approach of historians such as Huggins, whose words could almost serve as an epigram to certain sequences: "Whereas the master narrative detached . . . slavery and the slave experience from the central story . . . there can be no white history or black history, nor can there be an integrated history which does not begin to comprehend that slavery and freedom, white and black, are joined at the hip."[16]

These ideas are powerfully expressed in the flogging scene in *Glory*, as Trip and Shaw reenact a historical pas de deux that suggests that the stories of white and black in America are inseparable and mutually defining. Trip, the black soldier whose defiant character has already called forth particularly intensive disciplinary procedures, has slipped out of camp to acquire some decent leather boots. Caught and assumed to be a deserter, Trip is brought before Shaw and the assembled company to be flogged. Shaw insists on this punishment, over the protests of his second in command, determined to show his control over the men as well as his control over his own emotions. As Trip is readied for the punishment, the drill sergeant pulls the shirt off of Trip's back to reveal a torso covered with scars from previous whippings. Despite his evident shock and dismay, Shaw sticks to the order he has given. As the whipping commences, however, a certain reversal takes place. In a series of close-up reverse shots, Trip's self-discipline and control over his body are underlined, as he receives the flogging without "breaking down." Shaw, on the other hand, appears to lose authority with each stroke of the whip, as his rigidity is coded not as a form of strength but as inflexible adherence to a code that has suddenly been revealed to have two different meanings, one having to do with military discipline, the other with racial domination.

The flogging scene in *Glory* departs from actual history—flogging

was banned in the Union military—to make a larger point about the way the historical past marks black and white differently, but with the same pen. The whip marks on Trip's body are the signifiers of the other national narrative, a history that, although suppressed and marginalized, challenges the master narrative itself. Here, the film uses the imagery of scarred and lacerated flesh as a historical text to be read in counterpoint or, better, to be read interlinearly with the dominant narrative, like a coded message in which every other line carries the principal meaning, a meaning that often explicitly contradicts the text taken as a whole.

The commonality of these two histories is underlined by the physical mirroring of Trip and Shaw. Consider the following passage from Frantz Fanon on the way master and slave, colonizer and colonized, act out a kind of mirrored identification:

> A world divided into compartments, a motionless, Manichean world, a world of statues. . . . The first thing the native learns is to stay in his place and not go beyond certain limits. . . .
> . . . he finds he is in a state of permanent tension. . . . The symbols of social order—the police, the bugle calls in the barracks, military parades and waving flags—are at one and the same time inhibitory and stimulating: for they do not simply convey the message "Don't dare to budge"; rather they cry out "Get ready to attack." The impulse . . . implies the tonicity of the muscles. . . . The settler . . . keeps alive in the native an anger which he deprives of an outlet; the native [is] inwardly in a state of pseudopetrification.[17]

The flogging scene in *Glory* corresponds in an almost uncanny way to this description: the overall quality of motionlessness in its mise-en-scène, emblematized in the statuelike posture of Shaw versus the tensed, tight, muscular tonicity of Trip; the stiff formation of the soldiers; the trappings of military authority, the bugle call and the drum roll, which evoke here the contradictory emotions that Fanon describes—"Don't dare to budge," as well as "Get ready to attack"—producing an adrenalized stasis that is plainly represented in the body postures of Trip, the soldiers, and Shaw himself. Although the "symbols of social order" clearly mean different things for blacks and whites, the effects of power position Trip and Shaw in similarly fixed and inflexible roles. In an instructive analysis of Fanon's imagery, Homi Bhabha points out that the play of polarities in his description of colonial relations—Subject/Object, Self/Other, Oppressor/Victim,

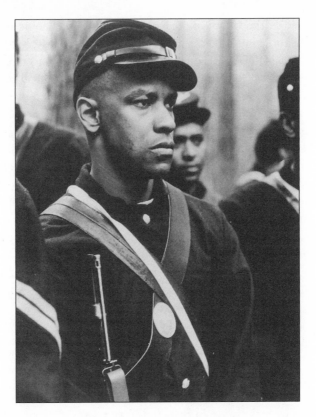

Power/Powerlessness—places both oppressor and victim in exceptionally similar predicaments: both are "pseudopetrified" in their antagonism.[18] In a similar fashion, Trip and Shaw become, in a sense, mirror images; in Trip, a continuous physical tension marks the conflict between the proscriptions of social reality ("Don't dare to budge") and the impulses of psychic reality ("Get ready to attack"), whereas in Shaw, the immobilizing effects of authority seem to mummify the character, marking his features and his body posture with a kind of rictus as he resolves to exercise the power of his office.[19]

Flogging scenes are a familiar staple of narratives set in the Civil War period; what sets this sequence apart is its dialogic quality. Rather than simply appealing to the masochistic or moral propensities of the viewer, the sequence is explicitly staged as a challenge to the dominant historical order and its way of perceiving race. Trip, a "graduate of the peculiar institution with [his] diploma written on [his] back," to apply

the words of Frederick Douglass, has in effect "educated" Shaw about a history he had been insulated from, a history that transforms the punishment of Trip from the singular event that Shaw perceives it to be to the replaying of a historical pattern.[20] In a striking and pointed reversal, the scene suggests that it is Shaw's understanding of the historical past—and, by extension, white America's—that is mythological and folkloric. The dominant tradition, with its idealized conception of the American past, is itself a form of mythology insofar as it represses the history of race. As Huggins writes:

> The story of the United States is of the development of the North (read Puritan New England) rather than the South. It is of whites unrelated or unengaged with blacks. It is of freedom and free institutions rather than of slavery. It is as if one were to write a history of Russia without serious consideration of serfdom: a history of India ignoring caste. The distortion would be jarring did it not serve so well the national mythology and an idealized national character.[21]

Although the film appears at first to draw the most extreme contrast between the historicity of the white tradition and the folkloric nature of its version of black history, these terms end up being reversed, as one kind of historical knowledge confronts another.

Two Historical Trajectories

With the flogging scene, *Glory* produces a striking impression of "turning the tables" on the dominant tradition. But the overall thrust of the film—which is, I think, focused even more closely on white identity than on black—also channels the message of the sequence in another direction, bringing it back to the question of whiteness, to how the white hero will respond. The film uses this scene to instill in Shaw a layer of guilt that will be played on throughout the film. The linked themes of guilt, reparation, and reconciliation are from this point forward used to define the narrative of whiteness in a way that is distinct from the story of the black troops. Partly, this is a consequence of the psychologizing of Shaw, the focus on his emotions and sense of self-doubt. But it is also an aspect of the deeper fault line in the film, which configures the black narrative and white narrative along two different historical plotlines.

Like a painting with conflicting vanishing points, the film sets out different historical teleologies for blacks and whites. The narrative of

collective emergence that characterizes the story of the African Americans is explicitly inverted in the story of Shaw, who we see discovering for the first time the hypocrisy of the white establishment. Continually confronted with venality, corruption, and lack of commitment in the military establishment, Shaw as a character becomes a way for the filmmaker to foreground the attenuation of the enlightenment narrative of history, of history unfolding in the service of liberty. With his continual wrestling with ethical dilemmas, and with the explicit message communicated through Shaw that the battle to be fought is not against an external enemy but rather against the internal complacency and self-interest of the whites, the Shaw narrative takes on the moral chiaroscuro more typical of the Vietnam film than the Civil War genre.

Nonetheless, Shaw is constructed as the hero of the narrative. Usually shown on horseback, often pictured in solitary contemplation of some distant horizon, Shaw is vested with the unmistakable iconography of the heroic. However, the film changes the meaning of his heroism from what it meant in the nineteenth century, for in *Glory* Shaw is constructed principally as a redemptive image of whiteness, a sacrificial figure who counteracts or "cleanses" the racial bias among the whites detailed throughout the film. Through Shaw, the narrative of whiteness becomes associated with social guilt and with the repayment of a historical debt. The theme of martyrdom, which dominated the Shaw legend in the nineteenth century, is here recoded to express a very different message of guilt and expiation.

In the scenes set on the road, the sense of a nation moving in two different historical directions is brought into relief. For example, one of the first shots in the film shows a mass of black families walking on the road near Antietam. As the film progresses, and as the soldiers of the 54th become increasingly disciplined and united in their resolve, the road is converted from an image of displaced drifting to a symbol of racial striving, with synchronized marching replacing images of wandering and admiring comments from bystanders supporting a sense of growing racial identity. One of the ways the film underlines the importance of the road motif is through its repeated use of close-up shots of running, marching, and bloodied feet. In a famous line, Frederick Douglass wrote, "My feet have been so cracked with the frost that the pen with which I am writing might be laid in the gashes."[22] The film reworks this image of wounded flesh, with its links to memory, into its own representational logic to signify the coalescence of a

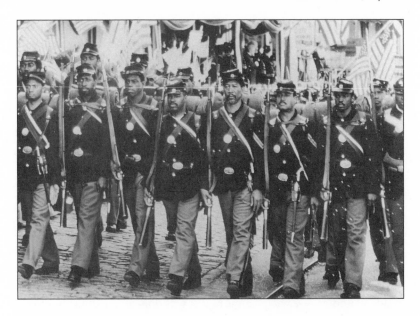

historical force and the beginnings of a new historical epoch, as the march of the black troops through the South clearly evokes the civil rights marches of the 1960s. From this perspective, the film corresponds closely to Mikhail Bakhtin's description of the "novel of historical emergence," in which the hero "emerges along with the world and . . . reflects the historical emergence of the world itself." The soldiers of the 54th Infantry of *Glory* are represented "at the transition point between two historical epochs," a transition that is accomplished, to paraphrase Bakhtin, in them and through them.[23]

The motif of the road conveys a very different sense of historical meaning, however, when viewed in terms of the character of Colonel Shaw. Rather than an image of collective emergence, the road represents something like a religious *via crucis* for Shaw, one that stretches from his near brush with death at Antietam to his actual death at Fort Wagner. The construction of Shaw as a purificatory figure culminates in the scene on the beach immediately prior to the assault on Fort Wagner. Here, in a solemn moment of poetic introspection, Shaw is shown gazing out to sea, in the company of his horse. In this scene, marked by solitude, interiority, and a sense of an approaching "end," there is little suggestion of an impending social transformation on the horizon. Instead, Shaw becomes the locus of a critical, post-Vietnam-style interro-

gation of individual and collective morality, especially the morality of white America. The message of historical emergence associated with the black troops thus meets a sense of historical closure in the character of Shaw, as the film projects a dualistic image of nation, one in which scenarios of continuity or dissolution seem equally available as possible futures that might be generated from the events of the past.

Racial Identity into National Identity

In what is clearly the summit of the film's aspirations concerning the recovery of African American history, *Glory* provides a long, detailed treatment of the collective religious ceremony called the shout, in which the black soldiers of the 54th define their own sense of collective identity. The filmmaker, Edward Zwick, has said that discovering the "voice" for this sequence was particularly difficult, and that he relied on the black actors and their experience of contemporary churches to fashion it.[24] Here, the film shifts to a different rhetorical style and mode of address—Zwick claims that it was done in an almost improvisational way—to underline the black "authorship" of the scene. And despite Zwick's seeming disclaimer as to its historical authenticity, both the imagery and the call-and-response pattern of the shout accurately render the communal practices of black people during the Civil War years, including black Union soldiers preparing for battle.[25] Music and religion, as Paul Gilroy notes, were the two resources of communication and struggle available to slave cultures: "The struggle to overcome slavery, wherever it developed, involved adaptations of Christianity and politically infused music and dance, which, in Du Bois's phrase, comprised 'the articulate message of the slave to the world.'"[26]

But the significance of this scene lies less in its historical authenticity than in the way it opens to larger themes of racial and national identity, especially the translation of racial identity into national identity. The shout in many ways functions as a kind of nerve center of the text, bringing the issues of race and nation, of identity from below and identity from above, into vivid conjunction. As the camera focuses on the troops assembled around a campfire, a lead vocalist is seen singing lyrics that communicate a double message: the story of Noah's Ark as an allegory of the slave ship. Certain lines of the song make this relation explicit: "He packed in the animals two by two; / ox and camel and kangaroo; / He packed them in that Ark so tight / I couldn't get no sleep that night." The song underlines the themes of diaspora and

wandering that will be played up throughout the sequence, and poetically converts the experience of slavery and displacement to a message of survival and providential guidance.

As the scene continues, the historical analogies encoded in song and testimony also continue, with each character's testimony accenting the themes of history and identity in a different way. Jupiter, for example, an illiterate field hand at the beginning of the film whose tutoring by the well-educated Thomas has been subtly insinuated into several scenes, speaks of going into battle with "the Good Book in one hand and the rifle in the other." The link between the Bible and the rifle calls to mind the particular accent black people of the period gave to the image of Jesus. As Lawrence Levine notes, Jesus was ubiquitous in the spirituals, but it was not the Prince of Peace of the New Testament that was celebrated but rather a Jesus transformed into an Old Testament warrior: "The God I serve is a man of war."[27] Jupiter's words also imply an image of a future that will be made with both the rifle and the book; the book, the film suggests here, is a weapon as powerful as the rifle and can serve as an agent of community, in this case bringing the rural field hand and the educated easterner together.

Another character, Rawlins, also makes a comparison to the Bible when he says that he has left his young ones and his kinfolk "in bondage." The phrase calls up images of the Israelites and the historical affinity of the black slave narrative with the story of Exodus. Finally, Trip gives a statement about the value of collective endeavor, couched in terms of family. Bereft of kin, continually on the run, Trip here redefines his tragic past through his identification with a larger collective endeavor. At the end of the sequence, Thomas, the cultured friend of Shaw, becomes the focus of the camera's attention. Although Thomas doesn't speak in this scene, he begins singing the chorus of the spiritual, clearly marking his identification with his fellow volunteers. As the film has progressed, Thomas has taken on an increasing understanding of a specifically black consciousness. When he is wounded in battle, for example, he vehemently insists that he "is not going back." The phrase conveys a double meaning. Not only does he refuse to be sent back to Boston and a life of comfort, "a cup of decent coffee, sitting by a warm fire, reading Hawthorne," as Shaw reminds him, but he refuses to go back to being a favored black man in an all-white culture. Thomas here seems to have fully embraced a black identity.

Stuart Hall has written of black identity as something that must

be constructed: "The fact is 'black' . . . has always been an unstable identity, psychically, culturally, and politically. It, too, is a narrative, a story, a history. Something constructed, told, spoken, not simply found. . . . Black is an identity that had to be learned and could only be learned in a certain moment."[28] The sequence of the shout strongly conveys this sense of identity being learned "in a certain moment"; black identity is "told" and narrated in such a way that a form of community emerges out of polyphony: a collective identity is here constructed from diverse voices and distinct trajectories. With Shaw manifestly excluded from the scene, the shout becomes a way for the potency and value of black collective life to pass directly to the spectator, as if the spectator were being invited to join in a dialogic ritual that, as Gilroy says, breaks down the division between spectator and performer. The signifiers of decline, isolation, and melancholy affixed to Shaw are directly countered by the vitality and exuberance of the black soldiers.

But as the film moves to its final, climatic scenes of battlefield carnage, this initial message of black identity as a dialectic of displacement and belonging is overlaid by the unifying paradigm of nationhood, in which the suicidal attack on Fort Wagner is configured as a necessary moment in the progressive unfolding of a plenary narrative characterized by racial and social advancement. In the ensuing scenes,

the expressive form and language of the shout, which explicitly articulates a narrative of black diaspora, a narrative of dispersal, is placed in the service of a restored narrative of nation. Imagery that was used to express a fragmented, diaspora history is converted here to the expression of a coalescing nationalist sensibility. The variety of linguistic practices and the sense of geographic diffusion that have been associated with the black troops throughout the film are, in its closing scenes, renarrativized in terms of an exodus whose point of resolution is the nation-state. Although strong traces of African tradition can be found in the imagery and structure of the shout, the overall message that emerges is of a translation: vernacular black culture writing itself into, or being written into, the discourse of American nationalism.

The convergence of the theme of African American emergence with the theme of national identity is staged in a remarkably direct way. In the sequence that immediately follows the shout, the soldiers are depicted in tight, parallel formation, forming a corridor through which Shaw walks as he inspects the troops. After Shaw pauses to receive a Roman-style rifle salute from Jupiter, the film cuts to a high-angle close-up of the Stars and Stripes that literally fills the screen. Earlier, the symbolic meaning of "carrying the colors" had dominated a conversation between Trip and Shaw; Trip's refusal of this "honor" placed him on the far end of a continuum of identification and resistance that included Jupiter's eagerness to "wear the blue suits" and Rawlins's ambivalence about accepting the rank of sergeant major. But in the climactic attack on Fort Wagner, Trip has something like a battlefield conversion, seizing the colors and leading the charge, and immediately paying the price.

The "symbolic repertoire" of the community formed by the black soldiers has been portrayed in the film as relatively unfixed and still evolving, combining elements of Christianity, African tradition, local culture, and the codes of military life. But in the translation of this discontinuous history into a nationalist narrative, the film attempts to fix these symbols into universal meanings, capable of binding the whole "national community" together.[29] It attempts to assert, under the banner of the national, a sense of black and white "having a common story and necessarily sharing the same fate," an awareness of commonality that for Huggins, the author of this phrase, entails nothing less than a wholesale challenge and overturning of the master narrative of

American history.[30] *Glory* takes this ideal as its goal, but stops far short of Huggins's conclusions, tying identity, instead, all the more securely to identification with the nation-state.

In the final scene, in which Trip and Shaw are buried together in a mass grave along with the other dead troops, the film refers to Griffith's *Birth of a Nation* and its very different tableau of racial brotherhood—the dying embrace of two white soldiers fighting for opposing sides. Seen as a dialogic response to Griffith, *Glory* can be said to push the question of race back into history; rather than seeing the persistence of racism and the legacy of slavery as forces that complicate or diminish the central American story, *Glory* treats them instead as necessary parts of the story, a point that is underlined by the ominous ending of the film, in which the Confederate flag is shown being raised over the bodies of the defeated troops. The overall political and historical context of emancipation is dramatized, then, not from the perspective we might expect, not as a privileged moment of decisive social change in which black and white came together, but rather from the viewpoint of the present, with its awareness of the relapses, resistance, and reactions that continue to plague the course of the struggle for racial equality in this country.

For all of the ways that *Glory* could be said to challenge racist ideology, however, its most resonant appeal is to forms of nationalism that are themselves "colored with racial connotations," reinforcing some of the ideologies the film seeks to challenge.[31] Although it restores, to some degree, the historical dimensions of black life in the United States, it also refurbishes national symbols of authority that require the renunciation of cultural particularity. And the links the film establishes among patriotism, militarism, and nationalism, its endorsement of a "mystic nationhood" revealed only on the battlefield, reinforce the dominant fiction at the site of its greatest potential harm, where it can have the most lethal consequences. Nevertheless, in its interstices, the film retains a quality of skepticism about the power of what Raymond Williams calls the "artificial order" of the nation-state in comparison to the more complete order of "full social identities in their real diversity."[32] In its unusually direct examination of identity from across—the particularities of white and black identity defined in relation to one another—the film makes evident the limits of its own nationalist solution to racial difference and antagonism, projecting in

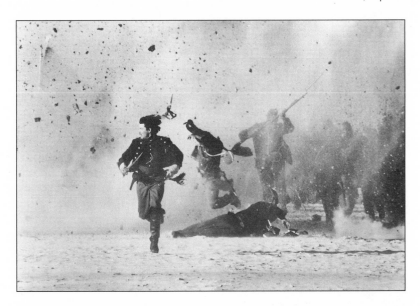

its closing images a message not about the end of slavery, but about the end of the nation as we know it. In the shots of the mass burial of the soldiers of the 54th that end the film, the national narrative is hauntingly evoked not as a triumphal story of social progress, but as a collective narrative of social loss.[33]

2 | Native America, *Thunderheart,* and the National Imaginary

Every state, according to Edward Spicer, is a plural entity, containing within itself two or more nations. Although the widespread use of the term *nation-state* tends to obscure the fact, the nation-state is not a "welded unity," but rather, almost without exception, consists of several entities that have long been considered nations in their own right, possessing distinct languages, histories, and cultural symbols.[1] Until recently, nation-states have generally succeeded in concealing or eradicating the cultural particularity of these "hidden nations"; today, however, partly due to the fascination of the mass media, many are becoming increasingly visible in ways that implicitly challenge the monological narrative of the state order. Native American nations are a striking case in point: historically among the most deeply hidden of the nations within the state, native nations have begun to break free of the "cocoon of invisibility" that the dominant culture had woven around them, an emergence thematized in several recent films that foreground the historical and poetic dimensions of native life.[2]

With this increasing visibility, Indian nations have also begun to acquire a different status and meaning within what Annette Hamilton calls the "national imaginary"—the collectively held images circulating within the dominant culture that aim to distinguish the "national self" from "national others."[3] In place of the disfiguring stereotypes of the past, Hollywood films and documentaries have recently visualized Indian nations as desirable alternatives to the nation-state, imaginative

substitutes for a state order that, as one writer says, "has largely lost the ability to confer an adequate sense of identity upon its people."[4] Although Native Americans have yet to gain access to the resources to tell their own stories in feature-length films, the complex forms of identificatory desire evoked by works such as *Thunderheart, Geronimo, Pocahontas, Legends of the Fall,* and *Dances with Wolves,* along with recent documentaries such as *Five Hundred Nations* and *The Way West,* suggest that contemporary images of Native America have become even more powerfully imbricated with the national imaginary than in the past.

Hamilton employs the term *national imaginary* to describe the way cultural identity coalesces not simply around a set of positive images, but, just as important, in opposition to images of the other, against which the self, or the nation, can be distinguished. Rather than emerging from concrete experience, the national imaginary is formed from the circulation of negative images or stereotypes of national others against whom the national self is defined. Hamilton compares this oppositional logic with the Lacanian mirror-stage, "a moment in development when the child sees itself in the mirror, while thinking it sees another." Images of national "others," she argues, actually represent unacknowledged reflections or aspects of the national self: "Imaginary relations at the social, collective level can thus be seen as ourselves looking at ourselves while we think we are seeing others." Stereotypes of national others may be understood as the split-off parts of the national self, aspects of nation that are sensible or visible only when projected onto the other.[5]

The identities defining the national imaginary can change, however, when the nation's sense of coherence is threatened. Hamilton suggests that this is the case in Australia, where the need to secure a stable national image and identity, an identity that has never been adequately defined, has been exacerbated by the widespread influence of external cultural forms now inundating Australia as a consequence of globalization. This has led to a widespread reevaluation of what it is to be Australian, a reevaluation that has transformed the meaning and significance of the native Aboriginal culture for white society. Long seen as an undesirable internal other, Aborigines have recently acquired a new prestige as embodiments of an organic Australian culture and spirituality that has survived for thousands of years, an identity that the dominant culture now wishes to claim as an aspect of its own heri-

tage. As Hamilton says, "Aboriginal identity may well become the Australian identity of the future, something not chosen by us, but imposed on us by the land itself."[6]

A similar shift appears to be occurring in the way Native Americans are perceived in the United States. Indians, of course, have long held a prominent position within the U.S. national imaginary, providing the principal terms of otherness—savagism, infantilism, cannibalism, madness—against which the nation-state has historically defined itself. Michael Rogin has shown how in the early years of U.S. settlement, the young nation's own insecurity and fear were projected onto the Indians, who became for the settlers imaginary embodiments of the infant stage of human evolution. Pictured as the "sons of the forest" or as "the children of nature"—images that dominated the political rhetoric of the 1800s—Indians were constructed both as symbols of a lost childhood bliss and "as bad children, repositories of murderous negative projections." The Indians "exemplified fears that the independent nation could not survive." They "attacked the young nation at its boundaries, keeping them confused and insecure . . . suggesting that early time when a secure self has not emerged, when it is threatened with retaliatory extermination for its own aggressive rage."[7]

In the present period, however, Native Americans have taken on another kind of meaning for the dominant culture. Figures of national imaginings for centuries, Indians have emerged in contemporary films as agents of a powerful counternarrative of nation, bearers of an alternative historical consciousness molded and shaped by centuries of incessant war, a message especially apparent in films such as *Thunderheart* and *Geronimo*. The theme of continuous struggle against the nation-state, a theme that defines many recent fiction films and documentaries on Native American life, can be seen as a crystallized and legitimate expression of the antagonism toward the nation-state that has become such a pervasive motif in contemporary American society, an antagonism Lauren Berlant describes as "refusing the interarticulation, now four hundred years old, between the United States and America, the nation and the Utopia."[8] The sense of ethnic mobilization and community characterizing the contemporary image of Native American nations conveys important lessons about the limits of the American national narrative and the changing character of national identity in the United States.

Thunderheart, a film directed by Michael Apted, provides a particu-

larly good illustration of the changing roles that Native American nations have assumed in contemporary national imaginings. In this chapter, I consider the film in light of two competing circuits of meaning that I believe characterize the imaginary relation of the dominant culture to Native American nations today. I first examine the way the film draws attention to the notion of Native American nations as the "first nations" of North America, a concept that emphasizes the antiquity of native cultures and the basis of Indian identity in the land. This idea is powerfully expressed in the film's opening sequence, which fashions a striking reversal of what might be called the "territorial imaginary" of the nation-state, a reversal that calls into question the dominant metaphor of east-west "progress" and the basic model of history underpinning the master narrative of nation in the United States.[9] Second, I note the way the film invites a kind of imaginary identification with Native Americans, a tendency that the Indian writer Ward Churchill says "empower[s] the non-native to begin to view him/herself as a new hybrid, embodying the 'best of both worlds.'"[10] Although the contemporary fascination with the mystic space and spiritual power of native North America filters into the film, its more vivid and resonant appeal to identification derives from its refashioning of older national myths. In its narrative patterning and visual design, *Thunderheart* draws substantially on what Mikhail Bakhtin calls the "genre memory" of the

western, one of the most enduring and important vehicles of national ideology in the United States.[11] The historical signals and cultural values associated with the western, what Hamilton calls "the relic imaginary of the past," interpenetrate and affect the construction of new images in *Thunderheart* in ways that suggest an affinity between the two nations, an affinity expressed in the narrative patterning of their primary war myths.[12] I will begin by analyzing the opening sequence of the film, which dramatizes in a highly condensed and symbolic form many of the themes and motifs discussed above.

Reversing the Territorial Imaginary

Thunderheart explores the particular circumstances and history of the Oglala Sioux, whose presence has been known to the dominant culture but whose cultural life has until recently remained largely invisible. Focalized through the perspective of an FBI agent who is selected to investigate a murder on the Pine Ridge Reservation because of his part-Indian ancestry, the film centers on the evolution of the main character as he comes to grips with his own partial and fragmented cultural identity. Underlining the ways nations survive within states—and stressing the persistence of Native American culture and identity in the face of continuing exploitation and domination—*Thunderheart* depicts the transformation of agent Ray Levoi, a seemingly mainstream American man, into an agent of the Lakota nation, a figure whose body, whose own DNA, comes to express a sense of internal otherness, of cultural alterity, and of a long-suppressed and competing concept of nationhood dwelling within the bordered imaginary of the nation-state.

One of the most striking ways the film distinguishes the Sioux nation from the nation-state that contains it is by contrasting the figures of temporality that serve to define their very different concepts of national belonging. Here I will enlist Benedict Anderson's influential description of the modern nation-state as an "imagined community," a description that stresses the link between national identity and the imagined parallelism and simultaneity of national life, emblematically figured in the structure of the newspaper and the realist novel, as a paradigm of the national order the film wishes to contest. Characterizing the modern nation as a kind of horizontal linkage of anonymous individuals moving along parallel pathways, Anderson argues that social cohesion is fostered and sustained mainly through the impression of temporal alignment promoted by the newspaper, the novel, the calen-

dar, and the clock—"a solid community moving steadily down (or up) in history." Simultaneity, in Anderson's view, is the principal trope of connection and belonging binding the disparate populations of the modern state together; the temporality of the modern nation, he writes, can be seen as forming a "complex gloss upon the word 'meanwhile.'"[13]

By contrast, *Thunderheart* emphasizes the sense of anteriority that molds and characterizes the identity of the Oglala Sioux, "a five-hundred-year connection: you can't break the thread," as one character says. The film's portrait of the Lakota nation is filled with references to and intimations of the past, with anteriority rather than simultaneity defining the tribe's principal form of social connection and national filiation. For the Oglala Sioux, national belonging is inseparable from an animistic conception of the world, characterized by spiritual experience and ancestral influences. Levoi, for example, is continually questioned about his kinship group as he conducts his investigation into the murder. Through a series of visions, he discovers that his grandfather was a powerful shaman who was killed in the massacre at Wounded Knee in 1890. The consciousness of nation that this produces in the main character, a consciousness of past tribulations rather than of past glory, creates a sense of agency that is very different from the attenuated forms of agency available to the citizen of the nation-state. Levoi, in epic fashion, saves his people from destruc-

tion by acting for the nation in a way that clearly fulfills a spiritual compact with the dead. The historical past is explicitly refigured here in terms of repetition and return, a theme that is literalized in Levoi's "vision" of being pursued at Wounded Knee, running among the "old ones," as if the history of the Oglala tribe were imprinted in the genetic memory of the main character.

These archaic and deeply sedimented ingredients of national identification are consistently contrasted with the "homogeneous, empty time" of the contemporary nation-state. Early in the film, when Levoi still identifies with the dominant culture, he is repeatedly shown checking his watch, "zapping" channels on his car radio, and working to meet an artificial deadline by which point the investigation must, ostensibly, be completed. As Fernand Braudel has pointed out, a "plurality of social times, a multiplicity of times" coexist in any given historical period.[14] *Thunderheart*, however, underlines the extent to which perspectives on time are intimately bound up with relations of power, a message that is expressed with exceptional precision in the opening sequence of the film.

In a scene that unfolds as a kind of time-lapse summary reminiscent of the opening reel of *2001: A Space Odyssey*, the film opens on a predawn landscape populated by Native American dancers circling a barren tree that has a few scraps of cloth attached to it. The symbolic repertory of the Lakota nation is immediately emphasized, as the silhouetted dancers are shown brandishing eagle feathers and wings; a staff with a crescent shape affixed to the end; a peace pipe, which is raised to the four cardinal directions, articulating the basic Lakota motif of a circle divided into four quadrants; and other artifacts. As the light of the rising sun encroaches on the sacred site, the dancers begin to fade from view and finally disappear. The camera then focuses on a lone Native American man, also seen in silhouette, running quickly uphill until gunshots ring out and blood and tissue explode from his chest, after which he plunges face down into a river. Moving along the surface of the water, the camera supplies a spatial transition as the color of the river changes, a modern bridge comes into view, and the sound of Bruce Springsteen's "Badlands" is heard on the sound track. The camera then rises to find the main character, Ray Levoi, driving a red Mustang on a Washington, D.C., freeway, impatiently switching channels on his car radio as he tries to negotiate a traffic jam. The sequence ends with a long shot of Washington, D.C., dominated by the

shape of the Washington Monument, which forms a kind of visual rhyme with the sacred tree of the Native American dancers.

The iconographies of the two different nations are visualized here in terms that are expressly related to images of time; the crescent moon, the rising sun, the clockwise movements of the dancers, the symbolism of the four directions, which "coincide with temporal references to the four phases of human life," are explicitly opposed to what Anderson calls the "transverse, cross time" of the modern nation, conveyed through images of simultaneity and convergence, a "league of anonymous equals" drawn together by the broadcast band, the freeway system, and the clock.[15] The opening thus communicates a strong sense of what Bakhtin calls "heterochrony," the copresence of a multiplicity of social times, of competing histories and traditions that both overlap and diverge contained within the bordered territory of the United States.[16]

But temporal regimes also involve strategies of power and control, and in its reprise of the imagery of conquest—the "vanishing" dancers and the murder of a Native American man, who is seen fleeing in a westerly direction—the scene touches on the key historical metaphors of the dominant culture. These metaphors are encrypted into what one writer calls the privileged "east-west directionality of the hegemonic American master narrative," which condenses ideals of historical progress, racial hierarchy, and the expansion of the state.[17] As Roy Harvey Pearce writes, "The history of American civilization [is] conceived as three dimensional, progressing from past to present, from east to west, from lower to higher" (that is, from primitive to civilized).[18] Such "images of centrality," as Edward Said points out, typically undergird the master narratives of dominant societies, "embody[ing] certain sequences of cause and effect, while at the same time preventing the emergence of counter-narratives."[19] The narrative of progress, of an America stretching from sea to shining sea, thus depends precisely on the centrality of east-west images in the United States.

In *Thunderheart*, as in Leslie Marmon Silko's *Almanac of the Dead*, the overcoming of the dominant order is expressed as a shift in the directional and temporal axes that organize the plenary narrative of history in the United States.[20] The symbolic geography constructed in the opening scene can be read as reversing the territorial imaginary of the dominant culture; figures of space, time, and the hierarchy of "primitive" and "civilized" are invoked here in a way that communicates a

certain remapping of the national paradigm of "progress." The causal and geographic link established between the reservation and Washington, D.C., a link that employs the symbolism of the river to connect the blood of the murdered Native American man to the capital and, by extension, to FBI agent Ray Levoi, whose own body will become a site of contestation between competing national orders, suggests that the dominant perspective here will be one that faces east.

As an imaginative restaging of events that occurred on and near the Pine Ridge Indian Reservation in the mid-1970s, *Thunderheart* dilates the historical and symbolic framework of the actual occurrences in order to create explicit links to the historical and mythic past, particularly to the epic story of Wounded Knee. As the film makes clear, the savage massacre at Wounded Knee in 1890 strengthened national identity and ethnic cohesion among the Sioux, furnishing an "epic legend on a grand scale"[21] that fostered a rebirth of national consciousness, most evident in the seventy-one-day siege at Wounded Knee almost one hundred years later, in 1973.[22] As Anthony Smith writes, "Ethnic consciousness [is] enhanced by adversity."[23] In many ways, *Thunderheart* centers on the way ethnic and national identity coalesces around the experience and memory of war. As the character Jimmy Looks Twice says, "It's a power deal . . . sometimes they have to kill us. They have to kill us, because they can't break our spirit . . . it's in our DNA. We know the difference between the illusion of freedom and the reality of freedom."

As a site of social memory, the Wounded Knee Monument plays an especially important role in the film. The main character, Levoi, visits the Wounded Knee Monument three times during the course of the film—first in the form of a vision of himself running with "the old ones," pursued by a mounted soldier who seems to emerge from the shadow of the monument itself. This vision is followed by a second, actual visit in which Levoi checks for the name of his ancestor, Thunderheart, on the grave stela. Finally, at the end of the film, Levoi visits the grave of the activist leader Maggie Eagle Bear, who was murdered because she discovered the illegal uranium drilling taking place on Indian lands.

At another level, however, the film appears to rely on a different national mythology, the genre of the western, to shape a new war myth with Native Americans as protagonists. Employing many of the visual tropes and narrative conventions of the western, *Thunderheart* prizes

out and critiques many of the ideological and racial messages embedded within the form, but it also rehearses a narrative pattern that forms part of the substratum of national mythology in the United States. In *Thunderheart*, a solitary hero, an outsider, acquires a sidekick and acts for the collective in a way that ensures the future of the community, only to ride off alone into an uncertain future at the end. By engaging the genre memory of the western as a war myth, a war myth that can be transposed and reenacted from the perspective of the margins, the film offers a kind of mythic continuity of identity between the two nations that would otherwise be lacking.

The Western and the National Imaginary

The Cherokee artist and writer Jimmie Durham has said that "the negation of Indians informs every aspect of American culture. . . ."

America's narrative about itself centers upon, has its operational center in, a hidden text concerning its relationship with American Indians. That central text must be hidden, sublimated, acted out." Although many aspects of the American myth are now being critically examined, he writes, "the central, operational part, the part involving conquest and genocide, remains sacred and consequently obscured. . . . The indigenous populations must be always and essentially unreal, a figment of the national imagination."[24]

One of the most durable and effective masks for this disguised operational center of the nation-state has been the western, a genre that has furnished much of the basic repertoire of national mythology for the United States throughout the twentieth century. As a form that preserves older concepts of nation while illuminating present-day conflicts and concerns, the western stands as an especially good illustration of Bakhtin's concept of "genre memory." Genres function, Bakhtin writes, as "organs of memory" for particular cultures, providing crystallized forms of social and cultural perception that embody the worldviews of the periods in which they originated, while carrying with them "the layered record of their changing use." Genres "remember the past [and] redefine present experience in an additional way." A genre form such as the western offers a vivid realization of this concept, for it clearly functions as a "repository of social experience" that preserves certain historical perspectives even as it has been adapted to new contexts.[25]

As a myth of national origins, the western serves an emblematic nationalist function, for it is a form capable of mediating and containing the central contradiction in American ideology—the contradiction posed by race. Although national identity in the United States is traditionally conceived as a "deep, horizontal comradeship," an "imagined community" of equals characterized by "social unisonance," the actuality of racial hierarchy and oppression and the drive for dominance by certain groups starkly contradicts this idealized image. In a recent essay, Virginia Wright Wexman argues that the imagery of the frontier—understood as a line of demarcation between civilization and the wilderness—and the myth of westward expansion at the heart of the western genre are exceptionally useful vehicles of legitimation for the nation-state, for they serve to justify the appropriation of Indian lands and the domination of racial others: "What is most conspicuously at issue in Westerns is . . . the right to possess the land. . . . Both the genre

and the images of its major stars . . . define land in terms of property and cultural dominance in terms of racial privilege."[26]

Thunderheart opens a kind of dialogue with the tradition of the western, offering a subtle analysis of the interlocking myths of the American empire while also, at particular points, claiming certain of these myths for its own purposes. Drawing on the western's principal visual and narrative strategies, the film effectively exposes links between images of landscape and the domination of indigenous people, between the vision of a community carved from the wilderness and the reality of conquest and colonial occupation, between the myth of settler heroism and the continuing reality of native resistance. From this perspective, the film can be seen as a kind of counterwestern, exposing the five-hundred-year-old struggle over land and the genocide that accompanied it as the concealed basis of the myth of the frontier and the epic narrative of westward expansion.

From another perspective, however, *Thunderheart* appears to embrace the imaginary it seeks to contest, depicting the ancient collectivity of the Lakota people in ways that seem to rehearse the western paradigms that the film strives to counteract. For example, the film depicts a Native American community that has been shaped by conflict and adversity, whose ethnic cohesion and identity have been molded by a continuous state of war. Now warfare, as we know from Anthony Smith, is one of the chief forces shaping ethnic cohesion and identity; prolonged warfare especially, he argues, promotes and strengthens ethnic self-consciousness and ethnic imagery: "Societies . . . owe much of their form and solidarity to the exigencies of war. . . . it is external conflict which shapes ethnic community, and more especially, its images."[27] *Thunderheart*'s use of the conventions of the western, which might be called the principal war myth of the American nation-state, to reinforce the image of martial solidarity it ascribes to the Indians is a striking example of the national imaginary at work—"ourselves looking at ourselves while we think we are seeing others." Rather than fixing on the "mystic space and spiritual power" of native North America, the film suggests that it is the image of a nation at war that best captures the "mythological and spiritual continuity of identity" that the dominant culture desires.[28] What I would like to stress in this part of my analysis is the way *Thunderheart* engages the tropes of the western in order to expose the theme of racial dominance as the "operational center" of the western myth, while at the same time appropri-

ating key aspects of this genre form in order to symbolize Native American identity in a way that fulfills the self-image of the dominant culture.

The Western and Its Tropes of Space and Nation

As a dramatic locale for myths of origins, the western landscape has often been associated with what the Australian critic Ross Gibson calls a "cornucopic mythology," a mythology symbolized by the passage from allegorical desert to garden in the storied settling of the West. Rather than being seen as a "thoroughly edited text, that already contains lessons for survival," the western landscape is instead viewed as a pristine surface receptive to the imprint of civilization, progress, and settlement.[29] Dramatic images of landscape are, of course, one of the chief generic markers of the western, which often features plots revolving around struggles over land. Even where land is not at issue, as Wexman points out, westerns invariably refer to its centrality by setting a great number of scenes against imposing natural landscapes. Panoramic shots emphasizing the scale and the emptiness of western landscapes are important signifiers of national mythology, for they suggest not only the grandeur of nature but also a kind of open potentiality: "Westerns often dwell on wordless images of the landscape. . . . the landscape is rendered as an object of discovery by the seer, who is

placed in a position of dominance. . . . Seemingly limitless views function as a prelude to the imperialist mission of defining territories and scanning perimeters. . . . The landscape's provocative emptiness invites the spectators imaginatively to penetrate and possess it."[30]

Thunderheart treats the landscape, however, as a window onto the genocidal past; the panoramic landscape shot is evoked in order that it may be critically examined. At several points in the film, the camera glides at a high angle over the terrain of the Badlands in a kind of accelerated tracking shot, both recalling the western convention of high-angle panoramas—described by Wexman as the "master of all I survey" scene—and disclosing what might be called the political unconscious of the unbounded western vista. Early in the film, for example, the camera abruptly descends from the lush greenery of the plain to a desertic crevice, a huge crack in the earth, to reveal the rotting corpse of a Native American man, face down in the dirt. A shot that began as a lyrical quotation of the myth of the virgin lands concludes with a dead Indian dominating the frame, and with the offscreen voices of approaching FBI agents claiming "jurisdiction" over the body. Far from revealing the "placid movements of horses, wagontrains, or cattle being driven to market," or from inviting spectators to "imaginatively penetrate and possess it," the landscape here is coded as a site of political and racial struggle.[31] The film effectively revises the scenic interlude of the landscape shot in such a way that the history of racial and cultural domination sedimented within it is brought to the fore.

From the opening scene of the vanishing ghost dancers through the vision that Ray Levoi experiences of running with the "old ones" at the first massacre of Wounded Knee, the landscape presents itself as a historical text—not as an object to be subdued or as something preternatural and sublime, but rather as "something to be learned from."[32] The lessons the landscape teaches in *Thunderheart*, however, are not so much the ecological lessons associated with Native American land-culture—although the plundering of Indian lands for uranium ore is a central element of the film's investigative plot—but rather the historical lessons that define and reinforce Indian imagery and identity. Here the historical past—specifically, the memory of the massacre at Wounded Knee—imbues the landscape with meanings very different from those conveyed by the narrative of the nation-state.

One of the key ways the film expresses this idea is by resuming the

century-old narrative of Wounded Knee in the frame of the present. Here, the film literally restages the flight of the Indians toward the "stronghold," a kind of natural fortress in the rock cliffs near Wounded Knee. In 1890, the Indians never reached the stronghold and were massacred by an overwhelming federal force. In *Thunderheart*'s climactic scene, however, the two main Indian characters make it to the base of the stronghold, where the assembled Lakota people confront the pursuing federal officers and rescue Levoi, whose ancestor, "Thunderheart," was killed while running to this natural fortress nearly a century before.

The legends that are embedded in this landscape, then, are the legends of the Native American people. Even the nomenclature of the land—the stronghold, the source, the monument, the Knee—communicate a sense of space that is imbued with potent national imaginings. Landscape in *Thunderheart* is invested with a narrative and symbolic dimension that consolidates and inspires native collective identity, rather than settler identity, and that propels it in the direction of nation formation.

War and the Forging of Ethnic Community

The imagery of war that so effectively links contemporary Indian struggles to the tribulations of the past also seems to echo the very national-

istic myths that the film seeks to overturn. The climactic standoff at the stronghold, for example, which appears to rewrite the massacre at Wounded Knee in order to change its outcome in the present, can also be seen as a borrowing from the western. From this perspective, the theme of Indian resistance appears to be laminated to the visual and narrative conventions of the western in ways that solicit an imaginary continuity of identity between the dominant culture and Indian nations.

Although the dramatis personae of the classic shoot-out are reversed, echoes of the western reverberate through this scene. After the Native American heroes have been chased through the desert landscape, they arrive at the base of the stronghold, where Levoi, who has now become an ally of the traditional Indians he initially opposed, faces off against his former mentor, Frank Coutelle—a scene that explicitly rehearses the classic western showdown. Levoi and his sidekick, Crow Horse, however, decide not to shoot it out, and turn their backs on Coutelle and his assembled gunmen to begin walking toward the stronghold. At this point, it appears that they will be shot from behind in precisely the same fashion their ancestors were in the first massacre at Wounded Knee. Just as Coutelle raises his gun, however, a large company of traditional Indians appear at the top of the fortress-like cliff, with rifles trained on the villains below. The FBI agent Coutelle wheels with his rifle in several different directions and, seeing himself surrounded, retreats. The camera then tracks up and away to reveal the deployment of traditional Indians in the stronghold, a deployment that suggests and recalls countless images of soldiers and settlers in westerns defending their outposts and forts against Indian attack.

The standoff at the stronghold dramatizes an instance of collective mobilization that seems to revitalize the Lakota nation, activating the latent energies of the people who had been depicted throughout as essentially passive. But in depicting the mobilization of the Lakota people in a manner that so clearly echoes the western formula, *Thunderheart* encourages an imaginary identification with the Indians on the part of the dominant culture. Moreover, the scene at the stronghold depicts the entire population of traditional Indians, including grandmothers and Grandpa Reaches, the holy man, defending their nation, creating a powerful image of national cohesion. Here, the image of the Indian other serves quite clearly as an image of an idealized national self, a national self that apparently requires "the hammer of incessant

war" to beat it into national shape, and that must now look to the other for images of social coherence.[33]

Nevertheless, one could also argue that the film's use of the western to create a potent, militant image of the Lakota Sioux represents a sifting of the form, rather than a wholesale reproduction. *Thunderheart* retains certain aspects of the western genre while repudiating others, emphasizing the mobilization of the Lakota people as a means of survival, not as a strategy of conquest. Rather than expressing a competitive, acquisitive attitude toward land, or expressing a myth of spiritually sanctifying violence, as in the mythology of "regeneration through violence" that Richard Slotkin finds at the heart of American ideology, *Thunderheart* addresses the western as a myth of collective survival, retaining its imagery of ethnic cohesion while repudiating its conquistadorial message concerning the land.[34] Thus, the film draws on the conventions of the western but imbues them, as Bakhtin might say, with a very different "social accent."[35]

Conclusion

By emphasizing the fact that the state's campaign of conquest and genocide continues in the present and that Indian resistance is ongoing, *Thunderheart* constructs a frame of encounter that conflicts with the narrative of the nation-state as a "continuous, homogeneous subject."[36] It echoes the activist view that "the Indian wars have never ended in America," employing the imagery of war in ways that reinforce crucial aspects of Indian identity and nationhood. This powerful evocation of Indian solidarity may also be seen, however, as a projection on the part of the dominant culture. As identification with the nation-state continues to wane in the absence of what Smith calls the "hammer of incessant war"—an essential condition, it appears, of social cohesion and strong self-images—Native American nations have begun to assume a heightened importance in the national imaginary as emblems of solidarity and self-determination. Resituated in the master American narrative as embodiments of desirable cultural values—above all, the values associated with the image of the warrior—Native Americans are now being appropriated as cultural progenitors, as American ancestors, "the first and best blood of America," as one writer calls them, whose most exemplary characteristics can be imagined as a form of cultural inheritance.[37]

But in a period when armed militias have declared war on the

American nation-state and have begun to construct their own mythologies around Waco, the deaths of Randy Weaver's wife and son, and the bombing of the Federal Building in Oklahoma City, it is important to distinguish the militant self-image of the "first nations" of the Americas from those of militias founded on ideological beliefs. Native American art, music, and spirituality speak to the organic and authentic nature of Indian culture; the social mobilization in defense of their nations that characterizes Native Americans' activism is a clear response to their actual conditions of existence. Where *Thunderheart*'s depiction of the Lakota nation clearly departs from other recent manifestations of ethnic nationalism, both within and outside the United States, is in the absence of a sense of "ideological destiny," of abstract ideals and territorial aspirations. The pursuit of a political ideal supported by an institutional, ideological program that animates the militia movement, as well as many other ascendant nationalisms, is a characteristic

that gives them a striking similarity to the nation-state order they ostensibly contest. *Thunderheart*, in contrast, stresses the ancient cultural reality of the Lakota people, which it depicts as largely free of concepts of destiny, ideology, or abstract political aspirations. Perhaps the strongest lesson the film has to offer is that nations do not need to become like states to promote the historical consciousness essential to the formation of community.

3 | National Identity, Gender Identity, and the Rescue Fantasy in *Born on the Fourth of July*

Born on the Fourth of July can be read as a particularly complex variant of the cultural tendency that Susan Jeffords has called "the re-masculinization of America": the restoration of patriarchal concepts of nation through narratives that emphasize the renewal of masculine identity in the post-Vietnam period.[1] Whereas Oliver Stone's film pointedly criticizes traditional myths of masculinity based on concepts of "punitive agency," it nevertheless asserts the importance of the masculine role in a changing narrative of nation. Linking the iconography of nationalism to the symbolism of gender in an overt way, the film anatomizes the failure of masculinist national ideals in the Vietnam period, offering in its closing scenes an alternative image of nation based on the metaphor of a maternal, social body America, an "America who can embrace all her children."[2] But despite the film's attempt to revise the gender dynamic of national identity, the metaphor of nation as woman in *Born on the Fourth of July* serves mainly to set the scene for a narrative in which the male hero gains authority by "rescuing" the nation from its own weakness, a pattern that closely resembles the unconscious fantasy that Freud calls the "rescue motif."[3] Whereas the film defines the role of the male hero in ways that suggest alternative approaches to masculine identity, its symbolic structure, organized around a series of maternal stereotypes, reveals a deep gender ambivalence. Its metaphors for nation range from maternal love (the nation as "milk-giver") to the nation as "blood-seeker" (a vampire), as if the

film's uncertainty toward its own nationalist agenda were projected onto the female figures in the text.[4] In *Born on the Fourth of July*—the film's title underscores the dominance of the metaphor—maternal images are elevated into emblems of national cohesion on one side or degraded to images of perversion and division on the other.

In its symbolic and metaphoric trajectory, the film thus appears to confirm Jeffords's thesis that by reaffirming masculinity, the Vietnam narrative also reaffirms other relations of dominance, particularly those of patriarchy. Indeed, this view constitutes the currently accepted critical perspective on the Vietnam film, a perspective that also discerns a straightforward oedipal patterning as the basis of the drama of masculine subjectivity in these films.[5] But *Born on the Fourth of July* also departs from Jeffords's description of the "masculine frame of narration" in significant ways as well, particularly in its equation of what Laura Mulvey has called "the overvaluation of virility under patriarchy" and the social problems of the Vietnam era.[6] Casting the protagonist as a victim of patriarchal society, the film draws on the generic resources of melodrama, a genre long associated with feminine emotion, to articulate the gap between masculinist cultural ideals and the lived experience of the protagonist. Moreover, whereas the suppression and subordination of the feminine serves, in the view of many critics, as the fulcrum of masculine renewal in Vietnam films, *Born on the Fourth of July* links the recovery of the male hero to the rescue scenario, with its emotions of "gratitude," "love," and "tenderness," and to the substitution of a feminine ideal of national identity for the fracturing violence of patriarchal concepts of nation.[7] In its portrait of the Vietnam veteran as victim of patriarchy on the one hand and as rescuer of a nation imaged as feminine on the other, the film solicits a more complex reading of masculine agency in the Vietnam film than has been given to date.[8]

Jeffords argues that narratives about Vietnam are most deeply concerned with the restabilizing of gender roles, that gender is what representations of the Vietnam era are about: "Though Vietnam representation displays multiply diverse topics for its narratives and imagery, gender is its determining subject and structure. . . . Gender is the matrix through which Vietnam is read, interpreted and reframed in dominant American culture."[9] Despite the Vietnam narrative's characteristically critical perspective—its display of the "apparent dissolution of traditional forms of power"—it functions largely, in Jeffords's under-

standing, to reinforce the authority of the state: "Along with the re-
negotiation of masculinity has come a renegotiation and reempower-
ment of the state. . . . rather than the Vietnam experience challenging
the current structures of American society, it seems only to enhance
them."[10] In contrast to Jeffords, I believe that *Born on the Fourth of
July*, which I take as an emblematic Vietnam film and one most di-
rectly concerned with the project of remasculinization, presents a highly
critical view of the close relation between masculine identity and na-
tionally sanctioned aggression. To a large extent, the generic codes of
melodrama that structure this film conflict directly with what Jeffords
calls the "masculine point of view." Rather than expressing the "inter-
ests, values, and projects of patriarchy," the film employs melodrama
in order to present a historical critique and counternarrative of Ameri-
can identity conceived along masculinist lines.[11] At the same time, how-
ever, the film finally conveys through its melodramatic structure a model
of national community based on the nuclear family, to some degree
reaffirming traditional forms of gender identity as the dominant per-
spective through which national identity is realized. *Born on the
Fourth of July* can thus be seen as an exemplary manifestation of the
complex nature of the Vietnam narrative, in which the most significant
issues of national identity, gender identity, and the narrative forms that
convey and reinforce them are set into new and shifting configurations.

In the pages that follow, I examine the film in terms of three
closely related strategies of representation. I begin by delineating the
film's use of melodramatic conventions and structures, which serve as
an index of its social ideology and which contrast with the forms of
narrative that Jeffords associates with the project of "remasculiniza-
tion." Second, I consider the film's analysis of masculine identity and
argue that the film puts particular pressure on the link between mas-
culinity and punitive concepts of historical agency. Third, I discuss the
film's use of maternal metaphors of nation to demonstrate that its ideal-
ized image of a maternal, social body America departs from masculin-
ist ideology while at the same time allowing the film to represent the
hero as a paternal figure, as the "rescuer" of the nation, restoring the
myth of the nuclear family as an emblem of promised community. I
begin by discussing the film's use of the genre codes of melodrama,
which convey a set of messages that both complicate and extend the
"masculine frame of narration" that Jeffords argues prevails in Viet-
nam representations.

Melodrama and National Identity

The historical signals emitted by particular genre forms constitute an important part of the messages we receive from individual texts. As Mikhail Bakhtin argues, genres impose their own historical perspectives and systems of value on a work, both recalling past usages and illuminating the present in new ways. In the Vietnam film, critics and theorists have, for the most part, sidestepped the issue of genre by, on the one hand, claiming that the Vietnam film constitutes a genre in its own right or, on the other, stressing the Vietnam narrative's oedipal configurations and its conversion of political and ideological issues into scenes of technospectacle.[12] In my view, however, the genre patterning of the Vietnam film, which can generally be characterized as melodramatic, constitutes a rich source of critical insights, allowing us to link the Vietnam narrative with earlier cultural attempts to come to grips with national trauma.

Melodrama has often functioned as an important vehicle of popular historical interest, and has, in times of crisis, helped to mold and influence concepts of national identity. In the view of George Lipsitz, melodrama constitutes a privileged form of popular connection with the past, and has provided a "particularly significant form of participation and investment within American commercial culture since World War II."[13] David Grimstead traces the influence of melodrama on national consciousness back to the nineteenth century, when theatrical melodrama played an important role in defining the national narrative. According to Grimstead, melodrama served as the "echo of the historically voiceless." Its stress on direct feeling as an index of moral value functioned, he maintains, as a "'great equalizer,' bypassing inequalities of class and education," and providing a source of national identity for a country convinced of the radically egalitarian nature of its social experiment.[14] Frank Rahill similarly attributes the rise of American melodrama to the need to redefine national identity after the Civil War. The cycle of "frontier sagas" and Civil War dramas that dominated the American stage in the 1880s provided "the sought for national drama."[15] In short, melodrama has served in the past as a way of framing U.S. national identity in terms of democratic and egalitarian ideals.

In the Vietnam narrative, melodrama has again assumed a privileged role in the articulation of national identity, but in a way that is

different from its function in the nineteenth century. As exemplified by *Born on the Fourth of July*, the genre conveys certain historical signals and a consistent system of values, but it has acquired a different "social accent" as it confronts a new context.[16] In making this comparison, I wish mainly to underline the ways that genres function, as Bakhtin says, as forms of cultural memory. Genres are best understood, he argues, as repositories of social experience, crystallized forms of social and cultural perception, "organs of memory" that embody the worldviews of the periods in which they originated, while also carrying with them the "layered record of their changing use."[17] In his view, they are the principal vehicles for shaping and carrying social experience from one generation to another, the connecting "'drive belts from the history of society to the history of language' and literature."[18] Through the process Bakhtin calls "genre memory," aesthetic forms both "remember the past . . . and redefine present experience in an additional way."[19] This leads to the concept of "double-voicing," which occurs when an older genre is adapted to a new context.

In *Born on the Fourth of July*, melodrama retains its historical provenance, visible in its emphasis on the claims of emotion and in its attempt to frame national identity in terms of familial relations.[20] More important, however, it defines the Vietnam narrative in a way that allows it to be joined to the broader national narrative, imposing a kind of teleological resolution on a national trauma whose materialization in culture has been exceptionally partial, protracted, and resistant to completion. The structural patterns of melodrama serve to fill out and set into place a narrative project—the cultural narrative of the Vietnam War and its aftermath—whose symbolic resolutions have only slowly seeped to the surface. The essential character roles and narrative patterns of the Vietnam "experience" congeal in *Born on the Fourth of July* into a form in which the historical period now appears to be rounded out and resolved, translated from the realm of political and ideological contradiction to the realm of universal family values. This is accomplished in the film through the use of the generic patterns of melodrama in both critical and affirmative ways, to critique the role of the family for its complicity in the war and yet to reaffirm the cultural role of the Vietnam veteran as rescuer of the nation and as paternal figure, the begetter of a new national paradigm.

In the film, which I see as both a compendium of Vietnam themes and the culminating work of the cycle, the theme of victimization is ac-

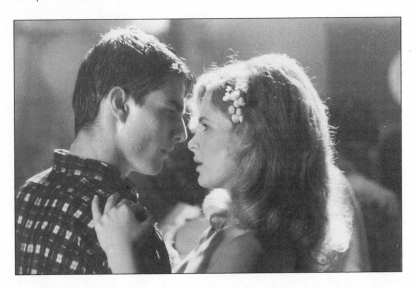

companied by two additional melodramatic tropes that can be isolated as fundamental to the historical project of the film: the trope of "misrecognition" and the device of the "rescue." The trope of misrecognition dominates the first half of the film, bringing the Janus-faced nature of national identity into relief as the seemingly irreconcilable gulf between the ideals of the protagonist and the actuality he confronts, between his past and his present, opens up a series of contradictions. The rescue motif organizes the second half of the film, allowing the male protagonist to redeem himself by "saving" the nation and restoring the national community to a form more closely resembling the ideal American homeland, a motif that is facilitated by the metaphoric identity of nation and woman.

By first approaching *Born on the Fourth of July* from this perspective, I wish to show how the film utilizes the cultural memory embedded in genre to shape and define its historical message. The "remasculinizing" narrative trajectory of the film is both qualified and reinforced by this generic intertext. In addition to misrecognition and the rescue motif, many of the most typical melodramatic tropes and devices are used in the film as forms of critical analysis: betrayal, villainy, victimization, and the personification of social forces in emblematic characters are recoded to express the rejection of older ideologies and the formulation of a different form of national identity.

Throughout the first half of the film, the main character, Ron

Kovic, enthusiastically presents himself as the representative of a nationalistic tradition defined by military force and moral rectitude. But after participating in the massacre of women and children in a Vietnamese village, witnessing the cover-up of his own accidental killing of another American soldier, and then being severely wounded himself, the character is wrenched from his secure historical identity and experiences a kind of dissolution of self. Paralyzed from the chest down, he sees himself as a victim of all the institutions that had previously defined him: family, community, the armed forces, history itself. The film uses his estrangement from the past to explore the erosion of a historical order that had imprinted itself on the gestures, behavior, and attitudes of his social milieu.

The first part of the film in many ways echoes the tendency Christine Gledhill describes in her discussion of King Vidor's *The Crowd*: "A specific date links a national historical occasion with an individual birth rather than a social fabric. . . . The nation's story will be vested in the individual trajectory."[21] Emphasizing both the typicality and the "individuality" of the main character, the opening scenes of the film unfold as a kind of diorama of national stereotypes: young Kovic playing "soldiers" and baseball, celebrating his birthday at a Fourth of July parade, being kissed by a girl to the accompaniment of fireworks, competing in high school athletics. The common identity of nation and individual is evoked and underlined through the exceptional typicality of these scenes. But the "uniqueness" of the character is also asserted, most directly by Kovic's mother, who calls her son her "Yankee Doodle Dandy" and who singles him out by relating her premonitory dream, on the occasion of President Kennedy's inauguration, that Ron will one day be speaking in front of a large crowd.

By presenting these scenes in a visual style that is almost operatic—moving from one dramatic set piece to another, with few of the connecting devices of narrative, with slow motion and music augmenting their emotional temperature—the film expresses both a sense of intense feeling and a sense of falseness and inauthenticity. The small-town world of the 1950s and early 1960s is portrayed in the opening in an overtly nostalgic manner that is strikingly reminiscent of the "Morning in America" theme of Ronald Reagan's presidential campaign. The hometown universe of the protagonist is shown to be thoroughly permeated by the mythology of the period: pop songs, the

Kennedys, Marilyn, the Yankees, television, family, the memory of World War II. These leitmotivs of mid-twentieth-century America encapsulate a world steeped in popular legend, a world replete with mass-produced images through which characters live out their lives. In foregrounding these stereotypes of the fifties and early sixties, the film emphasizes the consensual nature of the society, the cocoonlike enclosure of a period in which the dominant culture was largely unchallenged. Although the cultural changes associated with the youth movement and the civil rights movement were certainly apparent by 1965, ideological conflict is almost entirely absent from the suburban world the film depicts. Instead, the film emphasizes the naïveté and emotional idealism of the dominant culture of the early sixties, the contentment and complacency that Fredric Jameson calls the "misery of happiness," the self-satisfaction of small-town life that is seen to represent the whole of pre-Vietnam America.[22] The overall strategy of the film, however, is not so much to repudiate this picture of national life, which will be resurrected in the closing moments of the film, as to revise it and transfer its authority to more progressive features of the national text.

The second major sequence of the film functions as an explicit reversal of the opening boyhood scenes. After being wounded in Vietnam, Kovic is sent to a Veterans Administration hospital to recover from his paralyzing injury. With its scenes of physical deterioration, body wastes, and psychological degradation, the hospital sequence at-

tains the status of Grand Guignol without departing from a realistic portrait of the milieu. Rats, physical abuse, a negligent medical staff, the omnipresence of death and putrefaction—all are conveyed in a urine-yellow color and in a series of shock cuts that contrast vividly with the filtered luminescence of the boyhood scenes. In the contrast between the sentimentality and emotionalism of the opening and the historical and personal tragedy of Vietnam, the film insists upon the radical alterity of the two experiences, but it also implies a necessary connection between the two. The stark antitheses distinguishing the boyhood sequences and the body of the film function as a kind of dramatic reversal, which Thomas Elsaesser claims often has the effect of "exposing the incurably naive moral and emotional idealism in the American psyche." Elsaesser argues that melodrama uses sentiment and emotion in a dialectical way: by identifying characters with illusory hopes and self-delusion, and then forcing a confrontation "when it is most wounding and contradictory,"[23] melodrama opens up contradictions that realism, by contrast, seeks to contain.[24]

In scenes reminiscent of the crusading melodramas of Dickens, Hugo, and Eugène Sue, the film's indictment of government institutions and politics is set out in the language of individual victimage. Its withering critique of the V.A. hospital system, which can be taken as emblematic of larger social pathologies, is centered on the private ordeal of Ron Kovic, continuously processed through the subjective ex-

periences of the protagonist. Sequences of physical and psychological distress are intercalated, however, with Kovic's initial encounters with black consciousness and with the antiwar movement to suggest a dawning awareness of a larger social pathology, a social system in an extreme state of unhealth, rendered in microcosm in the world of the V.A. hospital. These themes can be glimpsed in a dream sequence in which Kovic rises from his bed and walks past his gray, unconscious roommates, fellow victims of institutional neglect, who seem to come to life as he passes—a sequence that foreshadows his later political role. But in the closed world of the V.A. hospital, he cannot shape events or influence his milieu: he is acted upon. He becomes a typical protagonist of melodrama, acquiring what Elsaesser calls a "negative identity through suffering."[25]

In the course of these two antithetical scenes, the film plays heavily on the melodramatic device of misrecognition. Kovic, the film implies, has misrecognized the true nature of the nation, and he is now being confronted with the reality of national life. Thrust from a childhood world of glistening surfaces to a world of Goyaesque disasters, he is unable to recognize himself, or the America that he left behind; the fixed points of his ideological compass simply do not correspond to the reality he encounters. The theme of misrecognition is articulated to greatest effect, however, in the homecoming sequence, as the false promises and seductive appeals of national identity receive their clearest embodiment and expression in the character of Kovic's mother. Emblem of both family ideals and national betrayal, the role of the mother focuses the contradictory interests of the text in an explicit way, embodying both positive and negative concepts of national identity.

As Kovic's mother comes to meet him for the first time since his paralyzing injury, the music swells in an emotional arc that is immediately countermanded by the distance and strain evident between mother and son. Unable to accept his condition, the mother, after a few inane and remarkably inadequate queries and responses, resolutely turns away from him. But while the mother is depicted as completely lacking in emotion and sympathy, the music accompanying this scene is unambiguously emotional and tender. The disparity between the musical accompaniment and the behavior of the characters expresses simultaneously the duality of recognition and misrecognition, of desire

and estrangement, of intense feeling and socially defined roles that is at the heart of the first half of the film.

The conflicting signals that mark this scene as the obverse of a typical melodramatic homecoming reveal the larger historical message of the film. Kovic's "homecoming" will be deferred, the film implies, displaced to the end of the film, when the character and the society have undergone the transformative changes of the decade. Although the music underlines the significance the film assigns to notions of family, community, and "home," these themes are placed in the service of a historical argument concerning the changing face and nature of the nation. Oliver Stone's portrayal of Kovic's mother, which has been heavily criticized for its negativity, can be understood in this context. A kind of composite portrait of atavistic values, the mother represents the old America, the America of the fifties. Cut off from the "mother culture" after his wounding, Ron Kovic must find a new cultural, political, and sexual identity.

Thus, while the first half of the film emphasizes the melodramatic tropes of misrecognition and victimization, it also inverts some of melodrama's traditional sources of cultural authority, revising the role of the mother, community, and family. The mother, in particular, is painted as selfish and heartless, a "blood-seeker rather than a milk-giver," to use the words of Frederick Douglass.[26] This inversion might be seen as an aspect of the "double-voicing" that occurs when an older genre is fitted to a new context. In the Vietnam narrative, the nuclear family is a site of profound ambivalence, often depicted as both the cradle of hypocrisy and the matrix of positive forms of identity. In this case, as Pavel Medvedev says, "genre appraises reality, and reality clarifies genre."[27] The picture that *Born on the Fourth of July* presents of the malevolent influence of the family, a subject I address at greater length below, draws on the resources of melodrama, but it evokes the themes and motifs of the genre in a complicated way, in order partly to crystallize its rejection of the reality that it traditionally conveys. At the conclusion of the film, however, the nuclear family (and the image of the mother in particular) is restored as the emblem of a nation seen once again as a loving heartland. As we will see, this redemption of the maternal figure, and of the family, is expressly related to another of the resources and potentials of melodrama, namely, the rescue motif that organizes the second half of the film.

The Critique of Masculinity as "Punitive Agency"

As Geoffrey Nowell-Smith has pointed out, the link between doing and suffering, between action and passion—themes that were once securely joined—has been severed since the romantic period. In U.S. films, these roles have typically been separated into different genres, with male heroes "impervious to suffering" dominating genres such as the western and the action film, while female characters, "whose role it is to suffer," dominate melodrama. Suffering and impotence, the failure to act in the world, have been seen until very recently not as part of the human condition but rather as the consequences of a "failure to be male."[28] In contrast, *Born on the Fourth of July* foregrounds the copresence of acting and suffering in a way that breaks the stereotype of the male hero. Although the resolution of the film links sexuality and social efficacy in a way that could probably be attained only by a male protagonist, the critique of the dominant cultural ideal of masculinity and the search for an alternative masculine identity are central elements of its social and political message. With its emphasis on sentiment and emotion, the film suggests not so much the patriarchal appropriation of a feminine mode of discourse, but rather a return to the Aristotelian definition of history as that which "Alcibiades did and suffered."[29]

While the search for alternative masculinities has been identified as a dominant motif of 1990s Hollywood films, *Born on the Fourth of July*, released in 1989, emblematizes the shift from the spectacular images of muscular masculinity that defined the films of the previous decade to a more internal, psychologically nuanced model of male identity. In a recent article, Susan Jeffords argues that the continuing decline of traditional sources of masculine authority, such as the workplace and the "national structure," has fueled a move away from the "highlighted masculinity"—masculinity as violent spectacle—that characterized the Reagan years to an exploration of male characters' "ethical dilemmas, emotional traumas, and psychological goals."[30] A parallel can be drawn to an earlier period, when the reformulation of national identity went hand in hand with the rejection of older models of male subjectivity. For example, Frederick Douglass, in his writings after the Civil War, explicitly rejected the "terse, masculine style" of his celebrated *Narrative of the Life of Frederick Douglass* in order to convey a different form of masculine and national identity; embracing a

discourse of sentiment and emotion, he sought to transcend the association of freedom and liberty with masculinized, "punitive" agency. As one commentator on Douglass explains:

> Mastery, masculinity, and agency are often linked to death, so that, rhetorically, to gain a manhood guaranteed by violence, no matter how liberating, was to incur fracturing penalties that could tear "life" from "liberty." . . . Douglass used sentimentality [as a way] to conceive of [an] identity that does not require liberty to be divorced from life, or mother from child, male from female, subject from object. What Douglass tried to do was map a definition of "America" that did not require one to wield a whip.[31]

Something similar to this rewriting of masculine and American identity through the rhetoric of emotion occurs in *Born on the Fourth of July*. In dramatizing the transformation of a protagonist who defines himself, from the outset, along the archetypal lines of male power, the film brings together suffering and acting in a way that departs from American myths of the national hero, traditionally based on what Richard Slotkin calls "regeneration through violence."[32] Although *Born on the Fourth of July* begins with an image of omnipotent masculinity, it deliberately details the disintegration of this ideal, as the display of male prowess in its opening scenes is steadily replaced by representations of interiority that stress the main character's "sensitivities, trauma and burdens."[33] However, in its approach to what one critic calls the "dilemma of masculine subjectivity,"[34] the film oscillates between progressive and regressive ideas; it offers a searching critique of the relation between nationally sanctioned aggression and the construction of masculine identity, but ultimately resolves the "dilemma" of masculine identity by casting the character in the role of leader in the antiwar movement, dramatizing his political ascendancy in a scene that unmistakably echoes the combat "proving ground" of the generic war narrative.

Nevertheless, *Born on the Fourth of July* departs significantly from the oedipal scenario that for so many critics has become synonymous with male-focused narratives, especially those dealing with Vietnam and, more generally, combat and war.[35] Instead, the film offers a trajectory of masculine identity that does not depend on punitive definitions of agency or subjectivity. Although the rebelliousness and defiance of the main character appear to have an oedipal accent, the film, on the whole, is not centered on male rivalry or the substitution of one father

figure for another. Unlike Oliver Stone's earlier film *Platoon*, *Born on the Fourth of July* revolves around definitions of masculine agency that are forged in relation to women, as it insistently plays out the metaphor of America as a woman. Although the rescue scenario that organizes the trajectory of the hero is fraught with limitations and patriarchal assumptions, it does mark a shift in gender roles and permits the film to question certain cultural definitions of masculinity. I would suggest that what Freud calls the rescue motif or rescue fantasy, which I discuss at greater length below, might constitute a fundamental underlying structure of the various narratives of masculinity, especially those involving Vietnam and its aftermath, that are currently being produced.

In first constructing the character of Ron Kovic as an avatar of masculinist mythology, the film seems to literalize the theme, sounded by Slotkin, that "myths reach out of the past to cripple, incapacitate, or strike down the living."[36] The thesis that American identity hinges on an ethos of violence is evoked from the opening scenes of the film, which feature Kovic as a child playing war games in the forest, noticing the disabled veterans of World War I being wheeled down the street during his hometown parade, and struggling, in a scene of slow-motion spectacle, against a superior male opponent in a wrestling match. The opening of the film illustrates the point made by Paul Willeman about the typical figuration of male characters in the cinema: "The viewer's experience is predicated on seeing the male 'exist' (that is walk, move, ride, fight) in and through cityscapes, landscapes, or more abstractly, history. And on the unquiet pleasure of seeing the male mutilated . . . and restored through violent brutality."[37]

The relation between male sexual identity and the warrior ethos is also made explicit at several key points. When the Marine recruitment team comes to Kovic's high school, for example, and the speaker begins boasting about the Marines accepting only "the best," Kovic is seen stealing a glance at his childhood sweetheart, Donna, who is walking by with another boy. Later, when he decides to enlist, he is shown discussing his decision with his friends while they pass around a copy of *Playboy*. The ideal of masculinity set up by the dominant culture is strenuously asserted throughout the first half of the film, but when Kovic persists in defining himself as the embodiment of the warrior ethos even after sustaining his paralyzing wound in Vietnam, the mes-

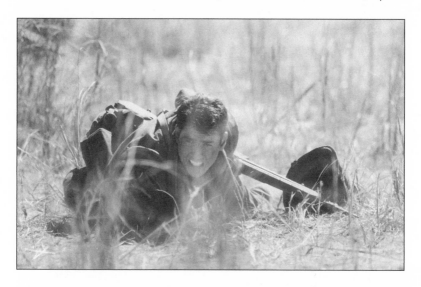

sage his broken body communicates recodes the masculinist ideology he espouses into a message of self-destruction.

In *Born on the Fourth of July*, the wound suffered by the protagonist becomes the mark of a history that is not to be passed on, of a tradition to be resisted. The character's injury reveals to him a different side of the national narrative; the national past is now perceived as an unbroken chain of broken bodies extending from the disabled veterans of the boyhood parade scene to the present. Although centered on the character's internal struggle to recover his sexual identity—the dialogue is filled with references to castration, to not being a man, to wanting to be whole again—the film brings into sharp focus the ideology of masculinity implicit in the military and national tradition he has begun to reject. The character's wound has the effect of defamiliarizing the various ideological props of masculine identity. The military, patriotism, sports, the family, religion, the profession—the various supports and appurtenances of masculinity are overtly scrutinized and rejected.

The uncoupling of the character from the national narrative that had defined him from birth is explicitly dramatized in the Fourth of July celebration at which Kovic is honored for his service in Vietnam. The film stages his breakdown in a highly symbolic fashion. Riding in the hometown parade, a direct echo of the boyhood birthday celebration, Kovic finds himself wincing at the sound of firecrackers, derided by young protesters, and demoralized by the long list of soldiers

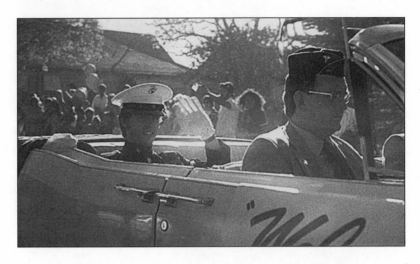

from Massapequa killed in Vietnam. Called upon to address the towns-people, he is unable to muster the words that would link Vietnam and the sacrifices it entailed to a tradition of heroic endeavor. The sound of a baby crying in the crowd, together with the sound of a helicopter, triggers memories of the traumatic incident in Vietnam when his platoon fired on a village of women and children, and when he mistakenly shot and killed a man under his command. The linking of person and nation that has constructed the character as an emblem of patriotism from the beginning of the film here conveys an opposite meaning: to be born on the Fourth of July has become synonymous with murder and death.

Cutting directly from the failed Independence Day speech to a television newscast of protesters marching on the U.S. Capitol, the film pointedly juxtaposes the attenuated mythology of wartime heroism with the growing popular discontent with the war. The increasing occlusion of American society manifests itself in the living rooms, barrooms, hospitals, universities, and suburban streets of the film—former enclaves of social consensus that became, in the sixties, a new kind of border zone. The internal divisions of the period bring the liminal and contestatory character of national identity to the forefront, as if the borders marking the limits of the nation had been displaced to the center. In a sense, the character of Ron Kovic, at this point in the narrative, constructs himself as a kind of outsider in his own culture, a colonial subject living under the rule of a foreign power. Cut off from

mainstream values, he becomes part of an America of "others." His alienation is expressed in a series of scenes in which he severs his ties with family, childhood, his hometown community, and the military tradition. At this prepolitical juncture, he defines himself principally by what he is not.

In the ensuing scenes, Kovic travels to Mexico, where he visits a seaside bordello that caters to the sexual needs of paralyzed veterans. Here, the film makes it clear that the crisis of masculinity the character experiences is really two crises: a shattering of male sexual identity caused by his paralysis and a more complicated, deeper loss of identity, the loss of affiliation with a larger social order, the loss of identification with the nation. In Mexico, Kovic attempts to recover a kind of physical authority based on the restoration of his sexual identity. Here, in a sequence that might be called the "virgin rebirth," Kovic has sex for the first time with a sympathetic prostitute and experiences a powerful sense of renewal and regeneration. But the brute, physical definition of masculinity that the character soon adopts—signified by the growth of facial hair, the eating of the worms from the bottoms of bottles of mescal, and the rather cynical use of prostitutes—quickly degenerates into exploitation and subjugation. The imagery of sex and renewal, emblematized in the full moon that illuminates his first lovemaking, gives way to the imagery of death. He begins experiencing flashbacks to the death of Corporal Wilson, the soldier he mistakenly killed in Vietnam in an incident of "friendly fire." In Kovic's memory, Wilson, who had been shot through the throat, is seen trying to speak, but the only sound that is heard is the crying of a baby, a memory-image that brings together not only the deaths of Wilson and the massacred women and children in Vietnam, but also, and more important, the identification of Kovic with the orphaned infant. The illusion of masculine power he constructs in Mexico is decoded by the unconscious into its opposite, a sense of infantile helplessness.

Significantly, the character returns in memory not to the incident of his own wounding, not to the point when his body was shattered and torn apart, but rather to the point when masculine power and aggression led to acts of villainy. Thus, the film situates Kovic's loss in the context of a larger failed narrative: the failure of Vietnam, the failure to accomplish the task, the failure to maintain mastery. Much of this section of the film revolves around the drama of the character's humiliation, his reversion to an infantile position. As Scott Benjamin King has

put it in a discussion of *Miami Vice*, "The male character take[s] on a role usually given to women: the ragged survivor of the narrative."[38]

Memory also plagues the other characters who have exiled themselves in Mexico. The illusion of fraternity, of an integral male world that the paralyzed veterans in Mexico try to sustain through poker games, feats of drinking, and sexual bravado, soon collapses into the naked expression of guilt and self-hatred. These themes come together in a powerful scene of self-excoriation, rendered, pointedly, in the form of a contest. After Kovic and his friend Charlie, another paralyzed veteran, are left alone on a rural Mexican road by a disgusted cab driver, they begin circling each other in their wheelchairs, spitting at each other and claiming, with vehemence, that they had each "put their soul on the line," that they had each fully experienced the horror of Vietnam, that they had each "killed babies too." They begin to wrestle in their wheelchairs, spitting, clawing, and cursing at one another, and wind up grappling in the ditch alongside the road. In this scene, the spectacle of masculine combat that so often serves as the climax of male film genres—the spectacle of the duel, the joust, the swordfight—is both invoked and inverted. The boyhood icons and ideals of the characters have come to this, the film suggests, to a desperate struggle against men who are their mirror image. Circling each other in a kind of helpless spiral, they express the trauma of their past experiences in the language of male aggression, a language of competition, one-upmanship, and ridicule.

After Vietnam, the film implies, the rituals and icons of male identity—the formation of masculine subjectivity in war games, varsity sports, and heroic physical prowess—acquire a different meaning. But what the film posits as an alternative masculine identity, one divorced from concepts of punitive agency, is highly problematic in its own right. As Steve Neale points out, images of masculinity in film are often caught between what he calls narcissistic authority, authority mainly based on physical power, control, and action (exemplified for Neale by the early Clint Eastwood films), and social authority, in which the male hero becomes identified with abstract values such as the law, the social order, and, by extension, the nation.[39] In *Born on the Fourth of July*, the male hero follows a similar trajectory from identity based on physical, phallic power and aggression to identity based on his ability, as one critic writes about a different film, to harness "phallic aggression to the ideas of freedom, brotherhood, and home."[40]

In the film's closing scenes, in which Kovic leads a protest at the Republican national convention in 1972, he assumes both attributes of masculine identity, serving as spokesman for the antiwar movement as well as strategizing and physically leading the storming of the security gate at the convention hall. Directly after, he is shown in the role of keynote speaker at the Democratic national convention in 1976. Here, we witness the acquisition of a new kind of phallic authority: the public and the private, the physical and the symbolic, the punitive and the

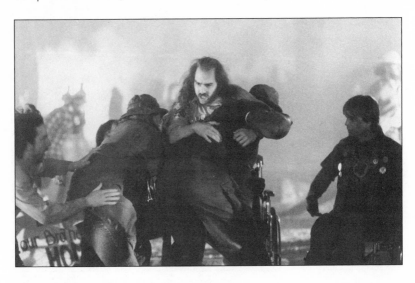

nonviolent senses of masculine identity come together at the end of the film in a way that asserts, above all, the paramount importance of leadership and individualism. Jeffords sees this type of resolution as an aspect of an emerging pattern in 1990s Hollywood films. Writing on the film *Terminator 2*, she says:

> Individual men . . . are made to seem not only effective but necessary, both to the protection of women and children and to the survival of humanity. . . . the power of individual decision-making and individual action is drawn as paramount. . . . Male viewers—particularly white male viewers—who may feel increasingly distanced from what they understand to be traditional male forms of power and privilege can be empowered through the assertions of the role male individualism must play in the future.[41]

Centered as it is on images of masculinity and codes of masculine behavior, it may seem somewhat surprising that *Born on the Fourth of July* confines its images of father figures to the biological father of Ron Kovic. In contrast to Kovic's mother, his father displays marked tenderness and heartfelt emotion at the fate of his son. As an alternative model of masculinity, however, Kovic's father lacks anything like social or phallic authority; he stands as a type of emasculated male, familiar from the films and television shows of the 1950s, a man whose emotionalism, combined with a lack of masculine authority, disqualifies him as an erotic object or as a figure of identification. The key relation

of desire and identification remains that of the nation in *Born on the Fourth of July*, and its avatars are not the male characters of the text, but the female characters, who are vested with all the qualities of potency, destructiveness, ambivalence, and understanding that the text requires to re-create, through the agency of its hero, an ideal American homeland. As we will see, the restoration of the figure of the mother is essential to the establishment of this relation of desire. Repudiated by the text in previous scenes, the mother is elevated by the end of the film into a symbol of national ideals.

Imaging the Nation

Nations are commonly represented in the form of idealized feminine figures, but *Born on the Fourth of July* gives the metaphor of America as woman—more precisely, as mother—an unusual thematic and structural emphasis. Motivating the key events of the plot along the lines of the familial dynamic it implies, the film draws from this metaphor a scenario of nation as a wayward and misguided woman, whose salvation depends on the efforts of its hero.[42] With the title of the film signaling the importance of the maternal metaphor, we are led to notice both the consistency and range of the various images of motherhood the film presents. Three contrasting figurations of nation as woman are set forth by the film. Initially, Kovic's mother, like America itself, turns away from her son, unable to accept his physical and emotional condition. Later, in a scene set in the South, the film supplies a maternal figure who functions as an icon of forgiveness and understanding, an emblem of promised community, who sets aside her own pain to sympathize with the protagonist. Between these two images, that of the "blood-seeker" and the "milk-giver," the film introduces a third stereotype, pervasive in Vietnam representations—the whore—embodied in the Mexican prostitute who introduces the protagonist to carnal experience.[43] By inserting the figure of the whore into its maternal constellation—associating her with the mother in an explicit way—the film reveals the basic, underlying pattern of its narrative of nation: the dramatic and symbolic logic of the film rehearses, in close detail, what Freud calls the "rescue motif" or the rescue fantasy, in which a man imagines he can "rescue" the woman, sometimes seen as "degraded" or "unfaithful," by keeping her on a virtuous path.[44] In patterning its plot after the rescue fantasy, *Born on the Fourth of July* transforms its hero, the Vietnam veteran, into the savior of the nation, a

resolution that recapitulates the evolution of the image of the Vietnam veteran in the films of the 1980s.[45]

In the process, however, the very myths of the nuclear family that had contributed to the war are redefined in the film as a solution to the disruptions of national community caused by the war. In this regard, the film is also symptomatic of a general tendency in Vietnam representations. As Rick Berg and John Carlos Rowe point out, the ideology of the nuclear family and the autonomous individual had much to do with the social problems of the Vietnam era. In the eighties, however, the nuclear family "began to look like a solution to the very political problems it had helped produce." Berg and Rowe make a critical point: "Rather than exploring just how our myths of the individual and the nuclear family had contributed to the war, the mass media focused instead on how our failure in Vietnam was reflected in the breakdown of the nuclear family and our loss of confidence in 'American individualism.'"[46] Vietnam was represented in the eighties mainly as a family trauma, embodied in the person of the psychologically disturbed veteran, who the family structure alone could cure. Even when the American family was not present in the narrative, anxiety about the family was nevertheless visible in a displaced form, shifted onto the Vietnamese peasant family. The massacre or murder of a peasant family, often with a Vietnamese child represented as the sole survivor, became a standard scene in these films. As Berg and Rowe aver, "The Vietnamese child came to represent, often in sustained close-up, what Americans had done to their own children."[47] Indeed, the Vietnamese peasant family in these films was constructed along the lines of a nostalgic image of a rural American past; generally showing them as country folk, with grandmother and grandfather prominently displayed, the depiction of the peasants "all too often looked more like life in Iowa than in Vietnam."[48]

Born on the Fourth of July adheres to this pattern in broad outline, including close-up shots of massacred peasants and a repeated traumatic memory scene of a newly orphaned Vietnamese child, but its analysis of the complicity of mainstream America in incubating the values and beliefs that allowed the war to occur sets it apart. The fundamental character of American life, with its stress on competition and individualism and its passion for authority in religion and politics, is held up to scrutiny. The family and the community are explicitly

depicted in the first half of the film as the source and breeding ground of the national trauma of Vietnam, but at the film's conclusion the family and the community are portrayed as the medium of reintegration and, somewhat surprisingly, as the basis of political and historical change. Thus, the film seems to combine the elements of an acute critique with an endorsement of the essential morality and benevolence of the American people, who, when presented with the facts—or, in this case, the "confession" of the main character—are able to achieve a moral consensus.[49]

These themes are crystallized in the female figures in the text. The portrait of Kovic's mother, for example, stresses the ways in which she inculcates the very values of individualism, male dominance, and xenophobia in her son that will ultimately result in the tearing apart of the family, the community, and the nation. In the film's portrait of the mother as relentless ideologue—and she seems especially proud that her son will serve in Vietnam—it comes close to the imagery Frederick Douglass uses in describing the slaveholding nation of the pre-Civil War years as a "vampire" whose "most fertile fields drink daily of the warm blood of my outraged sisters."[50] Obsessed with fighting communism, convinced that the greatest threat to her son is his sexuality, and equating his athletic success with moral character, Kovic's mother is the conduit for the ideology of the dominant culture, showing the ways, as Berg and Rowe write, that the "middle class family reproduced domestically the values and attitudes of the public sphere."[51]

In its blending of the imagery of familial and political authority, *Born on the Fourth of July* illuminates the metaphors through which America conceives and represents itself. Whereas the destructive figure of the mother in the first part of the film serves as a powerful indictment of mainstream beliefs during the Vietnam era, the concluding scenes of the film feature a different sort of maternal figure, a character who condenses the attributes of an America perceived as an ideal homeland, a place where community is restored and where the veteran can once again assume a leading role. In many ways, the film ends up, as Berg and Rowe conclude about the fate of the Vietnam veteran in general, reaffirming the very institutions, familial and political, that led to the war in the first place. It reiterates the pattern of many Vietnam films in this regard, in which the isolation of the veteran is finally over-

come in an image of communal redemption, where the conflict and division between individual memory and social coherence is resolved, and where the experience of the veteran serves as a kind of moral purification for the culture as a whole. As Michael Clark writes, "The critical implications . . . have been supplanted by a vision . . . that represents the veteran's presence in Vietnam as a memory of home; our collective relation to the past as a family reunion; and the restoration of the prodigal son as our national destiny."[52]

Prior to its final scenes of communal redemption, however, the film fashions another metaphor of nation in the scenes set in Mexico. Here, the demon/angel dualism described above is suspended for a time in favor of a highly unstable aggregation of the mother and the whore. In emphasizing the role of the Mexican prostitute, the film adheres to the standard iconography of the Vietnam narrative. The figure of the whore appears frequently in literature and films set in the Vietnam period, and is one of the genre's most heavily invested symbols. Alhtough usually depicted as a symbol of racial and sexual "otherness," the prostitute in Vietnam narratives actually functions as a textual nomad, a figure who migrates from a position of opposition to that of similarity, chiefly through her association with "American" values of commodity capitalism. In *Born on the Fourth of July*, the Mexican whore who first introduces Kovic to sexual experience is initially set out as the opposite of the film's maternal ideal: sensual, dark, and knowing. But the film creates a disturbing, and potentially incestuous, superimposition of mother and whore by having Kovic buy the prostitute a crucifix as a gift, an object strongly associated with Kovic's mother throughout the first half of the film. Directly after Kovic makes this purchase, however, as he prepares to present the prostitute with the gift, wrapped in paper decorated with hearts and stars, he sees her with another man, squeezing his crotch with seeming affection. As she later approaches Kovic's table, saying, "Today we get married, no?" his sense of betrayal is made apparent. From this point forward, the prostitutes at the brothel come to represent for him only dehumanized and anonymous sex, a point illustrated in a subjective tracking shot from Kovic's perspective as he wheels along a row of hookers, his eye directly level with their sexual organs.

In a sense, the whore in Mexico also represents America. The prostitute, like America, promises "happiness to everyone but [is] faithful to no one." The image of the prostitute, "vendor and commodity in

one,"[53] recapitulates the image of America as soulless commercial profi-
teer, first conveyed in an earlier scene through the person of Kovic's
childhood friend, who spends the Vietnam years building up his fast-
food hamburger business (and cheating customers by selling burgers
with concealed holes in their centers), for which he is accorded an hon-
ored place in the Independence Day parade. America, like woman,
once had intrinsic value, the film seems to be saying, an intrinsic value
that has been corrupted by money into a faithless and inauthentic ver-
sion of itself.

It remains for Oliver Stone to redeem his image of America with
another female stereotype, to resecure a traditional, virtuous concept
of the homeland. And here we can plainly discern the contours of the
Freudian rescue motif as the dominant underlying structure of the film,
a fantasy that allows the character to "rescue" the nation, figured as a
woman who has been turned from the path of true national character,
while simultaneously being "rescued" himself, restored to the commu-
nity as prodigal son and ultimately as paternal figure.

Freud describes a psychological pattern he calls the "rescue fan-
tasy" in men who fall in love with prostitutes and whose erotic interest
is dynamically linked to the need to experience jealousy. Typically,
such men endeavor to "rescue" the love object by keeping her on the
path of virtue. This type of behavior, according to Freud, stems from
the "mother-complex"—an unresolved libidinal attachment to the
mother. The unconscious correlation of mother and prostitute, which
seems at first glance to be a relation "of the sharpest contrast," results
from the child's first understanding of sexual intercourse, in which the
mother appears to the child to be degraded by intercourse and also
"unfaithful" to the child himself. Although the "love for a prostitute"
that Freud regards as a neurotic symptom is one expression of this
complex, childhood fantasies of rescuing the mother, or the father, are
commonplace; Freud argues that when they revolve around the
mother, they can be read as an expression of gratitude, a symbolic at-
tempt to repay her for giving the child his life: "When a child hears
that he owes his life to his parents, or that his mother gave him life, his
feelings of tenderness unite with impulses which strive at power and
independence, and they generate the wish to return this gift to the par-
ents and to repay them with one of equal value."[54] The child thus forms
the fantasy of rescuing the mother and saving her life.

Another way this wish is expressed is through the fantasy of giving

her a child—"needless to say, one like himself." Here Freud makes an interesting distinction between rescue fantasies involving the father and those revolving around the mother. With the father, "it is as though the boy's defiance were to make him say: 'I want nothing from my father; I will give him back all I have cost him.'"[55] Rescuing him then becomes a way of squaring his account. This fantasy, Freud suggests, is commonly displaced onto other authority figures, such as a king, an emperor, or a president, and in this form often becomes a subject for creative writers (or creative filmmakers, as Stone's later *JFK* and Wolfgang Petersen's *In the Line of Fire* attest). When it concerns the father, the defiant meaning of the rescue fantasy is paramount, whereas with the mother, it is the tender meaning that is by far the most important, giving rise to the grateful wish of "giv[ing] her another life." Of course, giving his mother a child who most resembles himself allows the boy to identify himself completely with his father, in essence, to "find satisfaction in the wish to be his own father."[56]

In *Born on the Fourth of July*, however, it is the nation itself, symbolically represented as a mother, that is in need of rescuing. In the erotic relation that Stone and Kovic construct with the concept of America, the symbolic engendering of a new American homeland both allows the protagonist a paternal identity, completing the project of remasculinization, and rescues and restores the character, in his role as wayward son, to the nuclear family and national community.

The scene at Corporal Wilson's family home in Venus, Georgia (the name of the town highlights the relation of desire that will be recovered here), captures these themes in a vivid way. After visiting Wilson's grave, Kovic arrives at the rural homestead and begins a conversation with Wilson's father. The father begins talking about the Marine color guard that came to bury his son, and about all the young men the town had lost. Leafing through a family album, he mentions that this town and his family in particular have a proud tradition, that Billy's great-grandfather was at the first Battle of Bull Run, his grandfather was in France during World War I, and that his family had fought "in every war this country's had." As if to underscore the point, Wilson's young son aims and shoots a toy rifle at Kovic. Kovic takes in the young son, the framed military medals in a glass case, the photos of dead ancestors, the deer's head on the wall, and begins to confess that it was he who had killed Wilson in the midst of an ambush, an incident of "friendly fire" very different from the story the family had been told

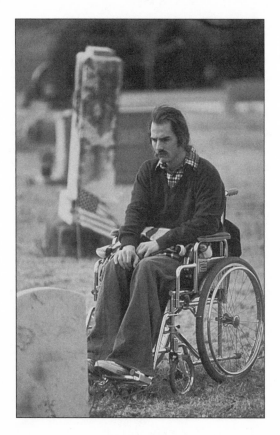

by the Marines. Wilson's mother forgives him, although Wilson's wife says she cannot.

The role of Wilson's mother is especially emphasized in this sequence, completing the maternal constellation, the three-way splitting of the maternal figure into demon, angel, and whore. As Kovic's re-memoration is heard, the mother is frequently seen in close-up, and it is her judgment that is appealed to at the end. Kovic himself appears in the role of surrogate son. The filtering of moral judgment through the maternal character restores the family structure to its dominant place. Whereas the myths of the nuclear family and the individual have been shown in the first half of the film to have contributed to the war, here, a family that had fought "in every war this country's had" serves as a synecdoche of communal redemption. The scene presents the rememoration of the protagonist as a source not just of individual expiation,

but of a wider social purification, which will be completed in the scenes of violent protest and civil disobedience that immediately follow.

The leadership role that Kovic assumes immediately after this scene underscores the presence of the rescue motif, which is augmented by a series of historical parallels and references. As the Civil War song "When Johnny Comes Marching Home Again" is heard on the sound track, the scene at Wilson's home dissolves to a shot of the American flag, and then to a group of protesters in wheelchairs, arrayed in a way that recalls the "Yankee Doodle Dandy" fife and drum trio that often serves as an emblem of the Revolutionary War. The imagery of past struggles for national autonomy and identity is recontextualized to express a concept of nation and history as a site of recurrent social struggle. But more important, these historical references place the protagonist in the symbolic position of fathering the nation anew, according him a masculine form of agency that continues the legacy of the national heroes of the past. In the closing scenes of the film, Kovic claims the role of spokesman for the Vietnamese—"a proud people who have been struggling for independence over one thousand years"; for the paralyzed veterans—"Our wheelchairs, this is our steel—your Memorial Day on wheels. We are your Yankee Doodle Dandies come home"; and for the people of the United States—"white, black, brown, red, yellow," invoked by Ron Dellums at the Democratic convention, where Kovic addresses the crowd of delegates.

The ending of the film expresses both a sense of restored community and what Michael Clark calls "an ideal of historical continuity that turns Vietnam into just one more chapter in the epic narrative of the American dream."[57] As the character wheels himself to the podium, a series of flashbacks to his childhood appear. A past that had been synonymous with an order of destructive social uniformity is folded back into a utopian vision of a transformed social world. And the Vietnam veteran, no longer a divisive or menacing force, is here celebrated by the media and presented as a new kind of national hero.[58] The final lines of the film bring the familial telos of the work to completion, as Kovic says to an Asian American woman reporter: "We're home. I think maybe we're home." Rather than a point of cultural resistance, the memory of Vietnam has in the film's closing scenes become a new way of reinstating family and home as the dominant fantasy and metaphor of national community.

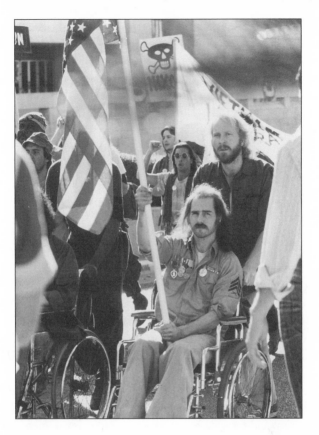

Conclusion

In its appeal to national identity based on the metaphor of America as a maternal social body, and its concomitant shift away from masculinist concepts of nation, *Born on the Fourth of July* exhibits a striking combination of blindness and insight. Replete with stereotypical images of femininity, the film nonetheless places substantial pressure on myths of masculinity that equate nationalism with competition and aggression. In trying to forge a new model of masculine identity that can serve as the basis of a changed concept of nation, the film sets out a trajectory for its male protagonist that may shed considerable light on the way masculinity is narrated and represented in films of the 1980s and 1990s. Film criticism has found in the oedipal scenario a nearly universal pattern for depictions of masculine subjectivity in the cinema, but I believe the rescue fantasy may be an equally important con-

cept. In contrast to the oedipal scenario, with its consistent emphasis on rebelliousness, competition, and lack as necessary components of identity and desire, the rescue fantasy is shaped by a variety of emotions, including "tenderness, gratitude, lustfulness, defiance, and independence," a range that gives the "performance of the masculine," as it is commonly called today, a more balanced and complex character.[59] The shift from punitive concepts of masculine identity in the "remasculinizing" narratives of the eighties to narratives that emphasize emotion and "commitment" in the male-oriented films of the nineties might be analyzed not in terms of the fading of masculine authority, but rather as an attempt to gain access to the paternal position, by way of the rescue fantasy, without incurring the fracturing penalties of oedipal rivalry.

Nevertheless, the rescue fantasy remains a drama about power and powerlessness, and the organization of the fantasy, in its dominant version, around the figure of the woman who would be lost without the man's help clearly represents a fantasy of control. As such, this scenario hardly provides a progressive basis for a new narrative of national cohesion. Still, there is a certain degree of reversibility in the roles of male and female characters in *Born on the Fourth of July* that we should not ignore: Kovic is himself "rescued" several times in the film—from a morass of unfulfilled desire and self-pity by the Mexican prostitute; from corrosive guilt and self-loathing by Wilson's mother; and from physical danger, twice, by anonymous black men. In Freud's description of the fantasy, it appears that a certain reciprocity and role reversal is built in. The male child who wishes to rescue the mother is in effect reciprocating her, not just for the "gift of life" but also for being "rescued" by her from the dangers of birth: "The act of birth itself is the danger from which he was saved by his mother's efforts. Birth is both the first of all dangers to life and the prototype of all the later ones."[60]

Despite this quality of reciprocity, however, the rescue fantasy itself is fraught with ambivalence toward the figure of the mother, a point that *Born on the Fourth of July* makes explicit. As Miriam Hansen writes about Griffith's *Intolerance*, "The wish to be rescued revolves around the figure of the mother who, like Whitman's 'fierce old mother'. . . has displaced a failing patriarchal lineage with an even greater threat of chaos and loss of identity."[61] In similar fashion, the film's attempt to displace or revise the codes of masculine identity is ul-

timately limited and distorted by its use of maternal stereotypes as emblems of both division and community. Nevertheless, the prominence of the maternal figure in the film suggests that the theme of a "failing patriarchal lineage" in Vietnam narratives may express itself not only through symbolic conflict with the father, but also through a more complex negotiation with the imaginary power of the mother.

4 | Modernism and the Narrative of Nation in *JFK*

The debate over Oliver Stone's *JFK* has been framed to date largely within the discourse of historiography, with greatest attention being paid to issues concerning the limits of fact and fiction and the erosion of the presumed boundary between documentary and imaginative reconstruction.[1] Defenders of the film have usually argued from a deeply theoretical position, pointing out the permeable nature of the border between factual discourse and imaginative reconstruction, as well as the protean quality of even the most substantial documentary record of the past.[2] In this chapter, I wish to shift the angle of approach to the film in order to consider another set of questions, revolving chiefly around the tension between the film's formal innovations and its explicit aim to articulate a narrative of national cohesion. The film's fragmentary form can be revealingly seen as an expression of a national narrative in disorder and disarray, its collagelike narrative structure reflecting the disruption of the evolutionary or historical narrative that gives continuity to national identity. From this perspective, the film's notorious mixing of idioms conveys meanings that depart from issues of fact and fiction: rather, it expresses the fracturing of historical identity, the breaking apart of a once unified national text. The film thus recuperates its radically discontinuous style by linking it to the loss of what Benedict Anderson called social "unisonance," to the absence of a unified national narrative, which it nostalgically evokes as the foundation of community and the ground for all other narratives of human connection.[3]

The concept of nationalism has increasingly been tied to the development of particular narrative forms.[4] In writing of the nation as an "imagined community," for example, Anderson has linked the ideology of the modern nation to a specific sense of space and time expressed most clearly in the narrative forms of the realist novel. The temporal parallelism of the realist novel—the sense of temporal coincidence and simultaneity, of a multitude of unrelated actions occurring in a single community in what Walter Benjamin calls "homogeneous, empty time"—is directly related, in Anderson's view, to the image of the modern nation: "The idea of a sociological organism moving calendrically through homogeneous, empty time is a precise analogue of the idea of the nation, which is also conceived as a solid community moving steadily down (or up) in history."[5] Emerging as a strong form in tandem with the rise of nations, the realist novel, with its composite structure, its depiction of the one yet many of national life, and its temporal parallelism, "allowed people to imagine the special community that is the nation."[6] As Anderson says, the structure of the realist novel as well as the newspaper, both of which are crucial to the development of the imagined community, can be seen as forming a "complex gloss upon the word 'meanwhile.'"[7]

By contrast, Hayden White argues in a recent essay that modernist antinarrative techniques, characterized by fragmentation, the exploding of the conventions of the traditional tale, and the dissociation or splitting of narrative functions, may be the most appropriate techniques for representing the historical reality of the contemporary period, with its unprecedented catastrophes and its compound global contexts.[8] His hypothesis—that there is a deep connection between the cultural genres of modernist aesthetic practice and the social dramas of the twentieth century—provides a suggestive contrast with Anderson's ideas about the cultural models of the nation-building past. White argues that the stylistic techniques of modernism, far from being ahistorical or removed from history, as so many critics have contended, provide better instruments for representing the recent events of the past than do the storytelling conventions of traditional historians or, for that matter, the storytelling conventions of realism. Traditional forms of historical explanation, relying on concepts of human agency and causality, assume a kind of narrative omniscience over events that, by their scale and magnitude, elude a totalizing explanation. Modernist forms, in contrast, offer the possibility of representing, for the Western

world, the traumatic events of the twentieth century, such as the two world wars, the Great Depression, and the use of genocide as a state policy, in a manner that does not pretend to contain or define them.

In these pages, I address the film *JFK* in terms of both of these models, hoping to show how *JFK* utilizes modernist, antinarrative techniques in order to express both the loss and the refiguration of a unified national identity. I argue that although the broken narratives and the profusion of stylistic forms in the film may seem at first appropriate to the catastrophic event of a presidential assassination and, indeed, convey a sense of a fractured social reality, they are ultimately recontained in a nostalgic image of social unisonance in the film's closing scenes.

The Temporality of Trauma

The disjointed temporality and dislocated spaces of *JFK* can be read as reflecting the distorted and irrational sense of national identity and the fragmented social reality that the film finds at the heart of the United States in the post-Kennedy era. Far from seeing the nation as a "solid community moving steadily down (or up) in history," the spatial, temporal, and narrative strategies of the film evoke division, rupture, and discontinuity between communities, between individuals and their actions, and between events and their causes. Analysis of the temporal register of the film in light of the idea of the nation as imagined community is especially revealing. The complex system of narrative temporality in *JFK*, to start with, is very far from the image of "homogeneous, empty time" filled up by the "steady, anonymous, simultaneous activity" conjured by the realist novel. Instead, the most striking characteristic of the film is its interweaving of past and present through an extraordinary combination of flashbacks, flashforwards, and achronic images—images that cannot be dated or assigned a temporal position. Moreover, time constitutes one of the principal thematic motifs in the film. Far from being seen as empty and homogeneous, time is thematized as heterogeneous and subject to human manipulation. Examples include the extensive newspaper report on Oswald that appeared in a New Zealand paper four hours before he was charged with Kennedy's murder; the *Life* magazine photo of Oswald with its contradictory times of day; the impossible chronology of Oswald's day on the date of the assassination; the delay in bringing Oswald down to the lobby of the jail, which allowed Jack Ruby to take his place among the crowd;

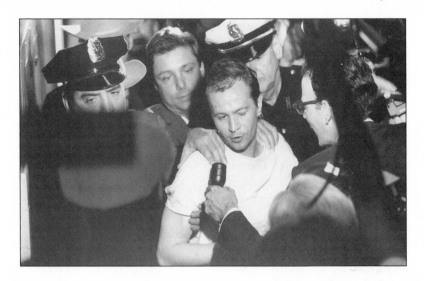

the phone lines into Washington that went out for hours immediately after the assassination; the live oak in Dealey Plaza that the Warren Commission claimed had unnaturally dropped its leaves in November, affording Oswald an unobstructed view; the shots themselves, with the Zapruder film serving as the "clock" of the assassination, giving the lie to the "magic bullet" theory, which would have us believe that a bullet could suspend itself in midflight for one and a half seconds. The overall picture of time that emerges is not one of uniform consistency, but of simultaneity corrupted by inexplicable delays, gaps, compressions, accelerations, and contradictions. Rather than fostering a sense of the security of parallel lives moving along the same trajectory, the film evokes time as a dimension that can be manipulated, a dimension that is open to doubt, ambiguity, and suspicion.

A comparison of two scenes in the film illustrates the close connection the text makes between structures of temporality and concepts of the national narrative and national identity. At the beginning of the film, time and date are specified exactly through voice-over, graphic titles, and overt period references. The historical portrait drawn by the film in its opening minutes depicts a society moving along parallel pathways in a homogeneous time, punctuated by clear-cut historical events. The re-creation of the assassination that occurs several minutes into the film furthers the impression of temporal simultaneity, as the time of day is foregrounded by numerous, almost obsessive, cutaways

to the clock overlooking Dealey Plaza. Further, when Jim Garrison (the New Orleans district attorney whose investigation into the assassination serves as the basis of the film) is first introduced, directly after the gunshots, the time of the event is specified orally and underlined visually by rapid point-of-view cuts from Garrison's perspective to an antique clock. Throughout the opening sequences, then, the dominant temporal form is precisely that of simultaneity and parallelism. The film creates a snapshot of the nation at the moment of the assassination, forging a picture of a national community beset by tragedy, linked, as with the newspaper of the realist era, by the ubiquitous television broadcasts detailing the news of the assassination, the arrest of Oswald, and the swearing in of Johnson.

This sense of simultaneity and parallelism, the impression the film creates of a community drawn together by a singular, punctual event, begins to dissolve as the investigation into the assassination proceeds. As the past is opened up through a series of character narrations, the time scheme of the film becomes increasingly complex. For example, in the sequence that summarizes the various mysteries surrounding Oswald, several different layers of time are folded together. First, the scene begins in a reassuring, communal fashion, as Garrison and his staff gather in a favorite restaurant to discuss what they have found so far. A sense of solid, social reality dominates the opening of the sequence, as the maitre d' anticipates Garrison's request for a drink, which has already been poured for him, and as various well-wishers exchange greetings. Then, as the assistant D.A. on Garrison's staff discusses the oddities of Oswald's character, a summary of his life, consisting of black-and-white still photos, black-and-white film footage, and color "home movie" footage, appears as illustration. Periodically, however, another set of images is inserted: color footage of a mysterious hand fabricating the photo of Oswald with a rifle that will appear on the cover of *Life* magazine, an image that will seal Oswald's guilt in the eyes of the public.

In addition to mixing images that are manipulated or highly ambiguous with images that seem stable and thus imply facticity, the film constructs time here in a way that undermines any sense of its linearity, causality, or embeddedness in social reality. By interrupting the flashback chronicle of Oswald's life with scenes that detail the construction of a composite photograph of Oswald, the film stages the narrative of Oswald's life as a construct detached from the realm of everyday real-

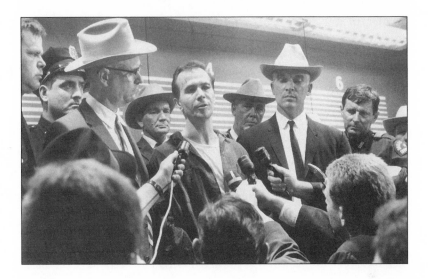

ity and from the solid sense of social space insistently presented at the beginning of the scene. Social reality is abstracted and defamiliarized, as the submerged past that begins to surface here will lead Garrison to say, at the close of the sequence, "We're through the looking glass here. Black is white. White is black."

This is a pattern that will be followed throughout. The character narrations and subjective flashbacks defamiliarize social reality by narrating the past as a site of contradictory, mundane, and abstracted details, overarched by an almost biblical sense of prefiguration and fulfillment. As Garrison reads the testimony of the train yard manager, Lee Bowers, for example—a witness who spotted suspicious activities taking place on the grassy knoll—the film provides a series of images, attended by Bowers's verbal description, that are specified exactly according to time, place, and perspective. At the close of this narration, however, the film suddenly introduces a still photograph of the same man now dead, covered in blood and slumped over the wheel of a car. Only much later in the film will the suspicious circumstances of his death be revealed. Here, the film uses a technique of temporality similar, although not identical, to the Oswald fabrication scene described above: it telescopes time by inserting an achronic, undated, almost unreadable image, an image abstracted from any temporal or spatial connection with the rest of the sequence, into a series of images whose chronology is precisely specified. The mundane and the portentous, the

particular and the prophetic (a textual motif underlined in the two Cassandra figures who inaugurate the film, Eisenhower and Rose Charmaine, the beaten woman who warns her doctors of the impending assassination), are placed in direct proximity in a way that transforms the past into something other than a horizontal cause-and-effect chain. The time scheme that dominates the film is one of anticipation within retroversion: flashbacks that also convey an instantaneous, but undatable, image of the future.[9]

Seen as a reflection of discontinuity and disorder in the national narrative, the temporal structure of *JFK* departs radically from the sense of continuity that traditionally defines the national past, and from the parallelism and simultaneity binding together, in Anderson's view, the community of the modern nation. The temporal collage the film sets up communicates instead the message that the national narrative has come unraveled, that the shots in Dealey Plaza have produced a caesura in the narrative of nation akin to the blackening of the screen that occurs in the film directly after the assassination. Many of the character narrations, moreover, come from socially marginal people whose testimony would not be seen as credible in a court of law: David Ferrie (a shadowy member of several extreme right-wing groups), Willie O'Keefe (a convicted homosexual prostitute), and the stripper from Jack Ruby's bar, for example, provide vivid and extensive character narrations, which, we are told, will carry very little weight in a legal proceeding. However, by looking to the marginalized and excluded as a source of authenticity and truth, the film implies that a split between the public sphere and the sphere of "the people" has further eroded the concept of nation as "imagined community."

If, as Timothy Brennan says, the nation is an imaginary construct that depends for its existence on an apparatus of cultural fictions, then the disjunctive, fragmentary form of *JFK* suggests the shattering of social identity.[10] It encodes stylistic characteristics such as fragmentation, rupture, repetition, and the atomistic scattering of details, as a sign of social morsellation, a mark of the falling apart of a once unitary nation. The message conveyed by the film's style thus intersects in complex ways with the positive argument, made by Hayden White, that modernist and postmodernist forms may provide the most effective methods for rendering the events of the recent past. Although the film vividly illustrates the thesis White elaborates—that historical reality far exceeds the capacity of any realist form to comprehend it—it nonethe-

less holds on to the very ideal of a coherent narrative of nation that its own formal structure seems to repudiate.

For White, the chief value of modernist techniques for representing the traumatic historical events of the twentieth century resides in the sense of doubt and uncertainty toward historical knowledge that a modernist approach to the past permits. Rather than assuming an illusory intellectual mastery over the event, a modernist style of historiography finds that the meaning of the past is contestable, because the questions we ask of the event cannot be answered with any semblance of mastery or totality. Historical reality itself has been transformed in the twentieth century, he argues, by the occurrence of events of such a compound nature and magnitude that any objective account or rational explanation based solely on "the facts" can only be illusory, implying mastery over events and contexts that escape explanation. The effort to come to grips with the "modernist" event can take place only in an atmosphere of historiographic doubt.

Although such a description clearly corresponds to *JFK*, with its mood of epistemological skepticism and lack of resolution, the film on the whole places a different kind of pressure on the question of modernism and historical representation. In terms of offering the cinematic equivalent of a sophisticated historiographic analysis, *JFK* is exemplary: it represents the event cubistically, from competing perspectives; it mixes film idioms, genres, and period styles (documentary, Soviet-

style montage, Hollywood naturalism, and domestic melodrama, to name a few) in order to represent the variety of overlapping contexts in which the events occur; it foregrounds the artificial and provisional nature of any reconstruction of reality by refusing to predicate any single version of events. Nevertheless, in its overall concern for the relation between the past and an ongoing sense of national identity, the film seems to be split between its modernist form and its desire to reconstitute or recover a seamless national text. Although it uses the full panoply of modernist devices, it implies that a certain sense of history is part of the social imaginary, and that historical ambiguity raises deeply disturbing questions about identity.

Certainly *JFK* questions history both as a mode of knowledge and as a means of understanding the present. However, by focusing obsessively on a historical event, it also affirms a desperate need for history as the foundation of national identity. It has been said that "The interrogation of history is a stage in the search for identity."[11] Above all, *JFK* demonstrates the problematic nature of history in relation to identity, exposing the contradictory faces of a historical narrative that has ceased to function as an expression of the imagined community.

The images of history evoked by *JFK* can be described in terms of two competing paradigms. In the first instance, as a result of its obsession, *JFK* appears to represent a traditional view that a unified and fixed historical reality exists and could be recovered were it not obscured by willfully deceptive stories and by the inaccessibility of crucial facts. Seen in this way, the film sets itself the task of imposing a metanarrative to unify the disparate stories, rumors, and contexts of the Kennedy assassination into a coherent frame. At other points, however, and closely similar to White's concept of the "derealization" of the event in the twentieth century, the film seems to represent history as an "epistemic murk," an unstable discourse of fact and fiction, truth and illusion, that discloses only the scattered remains of contexts, motives, beliefs, and regimes of credibility.[12] From this perspective, the film's project might be described as an attempt to write a history that represents the incoherence, the contradictions, and the inconsistencies that characterize the historical text, exemplifying what we might call, with Homi Bhabha, the "dissolution of history as fragmentary composition; the decomposition of narrative voice."[13] The film's insistence on explaining the historical event, and thereby recovering a sense of the unisonance of the nation, is thus contradicted by its violent polyphony,

its filtering of the national history through the epistemic murk of rumor, fact, and illusion, conveyed through the complex temporality of the jump cut, the fast forward, the freeze frame, and the splitting of sound from image in which the past escapes any possibility of realignment in "homogeneous, empty time."

The Imagined Community as Lost Object

JFK oscillates between these competing paradigms, which are represented, more or less explicitly, in a series of character narrations. In place of social unisonance, the film provides a series of readings of the assassination drawn from a wide range of social types. From the almost freakishly marginal David Ferrie to the seemingly informed speculations of "X," these readings exhibit common characteristics as well as telling differences: they adhere to the same code of explanation, but

make different appeals to belief. The confessional nature of Ferrie's account, the anguish and fear that permeates his monologue, conveys a strong sense of truth, underscored by the long-take camera work that seems to wish to offer itself as the equivalent of a visual polygraph test. By contrast, "X" offers the authority of an "inside view" and provides a sense of dispassionate analysis in which logic and history provide an explanatory framework. Juxtaposed in the film in a way that invites comparison, the narrations of Ferrie and of "X" exhibit a striking lack of unisonance at the level of the signifier.

Ferrie's narration, for example, stands out for the simplicity of its scenic construction. In a film characterized by virtuoso editing and stylistic "thickness," this scene is rendered in a straightforward presentation: there are no cutaways, inserts, or dramatized illustrations attending his description. Rather than establishing a unifying frame for the murder, however, a metanarrative that would resolve the incompatibilities of different texts and contexts, Ferrie offers a reading of the event that is polysemic: "It's a mystery, inside a riddle, wrapped in an enigma." He concludes by stressing the incomprehensibility of the event, its vastness and obscurity, a plot in which "everyone is always flipping sides" and in which the machinations of the Cubans, the CIA, and the Mob are described as "fun and games. It's all fun and games."

"X"'s narration, on the other hand, charts a different route into the social imaginary. Continuously framed with the monuments of Washington, D.C., behind him, "X" speaks of a plot that centers on the control, suppression, and manufacture of information. Cover stories, secret documents, conversations "in the wind" delineate a plot that has been rationally constructed from start to finish, and that could, it appears, be uncovered with sufficient access to "the facts." "X"'s narration, however, is replete with all the techniques that have garnered *JFK* such a notorious reputation for dissembling: it is filled with imaginary reenactments and recontextualized documentary images that dramatize a far-flung conspiracy emanating from the highest reaches of power. "X," unlike Ferrie, concludes by telling Garrison that Garrison can and must discover the truth, that his quest is "historical."

Drastically dissimilar appeals to belief are made in these readings: in one case, a straightforward scenic rendering of the character's version of events; in the other, a highly edited aggregation of existing footage, staged reenactments, and rumor made photographically concrete. In juxtaposing these two stories, both consisting of tenuous

threads of information, the film exposes a cultural landscape in which different kinds of knowledge and different types of visual and verbal evidence abound. The different rhetorical strategies characterizing these two narrations of the plot to murder Kennedy, however, come together in a set of common dichotomies: both the testimony from "below" and the testimony from "above" shuttle between explanations based on personal acts of revenge versus collective political acts, between crime and subversion, between fanaticism and economic calculation, between inside agents and outside agitators.

Underlying the discourse about Kennedy's assassination, however, is the more elusive and oblique subject of the national narrative. In these two dialogues, different rhetorics of national identity or, more precisely, different metaphors and myths of the nation are placed in uneasy proximity. Ferrie uncovers one such myth in his "confession" that all he wanted was to become a Catholic priest, to live in a monastery, to pray to God. One of Anderson's central theses concerning national identity is that "the dawn of nationalism at the end of the eighteenth century coincide[d] with the dusk of religious modes of thought," and that nationalism essentially extended and modernized "religious imaginings," taking on religion's concern with death, continuity, community, and the desire for origins.[14] For Ferrie, the centrality and communalism of the church, especially that of the monastic life, stand as an example of collectivity only poorly replicated by the criminal and state-sponsored institutions that have replaced it. Ferrie seems to occupy in a complex way the position of the exile, nationalism's opposite. Referring to Oswald as a "wannabe, nobody really liked him," Ferrie brings to the surface of the text the desire for affiliation, for community, for the univocality of assent. The figure of the exile, seen here in the person of Ferrie as a type hovering around the periphery of the national community, is, however, displaced, in a paradoxical fashion, into the center of the film's portrait of national life, extending ultimately to the figure of Garrison, who will, like Ferrie, be metaphorically "defrocked" and banished, at least temporarily, from the national community—a point made apparent in the slanted media coverage of Garrison's case against Clay Shaw. Moreover, Garrison's identification with Ferrie is figured directly in the subsequent scene at Ferrie's apartment, in which Garrison looks into the mirror and imagines the circumstances of Ferrie's death. The dichotomy the film sets up between exile and the imagined community illuminates its narrative address:

the film posits its viewer as a charter member of the community of nation yet simultaneously alienated from it, both insider and outsider, winner and loser, part of the whole yet driven to reject the premises upon which the national community has lately been established.

A very different myth of the nation, and a very different sense of cultural identification, permeates the dialogue of "X." Here, the assassination of Kennedy is placed in a historical frame that encompasses not only the national narrative, but the principal symbols of national identity. Beginning at the Lincoln Memorial and ending at the eternal flame marking Kennedy's tomb, the sequence details a secret history, a national past that has uncannily woven itself into the communal text.[15] "X" narrates a history consisting of covert operations in Italy, Tibet, Vietnam, and Cuba that brutally extended and consolidated the reach of American power in the 1950s and early 1960s. The murder of Kennedy and the national narrative in general are described by "X" in terms of a universal imperial pattern: Caesar, the Crucifixion, the killing of kings are set out by "X" as the salient intertextual references for the U.S. narrative of nation.

Counterposed to this clandestine history of the national security state, however, is the implied narrative of national life represented by the monuments to Lincoln and Kennedy, who, the film suggests, are linked in a different chain of affiliation, connected to a different narrative of nation. This narrative of national life is referenced metonymi-

cally in the shots of two black children playing on the grassy embankment near Garrison and "X," and by the black father and son who are seen paying their respects at Kennedy's tomb at the end of the scene.[16] Blackness in *JFK* functions almost like a motif, the visible signs of an idealized national narrative characterized by racial and social progress, a narrative capable of binding the whole "national community" together. "X"'s version of the narrative of nation—"The organizing principle of any society is for war. The authority of a state over its people resides in its war powers"—appears to be contradicted by the mise-en-scène, which evokes a national mythology and a historical life of "the people" that appears to be distinct from the martial authority wielded by the state. The mise-en-scène of this sequence illustrates a point made by Bhabha: "The living principle of the people as that continual process by which the national life is redeemed . . . [t]he scraps, rags, and patches of daily life must be repeatedly turned into the signs of a national culture."[17]

Between these different representations of the national past and the national culture—one narrated, the other expressed through mise-en-scène—a major fissure exists. The imagined community portrayed in the film is clearly not fixed, visible, or unified horizontally, but is instead split into several separate and distinct nations: those "in the loop" and those who occupy the position of exile; those who are "faceless" and those who are marked by history. Split and divided, the idea

of the nation becomes a kind of lost object in *JFK*, a unisonance once identified with patriotism and home—signified with exceptional nostalgic power in the lengthy montage scene that opens the film—now identified with loss and silence.

The imagined community as lost object—the modernist and postmodernist narrative techniques of the film express a sense of the splitting and division of a society, and of the loss of the idealized symbols of national identity. If the development of a coherent narrative mode is essential for achieving a sense of history and of cultural identity, as Anderson and others have argued, the film's antinarrative techniques would appear to signify identity's dissolution. If the realist novel is understood to serve a "nation-building function, equivalent to the institution of law," *JFK* would appear to display the divisions of culture, history, and symbolism that, the film implies, make our present sense of national identity so dissonant.[18]

On the other hand, the film's radically contestatory interpretation of the past can also be seen as a form of popular countermemory, bringing forms of popular cultural expression directly into the center of its narrative art. Bypassing the narrative forms of official culture, the film fuses vernacular idioms such as docudrama, television images, home movies, and grainy, tabloid-style still photographs to create a carnivalesque style of narrative texture replete with examples of "bad taste." The cultural and social landscape of late-twentieth-century America is embedded in the film's montage technique, through which, as Rowe and Schelling say, "different cultural worlds converge: a convergence of differences without uniformity."[19]

The nostalgic desire that permeates the film for a unified national culture, a culture of unisonance, a single national voice, is thus set against its modernist, montagist form, which draws on the multiple popular idioms of contemporary life. Cutting across the different social divisions and narratives of nation in the film, however, is the memory of violence, the memory of discontinuity emblematically figured in the death of Kennedy. In foregrounding the memory of violence, the film resists the reductiveness of a single, official history and defends the role and power of differentiated memories. Perhaps *JFK*'s greatest strength is its use of the disjunctive style of the contemporary media as an act of cultural resistance; it folds that message of cultural resistance into an appeal to national identity in a way that recognizes the media

as a terrain, analogous to the role of the novel and the newspaper in the past. But this strength might also be seen as the film's greatest weakness, for in the end this message returns us to the dominant narrative of nation and assimilates to national identity all other possibilities of community and solidarity.[20]

5 | Prosthetic Memory/National Memory: *Forrest Gump*

The extraordinary degree of contestation and debate circulating around recent interpretations of the American past has brought into view the powerful role that social memory plays in constructing concepts of nation. The public responses to recent museum exhibitions on the atomic bombing of Japan and the conquest of the American West, for example, have thrown into relief the radical differences between the interpretations of the national past offered by historians and the narratives of nation sustained in popular memory. Whereas social memory, as Michael Kammen notes, has long been uniquely divided from and joined to history in American culture—divided because the diverse and heterogeneous nature of American society gives us a multitude of memories, rather than a single unified memory; joined because the actual intermingling of cultures in American society gives us a history that hinges on memory[1]—social memory appears to have gained in value as a subject of public interest, while history, in the words of Thomas Elsaesser, "has become the very signifier of the inauthentic."[2] The rising importance and influence of social memory, moreover, has coincided with a widespread cultural desire to reexperience the past in material, sensuous ways, a drive that has been augmented by the mass media and the expanding reach of experiential museums and historical theme parks. With cinema and television increasingly drawn to historical subjects—examples include the advent of the History Channel on cable and the wide-screen success of films such as *Braveheart* and *Schindler's List*—

and with the growing popularity of experiential museums and historical reenactments—as exemplified by the Holocaust Museum and the recent D-Day celebrations—the cultural desire to reexperience the past in a sensuous form has become an important, perhaps decisive, factor in the struggle to lay claim to what and how the nation remembers.

Walter Benjamin, in his famous artwork essay, describes the desire of the masses to bring things close, to experience in a palpable, tangible way a relationship with objects and artifacts formerly venerated from afar.[3] In my view, the contemporary desire to reexperience history in a sensuous way speaks to an analogous desire to dispel the aura of the past as object of professional historical contemplation and to restore it to the realm of affective experience in a form that is comparable to sensual memory. The emergence of mass cultural technologies of memory, moreover, provides vivid experiences of the past that can shape and inform subjectivity. One writer has coined the striking term "prosthetic memory" to describe the way mass cultural technologies of memory enable individuals to experience, as if they were memories, events through which they themselves did not live; the new modes of experience, sensation, and history that are made available by American mass culture, writes Alison Landsberg, "have profoundly altered the individual's relationship to both their own memories and to the archive of collective cultural memories." Defining prosthetic memory as "memories that circulate publicly, that are not organically based, but that are nonetheless experienced with one's own body," she argues that prosthetic memories, especially those afforded by the cinema, "become part of one's personal archive of experience."[4] Citing psychological investigations from the 1930s on "emotional possession" as well as works by Siegfried Kracauer and Steven Schaviro on the relation between film and somatic response, Landsberg maintains that "the experience within the movie theater and the memories that the cinema affords—despite the fact that the spectator did not live through them—might be as significant in constructing, or deconstructing, the spectator's identity as any experience that s/he actually lived through."[5] Although the production and dissemination of memories that are defined not by organic, individual experience but by simulation and reenactment are potentially dangerous, posing the threat of alienation and revisionism, prosthetic memories also enable a sensuous engagement with past lives and past experiences that, Landsberg argues, can serve as "the basis for mediated collective identification."[6]

Memory and National Identity

The pervasive cultural desire to revivify the past through technologies and narratives of memory, moreover, may also be related to the contemporary crisis in national identity pervading late-twentieth-century American culture. At a moment of sweeping national redefinition such as the present, social memory and its technological variants may take on increased importance in the management of national identification, particularly when the national past harbors traumatic social experiences that have not been assimilated or integrated into the overall narrative of nation. As Elsaesser writes:

> What of the memory of events which live in the culture because of the images they have left, etched on our retinas, too painful to recall, too disturbing not to remember? "Do you remember the day Kennedy was shot?" really means "Do you remember the day you watched Kennedy being shot all day on television?" No longer is storytelling the culture's meaning-making response; an activity closer to therapeutic practice has taken over, with acts of re-telling, remembering, and repeating all pointing in the direction of obsession, fantasy, trauma.[7]

Elsaesser's example is a good illustration of the concept of prosthetic or mediated memory: even though the Zapruder film that he refers to was first shown to the public years after the assassination, it has become synonymous with the cultural memory of the event. Our individual and collective memories have been reconfigured by the Zapruder film; we imagine that it was part of our experience—we "remember" seeing the film when we "remember" our experience of the assassination. As this example indicates, film and media in the contemporary period have directly intervened in the cultural work of defining national memory, playing a key role in articulating and shaping the national viewpoint and debate around issues and events that have proven to be resistant to the larger projects of national construction and narrativization.

In this chapter, I consider the film *Forrest Gump* and its representation of the historical traumas of the 1960s as an example of the current preeminence of memory in the construction of concepts of nation and national belonging. In this film, the textuality of nation is expressed through memory; memory is thematized as the connective tissue that binds the lives of the characters to the narrative of nation, as

the webwork that supplies the forms and sites of identification that are essential to the emotions of national belonging. The film places in relief the power of memory and narratives of memory to create subjective connections to the national past, to call forth the sense of "I" and "we" that makes the national narrative compelling and meaningful. Moreover, it does so in a way that employs digital technology to "master" the past by "remastering" archival material, grafting the figure of the main character into historical film and television footage. But the positive value that the film accords memory as the modality of connection and belonging depends on a radical turning away from the historical register, understood as the broad spectrum of public events outside the archive of personal experience. The film conveys the message that history, seen in terms of public events and political conflicts, has somehow become disconnected from the authentic texture of national life, that it is detached from, rather than constitutive of, the narrative of nation.

In foregrounding memory as the connective tissue of nation, *Forrest Gump* appears to emphasize memory chiefly in order to construct an image of nation that can exist apart from, or float free of, the historical traumas of the 1960s and 1970s. The guileless hero, Gump, who comes across as a kind of national saint, narrates his own story in a way that emphasizes certain zones of social and cultural coherence within the deeply fractious social reality of the period, reordering the past in such a way that the political and social ruptures of the sixties can be reclaimed as sites of national identification. The film can thus be seen as an apparatus of memory that functions precisely like a pros-

thesis, supplementing or even replacing organic memory, which in the context of the sixties might be characterized as dysfunctional—cultural memories that in their organic form cannot be integrated into the larger projects of nation, that have been exceptionally difficult to assimilate. Social memory in *Forrest Gump* is in effect refunctioned in a way that allows it to be integrated into the traditional narrative of nation, producing an image of social consensus built around memory. What is sacrificed in this version of the national past, however, is the possibility of national identification built around history, understood, in the words of one writer, as the "chronicle of events driven by ideas that people have paid for with sacrifice."[8]

In using the concept of prosthetic memory, I depart from Landsberg's approach in one key respect: it is my argument that, rather than viewing prosthetic memory in the positive sense of creating an interface with "past lives, past experiences, past bodies" so as to ground individual subjectivities "in a world of experiences larger than one's own modal subjectivity,"[9] *Forrest Gump* revises existing cultural memory in such a way that it becomes prosthetically enhanced. Organic memory is refunctioned and redefined in *Forrest Gump* through mass media technology so as to produce an improved image of nation, at once potent, coherent, and "of the people"—a virtual nation in which the positive elements of national identification are segregated from the historical actions undertaken in its name. As Tom Conley aptly describes it, the project of national reclamation undertaken by *Forrest Gump* depends on the film's "wiping the slate clean of female presence" and on erasing the national canvas of social and, particularly, racial antagonism.[10] The film sets forth a narrative of memory whose transparent purpose seems to be that of "managing" the national traumas, the crises in national identity, that defined the sixties and seventies and that continue to trouble the nation's self-image.

Forrest Gump, the character, resembles nothing so much as the tattooed man of the Ray Bradbury story, a corporeal surface inscribed with the memory traces of a nation desperate to remake itself in the image of its remembered popular culture. Although history happens all around the character Gump—indeed, his life is shaped by it—his character seems impervious to the historical events that erupt in his immediate proximity. In the film *Forrest Gump*, nation is defined apart from history as a realm of mass cultural artifacts and experiences that are essentially detached from the traumas of the sixties and seventies. Al-

though the period the film covers was one of the most divided and violent periods in the nation's history, the film gives its eponymous character the recuperative function of drawing from popular memory the filaments of a different past, a past defined by popular culture and mass media stereotypes, and implies that this past is in some ways more authentic, more in tune with the life of the people, than that of public history.

In evoking memory, however, as the register of national belonging, the film simultaneously erases many of the historical events that continue to trouble the national narrative. The national trauma of slavery and its aftermath, for example, is evoked in the beginning of the film as the source for Forrest Gump's name. As his first interlocutor, a black woman, sits on the bus stop bench that Gump occupies, he begins narrating the story of his life, which begins with his recollection of his ancestor, the "famous Civil War general Nathan Bedford Forrest," who "started up a club called the Ku Klux Klan." As Tom Hanks's face appears in a mock period photograph and becomes animate in what appears to be archival footage of Klan members on horseback that follows, Gump talks about how the club "liked to dress up in white sheets, and act like a bunch of ghosts or spooks or something; they even put sheets on their horses." Later, the history of racial conflict that the film invokes in its opening scenes intersects with Gump's own experiences, as his image is digitally inserted into newsreel footage of the integration of the University of Alabama. As the two black students walk into the classroom building over the protests of Governor George Wallace and under the protection of federal troops, the figure of Forrest Gump appears, digitally grafted into the newsreel footage, glancing into the camera. Then, in a staged sequence, Gump picks up a book one of the black students had dropped and hands it to her. He waves to the hostile crowd, and then follows her into the schoolhouse. In the logic of the film, Gump's insertion into archival images of a defining historical moment suggests a kind of reconciliation, a healing acceptance, one prompted, however, not by an understanding of the history of racial oppression but rather by a lack of understanding, by an absence of historical knowledge. Only Gump's ignorance, or feeble-mindedness, the film appears to suggest, protects him from the scarifications of history and the resulting distortions of character that plague most of the other figures who populate the film.

Directly following newsreel footage depicting the shooting of

George Wallace, the black woman who had been listening to Gump's narration leaves, and a white woman and her young son take her place as Gump's auditors. Gump continues his narration, which now centers on his experiences in the army and in Vietnam. Here, the film invokes many of the motifs and iconography that have by now become a kind of lingua franca of Vietnam representation, chiefly in order to invert their meaning: for example, the film emphasizes the interracial friendship of Gump and the black infantryman Bubba, reversing the standard imagery of racial hostility and segregation in Vietnam familiar from *Apocalypse Now*, *Platoon*, and other canonical texts; the film emphasizes the dedication and humanity of the commanding officer, Lieutenant Dan, ignoring the antagonism between officers and enlisted men that has become a staple of the genre; it stresses the heroism of Gump, who seems to have wandered out of a war film from the 1940s or 1950s in single-handedly rescuing most of his platoon. Signaling the trauma of Vietnam through rock music motifs such as Jimi Hendrix's recording of Bob Dylan's "All Along the Watchtower," the dramatized scenes in this part of the film are for the most part revisions of sequences from *Apocalypse Now*, *Platoon*, *Born on the Fourth of July*, and *Full Metal Jacket*. Parasitizing these films in a way that empties them of their original content, *Forrest Gump* in a sense "samples" the Vietnam genre and converts it to a different message.

The connection between war and national or counternational iden-

tification, a theme that is so thoroughly scrutinized in *Glory*, *Born on the Fourth of July*, and *Thunderheart*, is represented in *Forrest Gump* in a manner that is consistent with its rewriting of the terms of national belonging. The film explicitly alludes to *Born on the Fourth of July* in its portrait of Lieutenant Dan, who loses his legs in a firefight, and whose ancestors, like those of Corporal Wilson, the boy mistakenly shot by Ron Kovic in *Born on the Fourth of July*, "fought and died in every war this country's had." Giving a pointedly comic reading to the connection between war and nation, the film offers a montage of Lieutenant Dan's forebears, each in period military garb, each expiring on what looks like the same patch of ground. Lieutenant Dan, after being wounded in both legs and carried out of the jungle by Gump, protests that it is his destiny to die in battle, and that Gump is robbing him of his destiny. These scenes provide an almost mocking commentary on or counterpoint to *Born on the Fourth of July*, as Lieutenant Dan, like

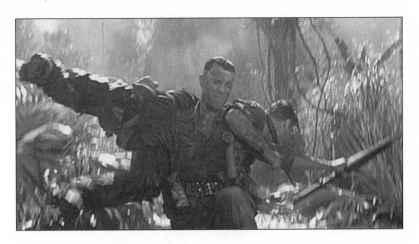

Kovic, becomes a bitter, disaffected, wheelchair-bound ex-soldier. Unlike Kovic, however, Dan is not treated sympathetically in the film; his rage is at every point set against Gump's sweet incomprehension, which paradoxically seems the more valid and authentic response: the excruciating social and personal traumas of Vietnam are in effect noted but bracketed in the film, as if they are disconnected from the text of nation.

Nation and Religion

Gump's heroism on the field of battle is similarly disconnected from any metaphoric or symbolic concept of nation. Benedict Anderson points out that the imagined community of nation is in effect a replacement or extension of older religious ideologies, and that the concept of nation shares with religion the notion of a common cause greater than the self. National identification requires a willingness to fuse self-interest and the interests of the collective to a degree that only nation and religion have traditionally commanded. In that most powerful of national symbols, the Tomb of the Unknown Soldier, religious and national modes of belief coincide, Anderson writes, for here the willingness to die for one's country meets a mystical belief in the eternal nature of the nation, the belief in a collective destiny that supersedes the claims of individual existence.[11]

In *Forrest Gump*, however, this conception of nation is satirized and rejected; the history evoked by Lieutenant Dan and his putative destiny is seen as pathological, self-destructive, and ridiculous. Gump's

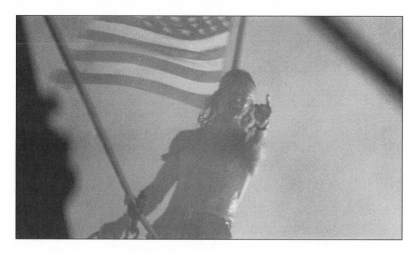

own heroism in rescuing his platoon is, in a sense, set against the script Lieutenant Dan wishes to follow: Gump claims he was simply following his sweetheart Jenny's advice—to keep on running. The fact that Gump misreads this advice in such a way as to become a war hero produces a complicated inflection of the Vietnam genre: the film rejects the war and the history it represents, but provides what may be the sole example of successful heroic action in the entire corpus of Vietnam films, thus projecting and extending a deeper narrative of nation, a narrative revolving around rescue. Later, serving as Gump's first mate on their shrimp boat, Lieutenant Dan will serve as the conduit for an explicit association of God and country, restoring the connection between nation and religion that was severed, in the view of the film, in the Vietnam War. Perched in the crow's nest during Hurricane Carmen, with the American flag whipping behind him, Dan rails against God, shouting that He "will never sink this boat." Then, after making a fortune due to the misfortune of the other shrimpers, Dan tells Gump that "I never did thank you for saving my life," and dives into a tranquil sea touched by a glowing, billowing cloud, revealing a large bumper sticker with the word "America" affixed to his wheelchair. Gump comments as Dan backstrokes contentedly in the water, "I think he made his peace with God."

Lieutenant Dan and Jenny, Gump's lifelong sweetheart, come to represent the twin avatars of a nation in peril, a nation in need of rescue. Posed opposite Lieutenant Dan on the cultural divide that defined the sixties, Jenny becomes a citizen of the counterculture; like Lieu-

tenant Dan, Jenny is rescued by Gump both from physical danger and from a corrosive self-hatred. In the world of *Forrest Gump*, the counterculture is depicted as far more vicious and self-deluded than the military, as if the collectivist and utopian sensibility that suffused countercultural ideology were only a screen for male domination and posturing. In the film's portrait of the period, Jenny's body becomes a cultural battleground, a terrain on which is projected the competing cultural tendencies of the period. Her college dreams of becoming a folksinger, for example, are realized in the form of a nude performance of "Blowin' in the Wind" in a topless bar, for which she takes the stage name "Bobbie Dylan." Her involvement in the protest movement culminates in a march on Washington with her violent and abusive boyfriend, Wesley, the head of the Berkeley chapter of SDS (Students for a Democratic Society). She emerges from the sixties to become a strung-out disco queen in the seventies. Later, she becomes a loving mother, but she has contracted a virus that will soon kill her. The alternative national consciousness that emerged in the context of the counterculture is retained only in the music the film quotes from the period, rock songs that convey an emotional depth and cultural sensibility that the film insistently counterpoints to its dramatized scenes of male posturing and female exploitation, as if to undercut both the mythology of the counterculture and the music that provided its anthems.

The film's project of revising the cultural meaning of the 1960s is perhaps best expressed in the scene following the Washington protest rally. After receiving the Medal of Honor from President Johnson, in a ceremony at which Gump, digitally inserted into television footage, obliges LBJ's request to show him his wounded buttocks, Gump happens upon a mass protest at the Washington Monument and is reunited with Jenny. As he accompanies her to the headquarters of the protest movement, he meets a group of Black Panthers and Wesley, Jenny's New Left boyfriend. The Black Panthers harangue Gump, as does Wesley, who is incensed at Jenny's claiming friendship with a "babykiller." After a short argument, he strikes her hard in the face. The camera provides an ironic counterpoint by including in these shots a well-known symbol of the period, a poster with a raised fist and the slogan, "Power to the People" emblazoned on it. The camera fixes on Gump's reaction, then repeats the blow from Wesley in slow motion. As Gump then pounces on Wesley, the raised fist of the protest poster

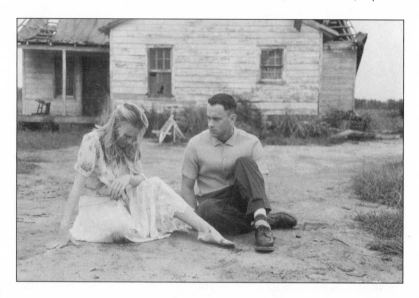

is toppled and upended as Gump delivers several powerful punches. Here, the meaning of the poster is explicitly inverted: the symbolic fist becomes a real fist, directed at the most visible representative of the protest movement the film chooses to give us. The scene plays as a long-deferred rearguard reaction to the myths and rhetoric of the sixties, in which violence, in the film's reading of the period, appears to be the province of the counterculture, whose representatives wield, at various points, guns, billyclubs, and fists—in addition to peace signs and guitars—a perspective that substantially reorders the signs and meanings that have up to now defined the period.

History thus enters and marks the lives of Jenny and Lieutenant Dan, who together, as a kind of combined object, embody the loss of ideals, the loss of innocence, and the profound experience of spiritual and physical damage that the film associates with the national drama of the sixties. Untouched by history, Gump becomes an explicitly redemptive figure, a being who can address an antiwar rally on the way home from a ceremony awarding him the Medal of Honor, who defends Jenny and instills a sense of self-worth in Lieutenant Dan, who makes a fortune as a shrimp boat captain and showers wealth on the black community of shrimpers. The atomized qualities of an idealized national identity are consolidated in Gump, who is above all a figure of idealized continuity and connection, a figure who in the fantasy of-

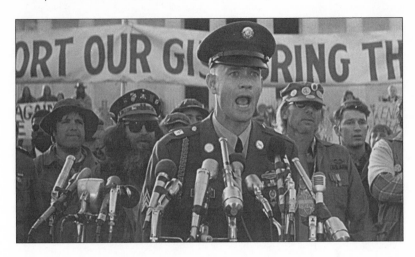

fered by the film sutures the divided zones of American culture, inter-calating black and white (the seafood company he founds is called "Bubba-Gump"), rural and urban (he becomes partners with Lieu-tenant Dan, a New Yorker), East and West, and who defines new zones of social coherence through his accidental influence on such disparate cultural icons as Elvis Presley and John Lennon.

As the national traumas continue to mount in the film's portrait of the period—the assassinations of the Kennedys, drugs, natural disas-ters, Watergate, AIDS—the character of Gump becomes a kind of alle-gorical figure of nation understood as an ideal, a holy innocent who wanders through 1960s and 1970s America erasing the sins of the his-torical past. At one point, Gump becomes a quasi-messiah whose fol-lowers believe that his running across America, several times over, ar-ticulates something of deep meaning and importance. As he strides past the barber shop in his hometown at the beginning of his mara-thon, we hear the ubiquitous television announce, "President Carter, suffering from heat exhaustion, collapsed in the arms . . ." After three years of continuous motion, running between sea and shining sea, Gump finds himself in Monument Valley, trailed by a group of disci-ples whom he has never addressed. Here, inscribed in a landscape that stands as a synecdoche for America, its fusion of narratives of progress and territorial conquest, and the projection of its mythology in films and advertising, Gump decides to stop running, as if to say the heroic narrative in which that landscape figures so large, the territorial imagi-nary that underpins the American narrative, had run its course. As

Gump's followers express frustration and confusion about what to do next, Gump decides to go home, a moment that seems to expunge the history of conquest and its theological alibi of providential guidance—themes that are encapsulated in the image of the prophet Gump in Monument Valley—in a personal epiphany of self-acceptance and self-healing. When he returns to his home, however, the film evokes, once again, the violence that seems to infect the public sphere, immediately announcing via another television broadcast the attempted assassination of President Reagan, thus bookending Gump's national pilgrimage with references to public events that seem entirely disconnected from the text of nation that has just unfolded beneath Gump's well-worn Nikes.

Redefining the Sixties

At this point in the film, Gump departs from the historical stage: his reunion with Jenny, their wedding ceremony, her death from an AIDS-like virus, and his quiet life with their son, Forrest, bring the film to its conclusion. What is interesting about this conclusion is what it implies about the cultural and social aftereffects of the sixties and seventies. In this counternarrative of the period, the women's movement, the civil rights movement, and the antiwar movement appear to be superseded in cultural significance by Gump-inspired innovations such as the "Shit Happens" bumper sticker, the smiley-face button, and the slogan "Have a nice day." The film ends with Gump describing to Jenny his life with young Forrest while standing over her frontier-style grave, as a flock of birds rise up from the fields in a kind of totemic recollection of her lifelong desire to become a bird so she could escape the miseries of her life. With the slate "wiped clean" of female presence, of racial others, and of social discord, the period can, in effect, be retrofitted to an emergent narrative of white male regeneration.

The reinscription and displacement of history in *Forrest Gump* memorializes certain aspects of the national past while creating critical amnesia in others. Its citations of public history are consistently juxtaposed to moments of personal crisis or renewal in ways that tend to displace the history evoked. For example, as a television newscast informs us that Squeaky Fromm has tried to shoot President Ford, a radio message comes through on Gump's boat to tell him that his mother is sick. Later, directly after Gump returns from his three-year marathon, we hear a news broadcast concerning the shooting of Presi-

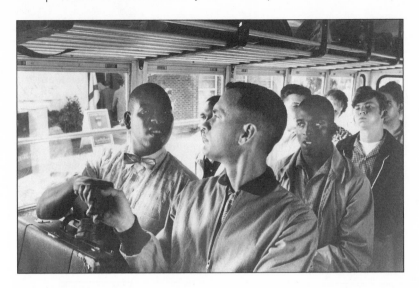

dent Reagan, a moment that is eclipsed in importance by the letter from Jenny that Gump reads seconds later. Throughout the film, public history is depicted as the register of social unrest and political violence, a register that is essentially detached from the imagined community of nation.

In a sympathetic reading of the film, Vivian Sobchack writes that *Forrest Gump* invokes history as a form of paradox, marking a sharp distinction between the personal and the historical only in order to collapse this distinction and to conflate the personal and the historical, the trivial and the significant: "The complexity of diverse individual trajectories and their nodal coalescence in the massive 'historical events' we see foregrounded as the film's background are . . . undermined by the visible evidence that 'History' is the concatenated and reified effect of incoherent motives and chance convergences. . . . The temporally inflated notion of something we might once have called 'the historical event' is deflated and its specificity reduced to generalized matter." Sobchack argues that the film provides an especially acute rendering of divided cultural attitudes about history, a "symptom and gloss upon" a contemporary moment in which history, and historical consciousness, has been said to be "at an end," while at the same time becoming the object of unprecedented public interest and debate. "While one can certainly argue its marking the dissolution and 'end' of history . . . *Forrest Gump* can be argued also as marking . . . a new and pervasive self-

consciousness about individual and social existence as an 'historical subject.'"[12]

Where Sobchack sees the film as engaging with the question of the role and importance of history in contemporary consciousness, I see *Forrest Gump* as framing a different set of cultural concerns revolving around national identity and the meaning and place of the sixties and seventies in national life. In a period in which the sixties have been startlingly reconfigured by some scholars as the source for the successful right-wing activism of the eighties and nineties,[13] *Forrest Gump* conveys in a singularly effective way the power of mediated memory to reorganize the historical past. In this case, it appears that the film evokes the cultural encyclopedia of the sixties and seventies chiefly in order to construct a virtual nation whose historical debts have all been forgiven and whose disabilities have been corrected. Although the film succeeds in defining broad zones of social coherence within a splintered national community through appeals to memory, it consigns to oblivion the most significant memory of all, the memory of historical agency that is the most enduring legacy of the sixties.

6 | The Columbian Exchange: Pocahontas and *The New World*

Among the deepest and most indelible fictions of American national origin is the notion of the "new world" encountered by the earliest English colonists—a world typically characterized as a dense wilderness populated by "children of the forest" and untouched by the hand of any culture. Forming the backdrop of almost all subsequent narratives of nation, this idealized image of America as an unblemished garden and as a virgin land constitutes a rich trompe l'oeil landscape, an imaginary locale designed to convey a story of emergence that is also constructed as a story of return. As the environmental historian Alfred Crosby writes about what is now known as the Columbian Exchange, "The two worlds, which God had cast asunder, were reunited, and the two worlds, which were so very different, began on that day to become alike."[1] Perhaps the most dramatic subplot in this drama of origins is the legendary rescue of John Smith by Pocahontas, an event that has been credited with saving the settlement of Jamestown from certain destruction. A story of interracial romance and mutual exchange, the history of the first English colony in America has been shaped by a myth of organic union, symbolized and expressed through the protagonists of the narrative, avatars of the Old World and the New.

In the contemporary period, however, a different story has emerged about the world-altering encounter of the Virginia Company and the powerful Algonquian chief Powhatan in Jamestown in 1607, a story

that highlights the transformation of the environment, the ecological shifts, and the social changes the colony brought about. The history of the first permanent English settlement, long celebrated for establishing representative government in English America and repudiated for introducing slavery in the English colonies, is now understood as inaugurating the destruction of a native empire and initiating the creation of a whole new ecosystem. As one author writes, "For English America, Jamestown was the opening salvo in the Columbian exchange. In biological terms, it marked the point when before turns into after."[2]

Taking the myth of national origin at its most nascent point, Terence Malick's *The New World* both challenges and reinforces the traditional story of the encounter, depicting it as both harrowing and full of utopian possibility, presenting the narrative as a tone poem of contrasting and dissonant parts. On the one hand, it amplifies the erotic and emotional bond between Smith and Pocahontas, conveying a tantalizing possible world of interlayered consciousness, interwoven cultures and natures with merging differences rendered through dual interior monologues and flowing associative images connected by a gliding, drifting camera. On the other hand, it portrays the founding of Jamestown as an environmental disaster, providing an eco-critical reading of the history of the earliest colony. The violence and perversity of the settlers makes them appear to be a malignant species—an invasive, alien life-form that simply does not belong in the Edenic world of precolonial North America. Deforming the landscape with borders and fortifications, denuding the land around them of all trees and grasses, burning the Indians out of their villages in order to plant tobacco—the settlers degrade the ecology of forest and marshland, and in the process degrade their own subjectivities and culture, resorting to murder and cannibalism, indulging in sadistic tortures, and abandoning their children.

In this essay, I argue that *The New World* reorients the settlement story of Jamestown, one of the foundational myths of nation, in a way that effectively defamiliarizes the viewer's experience of place, history, and identity. The film folds together the fictional romance of Smith and Pocahontas with the historically documented story of Jamestown, structuring the narration and the focalizing perspective around these two characters, and later around the figures of John Rolfe and Pocahontas, who become husband and wife. A radical experiment in narrative form,

the film can be considered a form of historical "revisioning," as Robert Rosenstone describes the process of re-imagining the historical past.[3] It portrays history both in terms of the "inside" and in terms of the "otherness" of historical events, presenting the interior lives of the characters, their fragmentary thoughts and reflections, while at the same time emphasizing the "otherness" of the historical past, underlining its remoteness, its strangeness, its distance from the present. In these two different approaches—close reenactment combined with techniques of defamiliarization—the film can be compared to what Paul Ricouer describes as historiography under the sign of the "same," as well as historiography under the sign of the "other."[4]

The film portrays its principal characters through interlocking voice-overs and expressive camera work that gives a poetic rendering of the subjective lives of the historical agents. Malick's film seems to illustrate Ricouer's summary of Collingwood: "the historian is the one who is obliged 'to think himself into the action, to discern the thought of its agent.'"[5] On the other hand, the extraordinary "otherness" and mystery of Native American life in the early 1600s is portrayed in vivid detail. The face and body painting of the warriors, for example, appears as complex and unreadable as the facial arabesques of the Caduveo in Claude Lévi-Strauss's description of the Amazon tribe; the bizarre, primal gestures and whoops of the men seem infantile yet simultaneously ferocious; and the frightening depths of animistic superstition permeating native culture are transferred, as if through sympathetic magic, to Malick's shots of landscape, animals, and sky.[6] The Native life-world registers as incomprehensible and utterly alien to contemporary modes of thought. With Pocahontas serving as the focalizing lens through which we see the founding of Jamestown, however, the film also succeeds in alienating the familiar, now cliched styles of sixteenth-century English custom by making them appear as strange and unfathomable as the culture of the Indians. The bizarre clothing of the settlers, with their armor and their starched ruffs; the effort they make to build fixed fortifications while continuing to sleep in barely-covered ditches inside the walls; the dark threats of mutiny that hang over every interpersonal exchange—the culture and society of the settlers seem like grotesque distortions of authentic human nature. Here the film seems to illustrate the other side of Ricouer's argument, the taking of a distance toward

the past, avoiding empathy: "a spiritual decentering practiced by those historians most concerned with repudiating the Western ethnocentrism of traditional history."[7] To borrow an image used by Benedict Anderson in a different context, we view the first English colony in America both from near and from afar, as if from the right and the wrong ends of a telescope.[8]

In a recent book Tom Conley writes, "A film, like a topographic projection, can be understood as an image that locates and patterns the imagination of it spectators. When it takes hold, a film encourages its public to think of the world in concert with its own articulation of space . . . a map in a movie begs and baits us to ponder the fact that who we are . . . depends, whether or not our locus is fixed or moving, on often unconscious perceptions about where we come from and where we may be going."[9] Films, like maps, are forms of locational machinery— we "lose" ourselves in films, which then serve to reorient us in their own space and time. The cartographic project of *The New World,* heralded by the rich sixteenth-century maps that adorn the opening credits, serves not only to reorient the viewer, but also to suggest a way of reorienting the national story.

The Columbian Exchange

One way of describing this reorientation is to situate it within the large ecological and geographical narrative now known as the Columbian Exchange. The movement of peoples, plants, insects, and animals between the European, Asian, and American continents that began with the voyage of Columbus is now considered one of the most important events in the history of life. Once unified in the landmass known as Pangaea, life on earth was sundered into two distinct halves when the original, singular land mass broke apart. After the separation, animal, plant, and insect species evolved in radically different ways. With the Columbian Exchange, these ecosystems were brought back together. As Crosby writes, "The connection between the Old and New worlds, which for more than ten millennia had been no more than a tenuous thing of Viking voyages, drifting fishermen, and shadowy contacts via Polynesia, became on the twelfth day of October 1492 a bond as significant as the Bering land bridge had once been."[10] The end result of the exchange has been to "reknit the torn seams of Pangaea."[11]

Malick's film explores the promise in Crosby's sentences mainly by way of the intense erotic rapture of Pocahontas and Smith. Their love story, as powerful as any in the cinema, seems to capture the description of the vocation of the cinema given by the Surrealist, Robert Desnos: "Their flesh becomes more real than living people's, and while they move on screen towards an irrevocable destiny they are taking part, for the sensitive spectator, in some more miraculous adventure."[12]

In contrast, the establishing of the colony unfolds as a hallucinatory nightmare, the germinal expression of the ecological imperialism that would soon follow. The initial shot of the colonists' wary transit through the landscape illustrates this well: it begins with a drifting camera depicting a tall green field of grass, almost humanly expressive in its waiting stillness. The hypnotic mood is broken as the edge of the frame is invaded by a large iron axe, followed by a group of fully-armored men slowly advancing. The first order given by the head of the Virginia Company is to clear the area of every tree. The mud, filth, and utter squalor that results gives the Jamestown fortification a pestilential appearance, and is set in sharp contrast to the woodland setting of Powhatan's encampment upriver.

In general outline, the formal and narrative conventions of the historical film adhere to a teleological structure in which the whole is visible in all of the parts, and where events and actions move in coordinated fashion toward a defined end point. As such, the structure of historical filmmaking has much in common with mapmaking. As Conley writes, "the history of cartography is marked by the appropriation, control, and administration of power . . . a film is a map, and [its] symbolic and political effectiveness is a function of its identity as a cartographic diagram."[13]

The New World, however, is far from a linear history framed by narrative devices of agency and event, cause and effect. Its innovative patterns of narration and focalization, of plot development and ellipsis, of temporal dilation and compression deviate from the straightforward dramatic unfolding typical of cinematic narrative. Rather, it seems closer to the style of narration described by Juri Tynianov as poetic, jumping narration, with one shot replacing the other: "shots in cinema do not 'unfold' in a successive formation, a gradual order, they replace one another, as a single verse . . . is replaced by another."[14] The

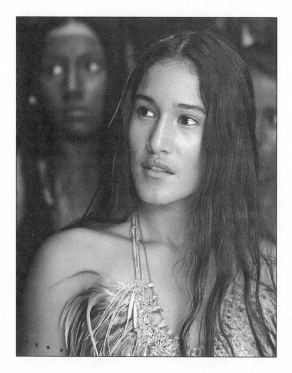

film alternates among multiple perspectives; interior monologues convey the subjective thoughts of at least four different characters, sometimes in close, almost overlapping lines. Moreover, an explicit authorial commentary emerges in the way images are arranged in counterpoint to character dialogue, in the close-up treatment of the soundscape of the natural world, and in the music, which is by turns majestic and poignant. *The New World* emphasizes the sensual, almost vertiginous experience of seeing a familiar geography with new eyes.

Without an obvious overarching perspective, distinct plot lines, or clearly etched protagonists and antagonists, the historical project of *The New World* communicates a sense of the overwhelming impact of an encounter. The absence of conventional formal and narrative patterning plunges the viewer into an experience of "otherness," a dislodging of expectation that extends to individual shots and shot sequences. The film's disorienting effect, the new sensorium it reveals, suspends the mental geography of the spectator. As Conley eloquently writes, "We find ourselves immediately undone by the weightless fact that we

have no reason to be where we are. The giddy and unsettling effects of watching and studying cinema may indeed have to do with the way the medium brings forward and summons issues of mental geography."[15]

The film illustrates these points in an emblematic way, beginning with the opening credit sequence. In a visually stunning overlay, the parchment maps of the period are first displayed in dun and umber shades, with only vague, ambiguous traces describing the land and river features of the interior. As the credits advance, the maps become progressively animated, rivers fill in with blue color, butterflies and dragonflies move over the surface, and flowers and vines grow to frame the camera's view. The map seems to come to life, as the topography becomes more and more detailed. The new world as imagined in the sixteenth-century is animated under the camera's gaze, with its gliding trajectory progressively bringing color, movement, and three dimensions to the flat, beige expanse of the chart. In its beauty and mode of presentation, the opening credit sequence looks like the images seen in the precinematic age of moving slide shows and stereopticons.

First Contact

The film begins, however, prior to the credit sequence. Opening with a motif familiar to readers of classical epic literature, the first image of the film is accompanied by an invocation. As the camera frames on a pool of water reflecting sky and clouds, a young female is heard in voice-off, asking for guidance: "Come Spirit, help us sing the story of our land. You are our mother, we the field of corn. We rise from the soul of you." The camera then cuts to a low angle shot of Pocahontas standing thigh deep in water, lifting her hands to the sky. The act of summoning a spirit to guide the telling of the story recalls the tradition of epic poetry; Homer's *Odyssey*, for example, begins with the invocation, "Sing in me, Muse, and through me tell the story of that man."[16] Here, the invocation communicates a sense of world almost forgotten in contemporary discourse, a glowing world overflowing with benevolence, a pantheistic universe.

As the credits fade, Pocahontas is seen swimming with other Indians in a fluid underwater shot, where water, light, fish, and human forms commingle. A sense of weightless, amniotic pleasure permeates the sequence. After several moments, the camera tilts toward the surface of

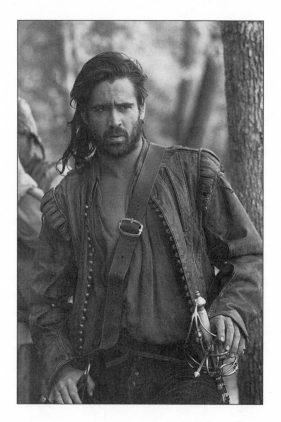

the water, where from beneath the stream we see a small group of Indians pointing excitedly out to sea.

A transition shot framed on the water from above brings the approach of three tall ships into view, marking the beginning of the historical narrative. Several long and medium shots, accompanied by a towering orchestral motif, convey the ships' rapid movement toward the land. A graphic title appears that tells us this is Virginia, 1607.

In striking contrast to the introduction of Pocahontas, Captain John Smith is first seen in heavy chains, imprisoned in the hold of one of the ships as it approaches the shore. Looking through an opening in the ship's hull, the sight of forested land seems to connect him with Pocahontas and the aura of enchantment that surrounds her. Despite the heavy chains, Smith lifts his hands to catch the thin stream of fresh water that falls into the hold, a gesture that rhymes with Pocahontas's graceful and balletic hand movements.

Throughout the opening scenes, Smith remains mute and enigmatic, a figure whose motives, offense, and character are difficult to discern. Smith's first interior monologue is revealing, however, as he describes the Indians and the land. Walking alone through the fields and forests, he observes that here "we will make a fresh start; nature's bounty is bestowed on all. Here there is no need to grow poor. No cause but one's labor."

This is immediately contradicted, however, by the following scene, in which the desperation of the colonists is made plain. Forced to try another tack by the colonists' hunger, the failure of crops, and the spoiling of stores, the president of the Virginia Company decides to return to England to bring fresh supplies and additional manpower to Jamestown. He takes the anchors and sails of the other ships with him, just in case anyone else had the notion to escape. Although the president of the group was a civilian appointed by the venture capitalists who formed the Virginia Company, he appears to have absolute authority over the colonists, a rag-tag group with only one man possessing any military experience. That man, Captain John Smith, is ordered by the president to travel upriver with a small band of men to try bargaining with the great chief Powhatan, whose reputation is known to the company. This task is made difficult by the fact that one Indian has been killed in the fort, and two others taken captive. "We have," as Smith says, "lost the favor of the naturals."

With the two captive Indians as guides, Smith quickly loses himself and his men in a marshland, and is captured, alone, by Powhatan Indians. The fate of his men is never disclosed. The natives triumphantly march him to chief Powhatan, pushing him through the large, well kept village of Werowocomoco—"where the chief dwells"—to an enormous longhouse occupied by the chief. Smith manages to communicate that the colonists cannot leave until spring, when the ships return from England. Powhatan silently orders Smith to be killed, at which point the screen goes black. We find out later, in Smith's voice over, that "at the moment I was to be killed, she threw herself upon me."

Although never visualized in the film, Pocahontas's dramatic and risky gesture and her special relationship with her father, Powhatan, spares Smith's life. In a remarkable scene that immediately follows, Smith is pictured supine on the floor of the longhouse, surrounded by chanting women. Visually similar to a revival meeting, with the laying

on of hands and loud vocal soliciting of the spirit within, the ritual climaxes with a shower of fine seeds being flung into air, and Smith being born aloft out of the longhouse. A form of baptism or cleansing of the spirit, the sequence is vivid and almost frightening. Smith has come within moments of being executed by the natives. One recalls that he was within moments of being executed by the colonists as well, the noose nearly fixed around his neck before the president of the Virginia Company pardons him. Powhatan decides to let Smith live and stay with the Indians until spring, with the understanding that he will teach Pocahontas about the ways of the people across the sea.

In the following scenes, Smith and Pocahontas are drawn to each other in a way that is exceptionally lyrical, the camera performing graceful veronicas around them as they exchange certain words, "sky," "sun," "water," and "eyes," "lips," "ears," in a way that gives their intimate exchanges the beauty and delicacy of a Gauguin painting. The first contact between Smith and Pocahontas plays into a long ethnographic tradition of first contacts, and despite its beauty and tenderness, it is fraught with the foreknowledge of what will come. Pocahontas brushes her fingers along Smith's eyes, lips, and ears. Self-consciously aware of what this communication with the "other" signifies, he looks deeply at her, and then nervously away, draws his gaze back to her, and then checks his surroundings to see the effect their exchange is having on the natives. After one particularly poetic exchange, where Pocahontas seems to pass the breath from her mouth into her hand to give it to Smith, a gesture she repeats, she is shown lying on the green grass, turned away from Smith, her breath coming quickly.

The Garden

The elegiac and moving love scenes between Smith and Pocahontas are set in a world devoid of strife and hardship, a mythical world of perfect beauty that fits the highly imaginative retelling Malick offers. The rescue of Smith by Pocahontas and the romance that follows almost certainly did not occur. The celebrated status of this myth of interracial romance may function like a cultural screen memory, concealing or displacing the near genocide of the native population that would occur in the years to come. Historians agree that Smith's stories about Pocahontas's role in his survival were likely fictitious. For one, Pocahontas would have been eleven years old at the time. And for another, Smith's earliest account of his capture did not refer to Pocahontas and did not mention a rescue. Later, in 1624, Smith published his story and appears to have embellished the narrative. As one commentator says, "being saved from death by a lady's intervention was a favorite motif in Smith's tales."[17]

In the portrayal of the Powhatan Indians, however, *The New World* provides a factual, useful reminder of the quality and character of life before colonization. Powhatan had established an empire among the Algonquians, with 14,000 Indians under his command in a chiefdom that extended 8,000 square miles. His village of Werowocomoco, a

site long regarded as a sacred place, supported some 100 Natives. The equilibrium that prevailed among the Indians, and the balance they had established with the natural world, made this a kind of golden age, a point that Malick emphasizes in his portrayal of village life. This depiction is in keeping with contemporary writings of the time describing the Indians as perfectly content, living in friendship with one another.

Utterly confident, fully in command of their universe, the Algonquian seem to welcome Smith into their midst. He is quickly integrated into the tribe, learning their agriculture, their fishing and fighting techniques, and their style of social interaction. The Edenic setting, with its natural expanses within the towering forest, and the portrayal of a population in which everyone seems to be physically graceful and strong, offers a poignant impression of a world that is complete. Images of corn being harvested, fish being trapped and speared, tobacco being dried, and pearls being harvested remind the spectator that eastern North America in the years before the colonies took hold was, in the words of one writer, "one of the world's most productive breadbaskets."[18]

The devastation to the North American Indian population after contact was staggering. Recent estimates place the Indian population in eastern North America in 1500 at just over a million, although some scholars believe the number could be twice as high. By 1650, the Indian population numbered only 379,000. Sixty percent of the Indian population in the Northeast was wiped out within 50 years of the settlement of Jamestown. The numbers for North and South America together are even higher. Between 1492 and 1650 the indigenous population fell by an estimated 90 percent.[19] Plagued by epidemics, by changes in the eco-system brought on by the importation of alien species, and by encroachment, the Indian world was destroyed with a rapidity and ferociousness that was almost an extinction. By 1800, only an estimated 178,000 Indians lived in eastern North America.

Damnation

The traumatic scenes that meet Smith when he is marched back to Jamestown in the early spring are like images painted by Goya: men driven mad with hunger and disease; children with no one to care for them; a report of a man who sleeps with the arm of his murdered wife

in order to gnaw at its flesh (a true account, according to a historical eyewitness); another man, moments after his death, has his hands secretly cut off. The violence and chaos that greets Smith is accompanied by the loud ranting of a demented Jeremiah, by the squabbling aggression of the children, and by the mud and filth throughout. The contrast between the garden-like setting of Werowocomoco and the squalor of Jamestown produces an almost biblical sense of a fallen world, of "damnation," as Smith calls it.

Convinced that gold and silver could be found in Virginia, the colonists failed to provide even the most meager subsistence for themselves. The English had planned to trade for food, rather than grow it, but eastern North America in 1607 had experienced a prolonged drought, and the Indians were not eager to part with their stores of food. In the film, however, the near failure of the colony is attributed mainly to the madness and incompetence of the colonists during Smith's absence, expressed most vividly in a frightening scene of men frantically digging into the barren earth with rabid ferocity for the gold they are convinced is hidden there.

The Virginia Company is depicted in the first years of its existence as a deeply pathological enterprise. The destruction of the land, the taste among the men for vicious punishments, the violence and the

killing all provide a picture of the first English colony that is compara-
ble to the most nightmarish scenes from the growing filmic literature on
colonial dissolution. Films such as *Aguirre, The Wrath of God, Fitzcar-
raldo, Apocalypse Now,* and others take from history an iconography
familiar to the horror film: a collection of heads, a marooned raft with
an insane father and two virginal daughters, a grim fortress populated
by cannibals and madmen. One historical eyewitness account describes
Jamestown in 1610 vividly: the colonists were dining on "dogs, cats,
rats, and mice," as well as the "starch from their Elizabethan ruffs,
which could be cooked into a kind of porridge." The film shows the
colonists boiling their thick leather belts and eating them. Some starv-
ing colonists "dig up dead corpse[s] out of graves to eat them." And
one man murdered his pregnant wife and "salted her for his food."[20]

By January 1608, only 38 of the original 104 colonists were still
alive. A visit from Pocahontas in the middle of the winter, bearing gifts
of food, gives the colony new life and a glimmer of grace. The radiant
presence of the young woman the colonists call "Princess" restores the
men to a courtly mode of behavior—bowing, deferential, and cour-
teous. Meeting with Smith, she tries to remind him of their love for
each other: "Remember?" with a gesture towards their lips. His words
to her are full of portents and warnings: "Don't trust me. You don't
know who I am." "Don't put yourself in danger." "You don't need to
do anything more for us." Later, Smith calls her "My true light; my
American." Pocahontas gives the colonists the seed for corn, and in the
summer, the corn crop begins to flourish.

The cornucopia that was North America is symbolized by Pocahon-
tas's visit; the pumpkins, game, and baskets of food she brings to Jame-
stown, along with the beautiful clothing of skins and furs she wears and
the healthy athleticism of all the Natives, places in bold relief the real
bounty to be found in America. Virginia will soon become England's
first overseas farm, as the colonists discover the agricultural resources
of the land. Freedom from hunger was the promise of the Americas for
the Europeans, far outweighing, for most people, the vaunted political
freedoms—the freedom of religion and the right to political represen-
tation that has dominated the mythology of the colonies. As Crosby
writes, "The peasants . . . may or may not have pined after political
and religious freedoms, but they certainly yearned after freedom from

hunger. Famine and fear of famine had been constants in the lives of their ancestors, time out of mind."[21] By feeding the starving colonists at their most desperate hour of the colony's first winter, Pocahontas comes to embody the promise of the New World itself.

Creating a New World

"Eden lies about us still. We have escaped the Old World and its bondage. Let us make a new beginning, and create a fresh example for humanity." The words of the president of the Virginia Company upon his return from England are starkly contradicted by the mise en scene, which emphasizes the standing water, mud, and the dejected postures of the colonists as he speaks. "God has given us a Promised Land. And let no man turn against God. Let us prepare a land where a man may rise to his true stature." Implied in his speech is the idea that the land is in some sense empty, vacant of human presence, untouched. In fact, the landscape as one writer says "was touched, and sometimes heavily."[22] Another writer describes the pre-conquest landscape as "a thoroughly edited text, that already contains lessons for survival."[23] The idea that the English were settlers of land that was unsettled before they arrived is part of the myth of America as virgin land; in fact, the three English ships that set ashore in a place already cleared by the Indians landed in the "middle of a small but rapidly expanding Indian empire called Tsenacomoco."[24]

The full impact of the concept of America as an unedited, pristine landscape becomes apparent very quickly in the film: directly after Smith leaves for further exploration in search of a passage to the Indies, the Natives are burned out of their homes and villages. Following closely on the president of the Virginia Company's speech about the "Promised Land," the Indians are pictured hurriedly carrying their children, their pottery bowls, and their sleeping skins away from the burning village. They confusedly wander wondering where to go in the smoke choked landscape, among the darkened and unrecognizable corn fields, which had stretched for 1,000 acres. Powhatan is seen in the longhouse tomb of his ancestors, praying for guidance, until the smoke forces him to leave.

The purpose of the burning out of the chief's village was to clear land for tobacco, a crop that required vast tracts of land because it exhausted the soil. Rather than cycling the land so that it could recover, the settlers grew tobacco in the soil until it was less productive, and

then used the land to graze their cattle. Because the soil was never given a chance to regenerate, the settlers had to expand, taking over Indian land; they fenced in and claimed as property what had purposely been left fallow and open by the Indians for hunting and easy passage. Although the tobacco plant was native to North America and the Indians had grown a weak strain of it, the Europeans found Virginia tobacco to be inferior: "poor and weak and of a biting taste." One colonist, John Rolfe, who had moved to Jamestown in 1610, persuaded the captain of a ship to bring him seeds from Trinidad and Venezuela. Rolfe cultivated a tobacco crop and brought a large amount of it to England in 1616 where it was well-received, "pleasant, sweet, and strong." With this shipment, the tobacco industry in North America was born. The profits to be made on tobacco were such that Jamestown quickly became dedicated to its cultivation. But tobacco "fueled an addiction for more and more land."[25] By 1616, there were only five houses within the fort and its environs; the rest of the Jamestown area had been turned into tobacco fields.

Rebecca

"She understands the culture of tobacco" is one of John Rolfe's early, admiring comments about Pocahontas. *The New World* is roughly divided into two halves, with the dream-like romance of Smith and Pocahontas shifting gradually to the somewhat more prosaic account of John Rolfe and his patient courtship of the Indian "princess." For providing seed corn to the colonists, Pocahontas has been disowned by her father and cast out from the village of Werowocomoco. She is then abducted by the Jamestown colonists—against Smith's wishes—who believe that her presence in the fort will protect them from Powhatan, who could massacre them at will. Smith and Pocahontas resume their romance, this time in the fort and its fields. When the president of the Virginia Company returns with new colonists and new supplies, he tells Smith that the King has requested that Smith prepare a new expedition, to explore the northern coast of North America. Smith instructs one of the colonists to wait two months, and then to tell Pocahontas that he has drowned in the passage. She reacts with grief and utter desolation, covering herself with ashes, throwing herself on the mud, and sleeping outside between the walls of the fort. "You have gone away with my life. You have killed the God in me."

Throughout the film, Pocahontas has served as the focalizing lens, the prism through which we see the profound changes in culture, environment, and mentality wrought by the Columbian Exchange. She begins to be acculturated into the habits of life at Jamestown, taking a new name, Rebecca, and being baptized. She is courted by John Rolfe whose internal thoughts and reflections are heard on the soundtrack: "She weaves all things together. I touched her long ago, without knowing her name." Where the romance of Smith and Pocahontas had been depicted as a breathtaking discovery of the unknown in the forest, the courtship of Rolfe and Rebecca reads as a kind of taming. Full of beauty and tenderness, their courtship is nonetheless conveyed in settings marked by domesticity—in the plowed fields, in the yard as she feeds the chickens, among the cattle.

The larger message communicated by Pocahontas's transition to domesticity—she agrees to marry the "decorous, pious, politically adept" John Rolfe—is found in the mise en scene of the film: the plain English clothing she wears and the four-poster bed that she and Rolfe sleep in give a personal, physical reading of the transformation of Virginia from a sylvan civilization to a modern order. The film holds the focus close to the perspective of the historical figures; the ecological impact of tobacco cultivation, the profound impact of imported animals such as horses, cattle, goats, and pigs on the earth, and the effects of the black rats, earthworms, and parasites carried over by the colonists, are not directly registered in the film. The shift to mono-cultural agriculture, the grazing of domestic animals on what were once fallow hunting grounds, and the long rows of plowed fields are conveyed as bucolic and picturesque. With Rolfe constantly smoking his clay pipe and Pocahontas, along with a few other Indians, working in the fields dressed in English clothing, the message is that Jamestown has been transformed into a simulacrum of England.[26] Rolfe and Pocahontas enjoy a period of rural tranquility; the film's plowed fields, fenced plots, domesticated animals, and scenes of Rolfe looking fondly at Pocahontas as she checks on the drying tobacco or strokes the brow of a large cow, look like they could have been painted by Constable.

Impressed by the growing success of the colony and by the stories he has heard of Pocahontas, the King of England invites Rolfe and Pocahontas to England for a royal audience. Directly after this invitation is

tendered, Pocahontas discovers that Smith is still alive. She turns cool toward her husband, telling him that "I am married to him. He is still alive." But she visits England with Rolfe and their child, proves a brilliant success at court, and then meets with Smith one last time. Their conversation is framed by formal gardens, clipped hedges, and polite exchanges. She asks him if he has "found his Indies," and he replies that "I may have sailed past them." It is, he says, as if he were speaking to her for the first time. She nods slightly and turns back to the estate. She then finds Rolfe, walks closely with him along a gravel path, and calls him "my husband."

The Royal Audience

Pocahontas's trip to the Old World is portrayed as powerfully unfamiliar, perhaps even more impressive in its novelty than the colonists' first experience of North America. Entranced by the bustling harbor market, she sees leaded window glass for the first time, a blacksmith shop burning coal, a child carrying a bright collection of ribbons, an array of hares, ducks, and geese hanging in an outdoor butcher shop, and fish for sale in their separate bins. The English people respond to Pocahontas as if she were nobility, regarding her with deference. She sees a black man for the first time, and gives a coin to an old beggar, along

with a touch to his cheek. Pocahontas's natural beauty and generosity win the affection of the crowd as well as the court, the commoners as well as the nobility. It may be only circumstance that bells are tolling all through London as she arrives, but it seems as if London is paying her court as if she were the one granting an audience, rather than the other way around.

In Buckingham Palace, King James receives Pocahontas with a full retinue of chamberlains and courtiers. She comports herself with perfect grace and naturalness, curtsying, smiling graciously, and allowing the king to take her by the arm. It is clear that she is the centerpiece of an elaborate display of New World fauna. An eagle and a raccoon are also displayed to the king, whose enthusiastic clapping as the eagle unfurls its wings seems almost like a burlesque imitation. But all other eyes are on Pocahontas. As she bends down to gaze sympathetically at the raccoon in a cage, the men's heads and necks bend and cock to follow her with their eyes, creating a subtle but effective visual rhyme. Pocahontas "performs" with exquisite poise, like the eagle stretching its wings. But a performance it is, carried off silently, in the language of gesture, costume, and facial expression. A poet reads words of salutation as Pocahontas enters, doggerel verse that draws on what are already clichéd sentiments concerning the benefits of cultural interconnection.

The full strangeness of this meeting between two worlds is perhaps best registered by the Algonquian who has been sent by Powhatan to report back on the English. He is to make a mark on one of several sticks for each Englishman he encounters, he explains to Pocahontas. Their one exchange at the beginning of the journey is marked by her attempts to be friendly, and his studied distance. In full warrior paint and skins, he strikes an intimidating figure on the ship, but on the docks of England and in the royal court, he appears simply incongruous. So incongruous, it seems that no one notices him. He walks alone on the docks, in the palace, and into the chapel without attention being paid. A lengthy, static shot shows him studying a stained glass window. Part of his mission from Powhatan is to see this "God that they always talk about." Later, he walks the grounds of the estate where Pocahontas and Rolfe are staying, looking at the topiary trees and the formal gardens, and touching their leaves to ascertain if they are real. Completely silent, shadowed, and nearly invisible in the dim spaces of the

palace and chapel, he is difficult to perceive. The dark paint and dun colored skins he wears give him a spectral, haunted aspect, as if he were a figure from a time already past.

Rolfe's voice-over letter composed to his son tells of the illness and death of Pocahontas, who became ill with smallpox at Gravesend as the family began its journey back to North America. Felled by an Old World disease, one of the European "crowd diseases" that would kill untold numbers of Indians, the death of Pocahontas foreshadows the work that Old World infections and parasites would perform on the New World native population. Rolfe narrates that "the events of which I write will soon be but a distant memory," a historically reflexive statement that communicates, at a more general level, the sense of a passage from one historical moment to another. The ending of the film returns to images of Pocahontas frolicking with her son in England. She offers a final interior monologue as she says, "Mother, now I know where you live."

The poignancy of Pocahontas's life, however, comes through most strongly when we consider her nomadic status, her shifting identities in history and in the narrative itself. At several points in the film she is in exile: exiled from her father and her father's village, walking alone among black roots and burnt trees; self-exiled from Jamestown after Smith leaves and supposedly drowns, sleeping on the dirt between the palisade walls and covering her face with ash; and exiled from her own sense of spiritual connection, "You have killed the God in me." Although Smith calls her "my American," Pocahontas is somehow a liminal character, both Indian and not Indian, both settler and native, both married and not married, both Pocahontas and Rebecca. This in-between, nomadic identity might be read as a counter narrative to the way the story of Pocahontas is made to serve a range of ideological functions, from the melodramatic figure invented by Smith to the various incarnations she has assumed in the mythology of the American nation. The film shows her as an "Indian Princess," a child-like dweller in the forest, an avatar of interracial romance, a chaste convert to Christianity, and a symbol of nature's bounty. In Malick's rewriting of the story, however, the outlines of another identity emerge happily: that of a "new human being," what Benedict Anderson calls "a firmly local member of the unbounded series of the world-in-motion."[27]

From Virgin to Widowed Land

Rolfe brought with him to England not only Pocahontas, but also his first major shipment of tobacco. The success of this shipment began a lucrative trade between Virginia and England. By 1620, Jamestown exported 50,000 pounds of tobacco, and six times more than that a decade later.[28] North America would become Europe's first "off-shore farm," with fields full of foreign crops such as wheat, rice, and non-native tobacco.[29] Thousands of English would come to Virginia to work as indentured servants in the tobacco fields, with the promise of a grant of 50 acres of land if they survived the hardships of servitude for four to seven years. The colonists did not discover a New World, Charles C. Mann writes, but rather created one.

The infusion of new crops, new food sources, and new trade goods into Europe from North America led directly to the industrial revolution. "Civilizations were each materially incapable . . . All but a few of their people were engaged in producing the bare necessities—food, fuel, shelter—and if they went off to do something else, stark poverty and famine would follow . . . It could only be accomplished by exploiting the ecosystems, mineral resources, and human assets of whole continents outside the lands of the society making the jump . . . Western Europe was able to make the jump using the New World the way a pole vaulter uses his pole."[30]

For the Natives, however, the invasion of the colonists was a biological catastrophe, a transformation of the garden into a desert. Epidemics devastated the native populations of North and South America. Immunologically unprepared, the Natives died in awesome numbers. Crosby writes that "there is little exaggeration in the statement of a German missionary in 1699 that 'the Indians die so easily that the bare look and smell of a Spaniard causes them to give up the ghost.'"[31] Infectious diseases that take hold in unprepared populations are called "virgin soil epidemics," a phrase that almost seems to mock the myth of the "virgin land."[32] Indeed, the settlers' major allies in their struggle for dominance with the native population were the diseases and parasites they carried with them.

In the specific case of Jamestown, some historians believe the settlers' major advantage in this struggle was the mosquito. Coming mainly from the swamp districts of England, the Virginia settlers were

human hosts for the plasmodium parasite, the cause of malaria. Over time, they had probably developed some immunity from the infection, but the parasite was nevertheless present in their bloodstreams. New World mosquitoes would simply transfer the parasite from the bloodstream of a settler to an Indian. Malaria causes repeated high fevers, sometimes occurring periodically over a length of years, and induces lethargy, weakness, mental dullness, and susceptibility to other diseases. Perhaps this explains why the Indians were unable to resist the encroachment of the settlers.

Historians have wondered why Powhatan's successor, his powerful, suspicious brother, Opechancanou did not attack and wipe out the colony in the years following Powhatan's death in 1618; a sustained assault on the colony in this period would have certainly destroyed it. Perhaps the Powhatan Indians were simply too weakened and dispirited by disease. For the Indians, the territory near Jamestown may not have been worth fighting over: "it would have been as if the environment around them had suddenly become toxic."[33] As Crosby writes, "When Columbus brought the two halves of this planet together, the American Indian met for the first time his most hideous enemy: not the white man nor his black servant, but the invisible killers which those men brought in their blood and breath."[34]

The bounded worlds of Europe and North America were opened and remade, for better and for worse, by the Columbian Exchange. Viewing the past from the perspectives of both Native Americans and colonists, the film creates a holographic image of the New World, shifting between romantic celebration and abject despair. The transformation of Jamestown from a colonial bedlam into a productive agricultural community is set against the torching of the native village and the Indians' near disappearance from the scene. The success and beauty of Rolfe's farm, the European rusticity these scenes evoke, is counterbalanced by the loss of the Indians' hunting, fishing, and farming lands, captured in the desolate scenes of their wandering among smoke-filled corn fields looking for safe ground. The bucolic scenes of Pocahontas interacting with the domestic animals on the farm and fertilizing the tobacco plants with large fish are set against our knowledge of the malignant effects of tobacco and tobacco farming, "which has an almost unique ability to suck the life out of soil."[35] And the English country

life suggested by the domestic animals pictured on Rolfe's farm is shadowed by our knowledge of what the imported livestock, unfenced and allowed to graze freely, would do to the Indian fields and villages nearby.[36] The film presents a kind of dialectical reading of the historical period, and of the landscape itself, approaching it from the perspective of the past as well as the perspective of the present day.

The interconnected world created in the Columbian Exchange comes through most strongly in the character of Pocahontas, who seems, as one character says, to be always able to bring good things out of bad. Pocahontas crosses what Crosby calls the "drowned seams of Pangaea" in both a literal and figurative sense, taking on the dress and customs of the Old World while keeping her spiritual connection to her earlier life.[37] Pocahontas in many ways comes to symbolize the Columbian Exchange, traveling to England and completing, in a few short years, an unprecedented transformation. The unbounded world that Pocahontas represents in this film inscribes her in a very different iconography than we are accustomed, one that looks to the future as much as to the past. In Malick's prismatic portrayal, the "Indian Princess" of mythology comes to represent a new form of human being, bounded neither by race nor continent, but existing firmly in what is clearly, irrevocably, the new world-in-motion.

7 | Homeland or Promised Land? The Ethnic Construction of Nation in *Gangs of New York*

The ethnic antagonism that dominates *Gangs of New York* highlights a recurrent tension in the national story seldom considered a constitutive or central part of its fashioning. Although ethnic tension has repeatedly challenged the vision of social coherence that animates the American project, it generally enters the American story only in a disguised form, cloaked in the theme of assimilation or dressed in the colors of the rainbow or the mosaic. In the traditional narrative of nation, conflicts between contending groups are universally resolved in the discourse of national belonging, with nationalism providing an apotheosis of difference ("out of many, one," as the phrase goes). *Gangs of New York,* in marked contrast, draws a portrait of nation marked by perennial antagonism and contradiction. As Homi K. Bhabha writes:

> The problem is not simply the 'selfhood' of the nation as opposed
> to the otherness of other nations. We are confronted with the nation
> split within itself, articulating the heterogeneity of its population . . .
> a liminal signifying space that is internally marked by the discourses
> of minorities, the heterogeneous histories of contending people, an-
> tagonistic authorities and tense locations of cultural difference.[1]

Gangs of New York dramatizes the emergence of American identity in the mid-nineteenth century precisely as a history of contending peoples, antagonistic authorities, and tense locations of cultural difference. Entering New York City at the rate of 15,000 a week in 1863, Irish

143

ethnics were immediately confronted with the hostility of the native born population of workers and wage earners, by the radical anti-immigration party called the Native Americans (nicknamed the "Know-Nothings"), and by the Civil War, which created a massive need for Union soldiers who were drawn in large numbers from young Irishmen coming directly off the boats.[2] The film exposes what is perhaps the deepest fault line in American society—the unstable zone where ethnic and racial identity pushes up against the larger "imagined community" of national belonging.[3] Although the DVD cover art for *Gangs of New York* proclaims that "America Was Born in the Streets," the film itself contradicts this assertion. Far from providing a unifying myth of national community, the film depicts a world where ethnic identity, in its full and lived reality, is in direct competition with national discourses of belonging, a point vividly expressed in the Draft Riots. In the brutal competition that characterizes New York in the mid-1800s, the rival *ethnies* struggle for dominance not only against each other but also against a nation-state attempting to impose its own agenda.

The main conflict portrayed in the film, the struggle between the new Irish immigrants and the combined political and criminal collective of Native-born citizens, who call themselves the Native Americans, provides the lens through which a very different story of American history takes shape, one defined by urban life (rather than the wilderness or frontier) with its multiple, often fractious zones of social interaction, and where ethnic survival (rather than national emergence) is the framing structure and the overarching theme. The polyethnic neighborhood of the Five Points, the principal setting for the film, is an especially mixed and chaotic site, combining several ethnicities in open competition with each other. Devoid of recognizable civic institutions, the Five Points is depicted as a primitive border zone of competing tribes, and a primordial battleground of contested spaces, continuous challenges, and expressive, spectacular violence.

Overture

The opening shots of the film focus on "Priest" Vallon shaving his face in candlelight, and cutting himself intentionally. When his son, Amsterdam tries to wipe the blood from the razor, his father corrects him, "No son. Never. The blood stays on the blade. Some day you'll understand."

The two then climb the rough spiral stairs out of the tunnels beneath the Old Brewery, collecting other warriors as they go. A combination of Irish flute music and African drums is heard on the soundtrack as a growing group of motley, ferocious looking fighters march toward the door, some pausing to receive Communion from a priest as they pass. When they approach the formidable Monk McGinn, and ask for his help in the coming combat, he sets a price for each new notch on his club. He then kicks the door open, and the warriors emerge into a frozen courtyard to confront their foe.[4]

The introduction of Priest Vallon and his son intermingles religious symbolism and a call to war, almost as if the battle about to unfold was a crusade. The bloodied razor and the invocation that accompanies it—a prayer to St. Michael the Archangel—takes on the aspect of a Eucharistic ceremony, a local version of the sacrament blending ethnicity, religion, and fellowship based literally on blood. Blood is taken as the foundation of community, recalling an older, by now almost archaic sense of Catholicism as a persecuted religion, a minority creed that renewed itself by the blood of its martyrs. In this symbolic system, the blood that "stays on the blade" is the blood of the kinsman, whose sacrifice strengthens the whole.[5]

Vallon is shown pausing for Communion as he marches through the Old Brewery, walking past a forge where axes and halberds are being beaten into shape, past a group of Africans drumming and dancing, with various eyeline shots of warriors preparing themselves for battle. The point of view is clearly that of Vallon's son, an eleven year old boy who marches with his father through the red-hued pandemonium of the Old Brewery.

Directly after Monk kicks open the heavy door of the Old Brewery, the camera tracks through to reveal the open, snow-covered ground of the small field called Paradise Square. Framed by the Old Brewery at one end and a burned out house sheathed in thick ice at the other, Paradise Square appears empty, ice blue, and silent—a sharp contrast to the crowded interior of the Old Brewery with its cacophony of sounds and firelit interior. As the camera holds on the scene, a few men begin to emerge from near the ice-encased building, among them Bill "the Butcher" Cutting. As more men gather, the camera shows Bill, in a rapid series of staccato shots, setting his feet in the snow, casting his

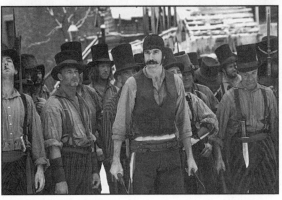

gaze across the square, and then, in an abrupt and startling sequence of extreme close-ups, the film cuts to an enormous shot of his eye—a glass eye with a blue American eagle engraved on it. This striking emblem of identity, marking a specific "way of seeing" and of being seen, is a badge of affiliation more emphatic than a tattoo, as expressive as the "blood on the blade" from the earlier scene. Bill Cutting and Vallon issue their challenges across the square, define the cause and the terms of battle, and calling on the Lord to guide their hands, begin their fight for the Five Points on the "chosen ground" of Paradise Square.

The rapid editing and varied camera speed of the battle scene, described by Scorsese as deriving from Eisenstein, provides a stylized metric montage punctuated by close-ups to Priest Vallon's son watching from above. As in Eisenstein, the moment of impact is usually not depicted: the camera cuts away just before the blow strikes home, usually

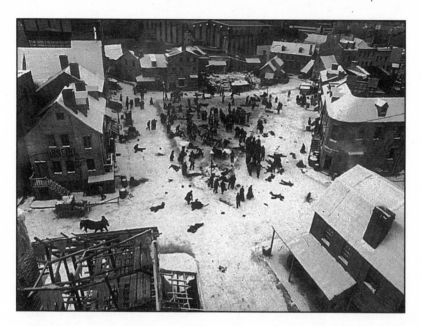

to show the effect of a different blow on a different victim. The battle is rendered in a series of short static shots, edited together for maximum conflict and collision: the fast juxtaposition of violent, nearly frozen images creates an impression of extreme dynamic movement. Scorsese varies the camera angle and shot size, while alternating between moving and stationary camera shots, dynamic and still images, and fast and slow motion film speed, creating an impression of extraordinary graphic intensity, almost like a comic book with its varied frame sizes and propulsive actions that seem to burst from the edges of the composition.

The camera cuts back frequently to the young Amsterdam Vallon watching the carnage, his face registering increasing degrees of fear and shock, a technique that directly quotes Eisenstein's Odessa Steps sequence in *Battleship Potemkin*. And as Bill makes his way through the melee and approaches Priest Vallon, calling his name, the scene is registered through the point of view of the son. Bill stabs Priest twice, surprising him. The action seems to stop around them as Priest falls to the ground, a motion depicted in three shots from three different angles, analyzing and highlighting the fall. Someone blows a primitive horn, barely managing to sound a single note, and the battle comes to

an end. Priest's young son rushes to his side, and Priest gives his final instruction, "Don't never look away."

Homeland/Promised Land

The two distinct ethnic tribes struggling over the Five Points have attached themselves to the most squalid, depressed neighborhood in New York. Yet the territory animates their struggles, infuses their symbols and myths, and provides a powerful sense of belonging. In the bloody battles over neighborhood dramatized in *Gangs of New York*, we find a mise en abyme of the larger struggle unfolding on a national level, one that will define the territory of the nation.

One of the key elements in the "ethnosymbolic construction of nation" set forth by the theorist of nationalism, Anthony D. Smith, is the sense of a "sacred homeland," a geographic territory that takes on a deep emotional meaning for the population, "the often fervent attachment of populations to particular stretches of territory, and their readiness . . . to defend them to the last inch." Describing the "territorialization of memory," Smith writes, "How is this close identification between the community and the landscape achieved in practice? By attaching specific memories of 'our ancestors' and forbears, particularly if they are saintly or heroic, to particular stretches of territory . . . across the landscape lie the 'sites of memory'; the fields of battle, monuments to the fallen, the places of peace treaties."[6]

The particular emotional connection that both the Natives and the Irish immigrants develop in connection with the Five Points can be understood in this light. Although the Five Points seems far from a poetic or historic landscape, the actions that unfold around and within it give it a pronounced symbolic status. When Priest Vallon instructs his son at the beginning of the film, he reminds him of the role played by St. Michael in Christian myth, his "casting the devil out of Paradise." The battle for the Five Points that subsequently unfolds in Paradise Square, a decrepit field at the center of the Five Points neighborhood, immediately takes on a legendary significance. After Priest Vallon is killed by Bill the Butcher, the ground on which he falls acquires an honored status; as Bill the Butcher names it, "this hallowed ground." The battle between the Dead Rabbits and the Native Americans is subsequently commemorated each year by Bill, who elevates his former enemy with

a lavish reenactment involving the drinking of fiery liquor and various theatrical displays.

The Five Points becomes something like a sacred territory for Bill and the Native Americans, a poetic space eulogized in speeches and chronicles "recited down the generations . . . The permanent and unchanging bedrock of the nation."[7] The Five Points are like a hand, as Bill says, "close the hand, and it becomes a fist." A cornerstone of the native-born American community, the Five Points is understood, at least by Bill, as a mise en abyme of the larger sacred territory, America, conceived as an unspoiled and unmolested land, defended to the death by Bill's father against the English. Bill, for his part, dedicates his life to the defense of the Five Points against the "foreign hordes" of Irish Catholics, who worship their "king in Rome, with his pointy hat."

In contrast, the Irish immigrants see the territory of the Five Points in very different terms, as part of a quest for freedom from persecution, hunger, and strife. The Five Points—Paradise Square—is the site where this utopia will be realized. As Smith writes, "The promised land becomes a land free from oppression, a land where a liberated community can build a New Jerusalem."[8] The Five Points can be seen as a mise en abyme of the larger symbolic landscape as well, representing another concept of America—as promised land, free from oppression and want, sacred for the potential it represents.

The contest between two different concepts of ethnoscape and nation that *Gangs of New York* renders can be read as a microcosm of conflicting concepts of America as homeland and as promised land, a conflict played out in miniature with each succeeding wave of immigration. America has been traditionally conceived in a split fashion, both a place of identification rooted in long habitation and generational memory, as well as a place of identity based on the promise of a new world where freedom from persecution, hardship, and the past could be found. For Bill, the generational memory of his father, who was killed defending the United States from the British during the War of 1812, is what sanctifies the nation; the blood of his ancestors, shed in defense of the nation, makes it inviolable: "I won't have them that had nothing to do with its making" coming in and corrupting it, he says. For Priest, on the other hand, America is conceived as a place of rebirth, of the promise associated with the new world, a place where

the Irish can claim equality and freedom. For the immigrants, the new land becomes part of their self-image, a form of identification, a providential reward for their perseverance through generations of strife and hardship, an achieved identity after centuries of oppression. These two competing symbolic identities are set in explicit opposition in the film.

Satan's Circus

After spending fifteen years in an orphanage, Amsterdam Vallon, Priest's son, returns to the Five Points, incognito. After being introduced to the new pecking order among the gangs by Johnny, Amsterdam is quickly adopted by Bill, who recognizes the young man's quick intelligence and his "sand," a colloquialism politely translated as "courage." For his part, Amsterdam hopes to get close enough to Bill to avenge his father's death in a symbolically meaningful way, but delays acting for a variety of reasons, including his growing admiration for Bill. In conversation and in act, Bill seems larger than life, a king of the streets. Alternately magnanimous and cruel, Bill also maintains a steadfast respect for the memory of Priest Vallon as a worthy, unforgettable enemy, a man who lived by the same code as he does, a man whose death he commemorates every year on the anniversary of the battle in Paradise Square.

After Amsterdam saves his life, Bill takes him into his confidence and discloses his past and the lessons he has learned. Appearing in the middle of the night, as Amsterdam is asleep, Bill, wrapped up in an American flag, begins by considering the reason he has stayed alive all these years: "Fear," he says, "The spectacle of fearsome acts. A man steals from me; I cut off his hands. He offends me; I cut off his tongue. A man stands against me; I cut off his head and put it on a pike, raise it high up so all in the streets can see. That's how one preserves the order of things. Fear." He then goes on to describe Priest Vallon, Amsterdam's father. He calls him "The only man I killed worth remembering," and goes on to say that "the Priest, he and I lived by the same principles. It was only faith divided us." It was Priest who gave him "the finest beating I ever took." After detailing the wounds he received at the hands of Priest, Bill describes how, at the moment he was to be killed, Priest spared his life. Unable to look him in the eye, Bill had looked away. The act of sparing him, in Bill's interpretation, meant that he would have to live with his own cowardice; he was spared, he says, so that he

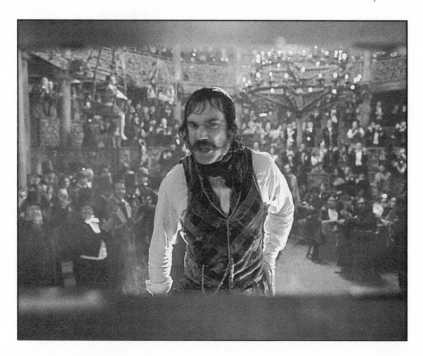

could "live in shame." Bill then tells Amsterdam how he got his glass eye: "the eye that looked away" he cut out of its socket, and sent to Priest wrapped in blue paper. "I would have cut out the other one too if I could have fought him blind." Finally, he comes to the climax of the story: "and then I rose up again with a full heart, and buried him in his own blood." He closes the story with a kind of benediction: "I never had a son. Civilization is crumbling. God bless you." He then lays a hand on Amsterdam's head, and walks from the room.

This powerful distillation of psychology, legend, and commemoration condenses a long history of ethnic bloodshed into a kind of epic shorthand, a song of deeds that had been done and of a hero that once walked the Five Points. Wrapped in the flag, conveying his points with quiet intensity and small hand gestures, Bill narrates the story of Priest Vallon, as well as his own story with none of the ostentation and bravura that characterizes his frequent public performances. With his blessing of Amsterdam and the laying on of hands, the scene stands as a counterpart to the "blood on the razor" sequence that initiates the film.

But it has a deeper meaning as well. The American flag that Bill

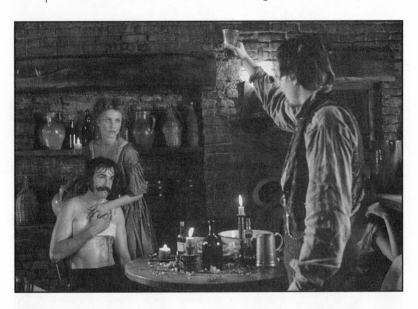

wraps around himself as if it were a Roman toga can be read as a state-
ment about the nation-state itself, a state founded, preserved, and ex-
tended through "the spectacle of fearsome acts." The dramatic acts of
violence Bill describes to exemplify power and dominance can be seen as
more than the primitive semiotics of a tribal or clan leader. They might
rather be seen as the distilled expression of a counter-history of nation,
a nation with a long tradition of fearsome spectacles, often oriented
around race and ethnicity. The extraordinary violence that suffuses the
film begins to resonate as a microcosm of the nation-state as a whole.

In the preceding scene, Bill had nearly been assassinated while sit-
ting in a theater, while an actor representing Abraham Lincoln per-
formed on a stage. As the Lincoln character calls out, "We must heal the
divisions between us," and as the audience responds by throwing rot-
ten fruit and shouting "down with the Union," an assassin approaches
from the stage. As he fires his pistol from point blank range at Bill, he
shouts "For the blood of the Irish!" Only because Amsterdam has seen
the assassin and tackles him as the shot is fired is Bill spared.

As the auditor of these history lessons, Amsterdam has been placed
at a crossroads, the point at which the two legacies, the history of his
father and the history of Bill, or more broadly the history of the Irish
and the history of the Natives, have intersected. Until this point in the

narrative, Amsterdam has been a "patient" of the narrative rather than an "agent." He is now faced with the requirement to act, either to rehearse the narrative trajectory that has been laid out for him, or to find another path. At the conclusion of the scene, Jenny confronts Amsterdam with the question hanging over the entire film so far, "Who are you? Who are you?"

History and Utopia

The answer to this question is complicated, for it extends beyond the deepening conflict between Amsterdam's need to avenge his father's death and his growing respect and affection for Bill. The question, "Who are you?" opens onto the larger issue of collective identity in a period when mass immigration and emancipation were challenging the dominant order. In the scene immediately preceding Bill's armchair confession, Amsterdam had been challenged by Monk, the Irishman with the notched club, who, recognizing him as Priest's son, mocked him for being "downright Shakespearian," saving Bill's life when he ought to be killing him. "For all his flaws," Monk says, Amsterdam's father "never forgot his people." The larger question the film poses, and reframes in terms of Amsterdam's own ambivalence, is whether the past, understood in terms of ethnic memory, can be superseded or erased, or whether the blood must "stay on the blade."

In the New York of the early 1860s, the varieties of Americanness were multiplying on a seemingly daily basis. The Irish, the Chinese, and the free blacks, thrown together in the vortex of the Five Points, were creating a new, polyethnic city of immigrants and nomads. As Bill watches a black man dancing an Irish jig, while he is attended by a woman of indeterminate ethnicity, he describes the emerging nation with his characteristic flair: "Rhythms from the Dark Continent, stir it together with an Irish shindig, pour it out and it's a fine American mess." The overlap between ethnicity and nation, between homeland and promised land, between history and utopia, is expressed throughout the arcade-like setting of New York, with army recruiters, protesters against the war, newspapers, theaters, political campaigns, and amusements like P.T. Barnum's indoor zoo vying for attention. Out of this panorama, the film suggests, a kind of motley cosmopolitanism is beginning to take shape.

In the multicultural metropolis of New York in the 1860s, a kind of polyglot nation seems to be forming out of the sheer infusion of vast numbers of people. The population of New York grew from roughly 60,000 in 1800 to about 1.5 million people in 1860.[9] Despite the ethnic rivalry that permeates the early scenes in *Gangs of New York,* the middle portion of the film depicts a relatively tolerant quality of daily life, with money to be made and a sense of enterprise in the air, notwithstanding the colorful criminal behavior that supports it. So pungent and attractive is the life of this polyglot metropolis that the highborn of New York society and the leading newspapermen of the day made tours of the Five Points, a scene depicted in the film as a major public relations success for Bill, who behaves toward the newspaper publisher, Horace Greely, and the highborn family, the Scamerhornes, with courtly and flattering grace.

All this is pushed aside, however, by the Civil War and the reach of the Federal government. In a long, single shot sequence Scorsese shows dozens of Irish immigrants getting off the ships in the harbor in immigrant clothing and carrying rough bags. William "Boss" Tweed says, "That's the building of our country right there, Mr. Cutting. Americans a-borning." Bill bitterly disagrees, and becomes vehement when Tweed tells him they are contributing "votes." "My father and all his men were murdered by the English, defending this great country . . . And I'm going to be giving this country over to thems that's had no hand in the fightin' for it?" Tweed finally tells him he is "turning his back on the future." Bill responds, "Not our future." The camera then tracks away from Bill to a long line of immigrant men who have just stepped off the ship, who are being granted instant citizenship and enlisted into the Army in a single process at a table set up on the docks. A man in a top hat tells them, "That document makes you a citizen, this document makes you a private in the Union Army. Sign here, or make your mark. Now go fight for your country."

This machine for creating citizens is accompanied by a period song, which in many ways stands in counterpoint to the anthem that concludes the film. Rather than singing of "The Hands That Built America," the singer laments the fate of the young Irish men shipped off to fight and die for a country they had known for only a short while: "When we got to Yankee land, they shoved a gun into our hands, saying Paddy you

must go and fight for Lincoln." The camera continues tracking, as the newly minted citizen–soldiers, now dressed in Union blue, climb the steps to the deck of the ship. As the men ascend, caskets are shown being lifted off the ship and arranged in neat rows on the dock.

The scene is composed in a way that plainly refutes Bill's statements a few moments earlier, that he will never give this country over "to thems that's had no hand in the fightin' for it." The Irish were clearly laying down their lives in large numbers for the country, a country that now consists of emancipated slaves, Irish and German immigrants, and Chinese laborers in addition to the Anglo-Saxon majority culture dominant in America since the framing of the Constitution.

Amsterdam's ambivalence, his complicated filial feelings toward Bill, can thus be read as a dawning recognition that the deep enmities of the ethnic past were now being redefined, that war, politics, and the pragmatics of survival demand a different understanding of ethnicity, nation, and belonging. The indelible identities of earlier generations were now being transformed, overwritten by a nation hurled toward modernity by way of the newspaper, the telegraph, immigration, the vote, and above all, by a massive, total war that required the performance of national belonging by being willing to sacrifice one's life for it.[10]

Ethnie and Nation

Here it may be useful to review Smith's distinction between "ethnies" and "nations." Smith defines the ethnie or ethnic community as a population with a mythology of common ancestry, shared historical memories, a link with a homeland, and a certain measure of solidarity. Ethnies, he writes, "are defined largely by their ancestry myths and historical memories."[11] Nations, by contrast, are defined by the "historic territory they occupy," and by mass public culture and common laws. An ethnie may exist without a territory, as is the case with so many diasporic ethnies. A nation, on the other hand, exists only insofar as it inhabits a historic territory; nations without territories are a contradiction in terms.

Smith defines nationalism as a combination of ethnic and national traditions. Arguing against the postmodern understanding that nationalism is a construct with a shallow degree of penetration into the inner lives of its members, Smith argues that the nation is based on, and

draws sustenance from, much earlier ethnic emotions of purpose and belonging and the collective symbols that go with them. Nations, he says, carry forward the "preexisting symbols and cultural ties and sentiments" in which the nation is embedded.[12]

Gangs of New York dramatizes the importance of ethnosymbolism in the construction of nation, but stops short of conceiving ethnic identity as a direct conduit to larger national concepts of belonging. The main thrust of ethnic liberation here seems far removed from the national project set forth by Lincoln and Frederick Douglass; it has little to do with the Civil War, emancipation, or the draft. Instead, the Irish pursuit of a promised land in America, a land free from persecution and hunger, takes an old world detour into religion. For the Irish ethnics depicted in the film, the route to modernity passes through the deep past of pre-modern Christianity.

Religion and Nation

Scorsese makes a number of explicit visual and verbal associations between the collectivization of the Irish in New York and Christian imagery and motifs. The revival of religion in the life of the immigrants, symbolized by the church they build and underlined by the textual motifs of crucifixion, resurrection, and martyrdom, draws the Irish together, and extends outward to include a large group of the non-Irish poor, ultimately bringing a modern polyethnic community into being under the mantle of the Catholic Church. Forming alliances both with the Church and with Tammany Hall, for whom the Irish represent a huge voting bloc, Amsterdam lays claim to the territory of the Five Points, and by extension stakes a claim for the Irish in the emerging nation-state.

Betrayed to Bill by his friend Johnny, Amsterdam's first halfhearted attack on Bill is easily deflected. Bill gives Amsterdam a vicious beating and brands his face; from this point on, he will wear the "mark of Cain." He will be "God's only man." Nursed back to health by Jenny in the depths of the Old Brewery, with the skulls of the dead stacked in recesses in the walls, his long recuperation leads him to form a different plan of attack. Emerging from the catacombs of the Old Brewery, Amsterdam is depicted in a long tracking shot from a subjective point of view, making his way through the alleys and mud streets of the neighborhood. The people who glance his way draw back, as if frightened,

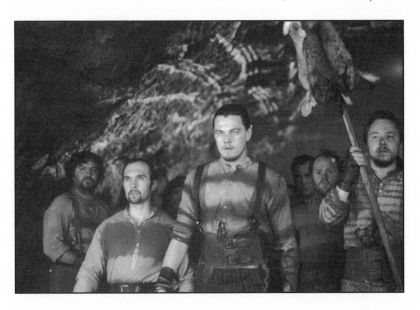

as he moves with purpose toward the iron fenced enclosure at the center of Paradise Square. There, he hangs a dead rabbit on a fence post, alongside a bronze sculpture of an American eagle, wings spread for flight. Soon, people begin to gather around, watching and observing Amsterdam who has resurrected a banned symbol, a direct challenge to Bill and his dominion over the Points.

The Dead Rabbits reform around Amsterdam Vallon in a vivid reminder that the symbols and legends of the past have not been forgotten. At the same time, the Rabbits are reborn differently, now as a polyethnic community. The group that forms around Amsterdam is large and inclusive, incorporating the one black member of the neighborhood, a ferocious, bearded priest, and by extension, all who dare to join. Here, the wider civic or public culture associated with the Dead Rabbits is represented by the church they successfully restore, a collective enterprise that functions almost like a John Ford-style icon of community and fraternity.

Gangs of New York depicts the Catholicism of the Irish in New York as a martial religion, organized to protect the Irish and to assert a territorial right over the Five Points. Amsterdam, in voice over, describes the 15,000 Irish coming into New York each week as not a

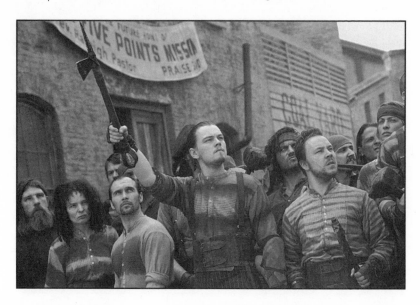

gang, but an "army," and underlines the martial imagery by claiming "Our faith is the weapon most feared among our enemies, for thereby shall we lift our people up against those who would destroy us," while depicting the newly formed community receiving communion. The film pictures the deep symbolic resources of the Catholic religion not as an atavistic remainder of an earlier time, but rather as a framework for articulating a sense of collective purpose. At least one of the newspapers in New York sides with the Irish immigrants in their battle against the Natives, and the political machine controlled by Boss Tweed, Tammany Hall, allies itself with Amsterdam and the group he represents. As Amsterdam says, "The past is a torch that lights our way. Where our fathers have shown us the path, we shall follow."

"All We Could See Was the Hand in Front of Us"

This path—the exodus out of persecution and prejudice into the promise of full civic participation—is blocked, however, by the Natives. "We've been at war for a thousand years. We never expected this war to follow us over. And it didn't; it was already here." Although the bitter ethnic enmity between the Rabbits and the Natives spirals closer and closer to a culminating standoff, the battle between them ultimately seems an archaic reprise of the past, one in which only primitive weapons

will be used and which will be fought on the now sanctified ground of Paradise Square. With little concern for the cataclysmic social pressures building in New York because of the Civil War and the draft, the climactic battle between the Rabbits and the Natives seems at once to be both irrelevant to the larger historical issues of the period as well as a precise and succinct expression of the nation split within itself, the "heterogeneous histories of contending people," now occurring throughout the nation-state.[13]

The larger national story, however, is rendered by Scorsese in a cascading series of crosscuts, connected by a voice-over reading of telegraph messages that sound like archival records. The riots, which started with the torching of the draft office by the uniformed firemen of the city, quickly metamorphosed into a vendetta against African Americans and against the rich. The intensity of the riots, which spread throughout the city and raged for four days and four nights, led Lincoln to order troops from Gettysburg, two weeks after the decisive battle had been fought there, to assert territorial control over the city. Until this time, the national government had kept its distance from the affairs of the states and the cities; it had been perceived as "a remote and passive institution."[14] Now Lincoln's Army faced off on crowded streets against a civilian population. The military occupation of New York City that ensued was accomplished only after the U.S. Army forcefully confronted the rioters, killing dozens, and after the city was bombarded by naval vessels stationed in the harbor. Most estimates place the number of dead at around 105, but it may have been much higher.[15]

The film treats the Union Army occupation of New York City as it might have been seen by the immigrants and the poor of 1863, portraying the Union Army as if it were basically a well-equipped gang, no more or less legitimate than the Dead Rabbits or the Natives. The U.S. Army, however, unlike the gangs, did not limit itself to the use of "bricks and bats, axes and knives," the weapons agreed upon by the Natives and the Rabbits. In a series of crosscuts, the film makes several explicit parallels between the two gangs lining up against each other in battle formation, and the U.S. Army confronting and taking aim against the rioters. As the Union soldiers fire several volleys into the crowd, the film renders the carnage in slow motion, and accompanies the slaughter with music that underscores the poetic, tragic

dimensions of the event. As if to underline the parallel between the Army versus the rioters and the Natives versus the Rabbits, the film shifts into an elevated, epic style of presentation as the soldiers shoot into the crowd, with the music of bag pipes and drums poetically linking the slaughter of the crowd on the streets to the ethnic battles that were fought in the past.

The naval bombardment of the Five Points, followed by troops marching into Paradise Square dissipates the battle between the Natives and the Rabbits, whose members are thrown to the ground, shown staggering into the smoke and dust, and left in complete disarray. Bill, however, persists in pursuing Amsterdam to the end, attacking him out of the murk that fills the air, running at him from behind and hacking at his legs. Another shell strikes nearby, and both characters are blasted to the earth by the bombardment, covered in ash and dust, with Bill receiving the worst of it. Shrapnel from the Union bombardment has pierced his kidney. Just before Amsterdam finishes him off, he says, "Thank God I die a true American." Hands clasped together, Bill and Amsterdam both sink to the ground, fog and gray dust surrounding and covering them, a direct recall of the battlefield scenes from Griffith's *The Birth of a Nation* (and an uncanny anticipation of the dust and smoke clogged scenes emanating from New York on 9/11). A close-up on the clasped hands of Bill and Amsterdam bring to an ironic and unexpected conclusion the symbolism of the Five Points, the bedrock of the small nation that had been formed there since the first battle of Paradise Square.

The Territorial Nation

The relation between ethnic identity and national identity, between the emotions of belonging associated with ethnicity and the sense of purpose and "imagined community" built around the larger territorial nation remains a question mark in the film. "America Was Born in the Streets" may be the tagline on the DVD of *Gangs of New York*—and the lyrics of the closing anthem by U2, "The Hands That Built America," asserts this theme as well—but the potential links between ethnic identification, so powerfully expressed throughout the film, and identity with the "imagined community" of nation are difficult to find. The world inhabited by the Irish and the Natives in the Five Points seems

insular, a tribal conflict that has little to do with the deeper historical currents moving through and around the Five Points, currents that finally break to the surface during the draft riots. The modern nation being formed in the carnage of the Civil War seems to be occurring elsewhere, distant from the neighborhood, and by extension, from New York itself.

The violent, panoramic treatment of history that dominates the last act of the film has received a good deal of criticism for its sudden dilation of the core story. That story, variously described as a revenger's tale, as an Oedipal drama, and as a Scorsese gang story, conveys ethnic struggle as the motive and the background for its narrative events, but the story of the larger nation—the Civil War and the emancipation of the slaves—seems remote to the point of near invisibility until the very end of the film. However, the sharp intrusion of external historical events allows Scorsese to make what is certainly the most unexpected and radical editorial statement in the film, an assertion that is conveyed almost entirely through crosscutting. If we expand our reading of the device of parallel editing, and fully consider the equation Scorsese makes among the U.S. military, the rioters, the Natives, and the Rabbits, the meaning of the "gangs" of the film's title takes on a different coloration. Viewed from this defamiliarizing perspective, the Military Conscription Act, the aggressive expansion of Federal power in various ways during the Civil War, and the violent military response in New York City begin to look less like a legitimate response to civil insurrection and more like an aggressive territorial incursion. The parallels that the film sets forth suggest that the United States was engaged in naked competition for control of the people within its boundaries.

In comparison with the ethnic groups that came to America with deep and shared traditions, the United States was relatively weak in symbolic resources. Absent a heritage-culture of shared memories, without a golden age, a sacred homeland, or a concept of itself as a chosen people fulfilling a heroic destiny, the United States at the time of the Civil War had a meager set of symbols with which to mobilize and motivate large numbers of its population. As Smith writes, nations feeling at a cultural and historical disadvantage "may seek to compensate for these deficiencies by a more violent display of territorial attachments."[16] The striking parallel Scorsese creates produces an image of

nation determined to assert its authority over a certain territorial expanse, far from the understanding of the Civil War—the preservation of the Union and the expansion of human liberties—that are traditionally set forth.

The Songs of the Street

The film depicts an America that is multi-stranded and contested, where national identity is continually subject to change. By the end of the film, Bill's America has been radically transformed, from an Anglo-Saxon protestant world to one populated by multiple ethnicities and religions. Scorsese's film, released in the immediate aftermath of 9/11 but filmed, for the most part, in the very different historical period pre-9/11, can be read in the same light. In terms of its reference period, New York from 1845–1863, it stands as a monument to an American past in which nation was not yet an all-encompassing category, where it was something of an afterthought and where cultural difference was not immediately subsumed or exploited by larger interests, needs, and by the prescriptions of a distinctly national authority. For all the violence, criminality, and intolerance that suffused the New York of 1863, the wild, carnivalesque character of the early metropolis, its polyethnic collisions and contradictions, carried a certain utopian charge.

In the context of its production and release dates, which straddle the line between pre- and post-9/11, a similar shift in national identity can be sensed. In the coda of the film, Amsterdam has come with Jenny to pay his respects and to bury his father's razor near his grave, and near the neighboring grave of William Cutting. As Amsterdam covers his father's razor with dirt, the sense of burying the past, with its legendary figures, its symbols, and its conflicts, is explicit: "Like we were never here," is the sentence Amsterdam utters. Directly after he exits the scene, the closing song rises on the soundtrack, and a lap dissolve sequence begins. For a film replete with powerful cultural symbols and emblems, these final images of *Gangs of New York* convey a particularly forceful emotional charge. The city is shown being built from the ground up, rising through a century and a half of willed continuity in a minute of screen time, with the Brooklyn Bridge, the Empire State Building, and the World Trade Center standing together for just a moment as the link between past, present, and future. The sequence

depicts a New York leaping into modernity, symbolizing a nation reaching out and extending itself into a globalized network of influence and power. The sequence is connected explicitly to the body of the film by the soundtrack, as U2 begins the instrumental lead-in to the closing song. In the next moment, however, the screen fades to black, as if the New York skyline, its symbolic meanings of connection, inclusion, and achievement, could not be visualized without the hopeful teleology of the World Trade Center. And in this moment of expressive cinematic punctuation, the "blood and tribulation" from which the city was born seems to return as a somber suggestion of conflicts yet to come.

8 | Haunting in the War Film: *Flags of Our Fathers* and *Letters from Iwo Jima*

Shortly after the introductory logo sequence of *Flags of Our Fathers,* a faint voice emerges from the darkness of the screen, a voice with an old-fashioned texture and grain, singing a song that sounds like a fragment of a half-heard radio broadcast. The lyrics, barely audible, come through as "Dreams we fashion in the night. Dreams I must gather," setting a mood of solitude, loss, and regret. The source of the song is ambiguous; it seems to float between the opening Dreamworks logo, crafted in antique black and white, and the beginnings of the diegesis, to be in both places at once, "haunting the borderlands." The song is neither on screen nor clearly off screen, neither part of the credits nor part of the fictional world. It suggests the ghostly offscreen voice that Michel Chion describes as the "acousmetre."[1]

As the narrative begins, another unlocalized voice is heard, but this time in a completely different register. As we open the film with shots of a lone character running on the dark surface of Iwo Jima, we hear another voice shouting "Corpsman! Corpsman!" It echoes and recedes as the character looks around and desperately tries to find its source. It then repeats. Disequilibrium and anxiety permeate these opening moments, as the voice seems to wander in and around the visual field, in the world of the story and outside it. Finally, the character, Doc, fixes the camera with a direct stare, as if the voice calling "Corpsman!" could come from only one place, the space of the spectator.

The uncanny effect of this opening scene of *Flags of Our Fathers* conveys a powerful sense of unease, a mood that pervades the whole of the film. This is partly due to the voice—as Chion says in *The Voice in Cinema,* "The sense of hearing is as subtle as it is archaic. We most often relegate it to the limbo of the unnamed; something you hear causes you to feel X, but you can't put exact words to it."[2] Here I would like to emphasize the words "archaic" and "unnamed," for these are the words that Freud associates with the uncanny. In this chapter, I argue that the motif of the haunting of the present by the past is key to the powerful affect that both *Flags of Our Fathers* and *Letters from Iwo Jima* convey, a theme that can also be found in a number of other war films. The unlocalizable voice that opens *Flags of Our Fathers* provides a kind of signature moment of this device, a haunting voice that seems to be everywhere and nowhere, a voice that can "see everything," that "no creature can hide from," and that creates a powerful opening impression of a fictional world haunted by ghosts, of a film and a character possessed by the past.

In a different but equally powerful way, *Letters from Iwo Jima* draws on the potent symbolism of the voice that "sees" and the voice that causes you to "feel." The film takes its title from a cache of letters buried in an Iwo Jima cave during the battle and discovered in 2005, sixty years later. The intimate history contained in these lost letters, a history of excruciating hardship, familial love, and courage in the face of certain death forms the subject of the film. With the discovery of the letters serving as a framing device, the film cuts directly from 2005 to the preparations for the defense of the island in 1945. The work unfolds as an extended flashback, as if the shades of the past were brought to life by the correspondence that had been secreted in the cave. In the film's final scene, the buried letters are fully unearthed, and are vocalized on the soundtrack as they tumble to the cave floor in a rushing, overlapping sound collage, as the thoughts and sentiments embodied in the letters are suddenly made audible. The voices crowd the sonic space, giving an eerie impression of the souls of the characters finally being released to tell their stories, to find their audience, and to seek their final destination.

Both films have an intense, spectral quality, placing in relief the unsettling and uncanny characteristics of the war film, a quality that pervades the genre. Despite its long-standing reputation for realism and

authenticity, the war film frequently departs from the conventions of verisimilitude to convey the nightmarish effects of a historical past that exceeds the representational range of realist forms. Although realism has provided a touchstone for the genre's development and an indexical sign of its good faith contract with the past, films such as *All Quiet on the Western Front, Hell's Angels, The Longest Day,* and *Apocalypse Now* are defined as much by their ghostly, spectral encounters as by their faithful reproduction, their close adherence to the experience of the generation that had gone before. Sonic and visual realism has been celebrated as the war film's particular contribution to the history of the cinema and a key to its historical legitimacy, but the cultural trauma that the war film conveys goes beyond the frame of even the grimmest forms of verisimilitude.

The past asserts itself in these films in ways that cannot be accounted through codes of realism and authenticity. The presence and persistence of the past is rather found in the way it seems to "possess" the present in the war film, seeming to haunt it and to shadow it at every turn. Many of the most important films of the genre include literal scenes of spectral haunting, the reappearance of the dead in memory and hallucination, or independently of the subjectivity of the characters, with images and the voices of the dead addressed directly to the viewer. Like a screen memory, the "reality effect" of the war film—the graphic impact of its battle scenes, the accuracy of its military maneuvers, the authenticity of its portrayal of the platoon or small unit—camouflages the deeper source of these films' affect, their way of conveying the spectral presence of the past, the reality of a past "that hurts."

Rather than verisimilitude, the reoccurrence of disembodied voices, premonitions, strange encounters, and traumatic memories suggests that the defining and distinguishing feature of the genre is the haunting of the present by the past, the past trying to possess the present. These motifs manifest themselves throughout the war film; faint fragments of voices and songs, ghostly encounters, a powerful sense of debt and obligation, of a legacy that must be repaid. Barely acknowledged in the critical literature, the theme of haunting provides a new way of looking at the war film, illuminating the presence of the past in film in ways that suggest the war film's power to evoke not just the tangible world but its uncanny double, a subject that shifts the discourse of the war film from ideals of authenticity to that which is invisible but still present.

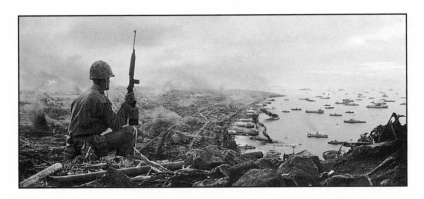

All Quiet on the Western Front, J'Accuse, and *Flags of Our Fathers,* for example, convey the return of the past in a literal, concrete way in the form of conversations with the dead, distressing memories and dreams, unmotivated flashbacks, and the collapse of realist space into a zone of unnatural manifestations. Other films, such as *Saving Private Ryan, Open City,* and *Letters from Iwo Jima* are dominated by the explicit recognition that the dead make claims upon the living. A film such as *Patton,* in another variant of haunting, depicts the main character as possessed by the ghostly memory of the past. In one scene, Patton visits the site of an ancient battlefield, and describes to General Omar Bradley in graphic detail the struggle there 2000 years before—the bloated corpses, the heroic last stand, the stripping of the bodies. He ends by saying simply, "I was there." The explicit theme of haunting is interwoven with codes of realism in the war film to create a potent figure of the genre and a key to its symbolic meaning.

In *All Quiet on the Western Front,* for example, the opening scene focuses on a German professor giving a lengthy, impassioned pro-war speech, trying to bully his young male students, who look to be about 16 years old, into enlisting in the army to fight for the Fatherland in World War I. As he speaks, the blackboard behind him displays two inscriptions, one in Greek and one in Latin, which seem to support the professor's argument. In the middle of his speech, however, the "writing on the wall" changes: now a different Latin inscription appears, as if some invisible agent erased and rewrote the original text. The new writing on the wall offers a very different message: "Whatever you do, do it wisely and keep in mind your purpose," undercutting the professor's emotional claim of how "sweet it is to die for the Fatherland."[3]

The motif of haunting is also connected to place. The war film, with its iconographic combat zones of trenches, foxholes, embattled beaches, jungles, and ruined villages possesses a special resonance as a sector of spectral encounters. This is especially evident in films set during World War I. In *All Quiet on the Western Front,* the trenches are portrayed as tombs for the living and the dead alike, together in one space. The main character Paul, for example, is shown spending a day and a night in a shell crater with the corpse of the man he has just killed, apologizing to him, promising to contact his family and claiming an identity with him. The grim setting is compounded by the scene that immediately precedes it: the shelling of a church graveyard, with caskets heaving from the ground. As Pierre Sorlin writes about the iconography of the World War I battlefield, the trenches, the barbed wire, the night patrol, the flares and searchlights, and the zone between the trenches known as No Man's Land defines these films in terms of an unspecified, confusing spatial geography—a space that is devoid of familiar landmarks.[4] Like the wandering Freud seemingly compelled to return to the same streets and squares of a provincial red light district, the locational machinery of the characters in these films—and by extension the spectator—is thrown off, suspended in areas of mist, confusion, and spatial disturbance.[5]

Flags of Our Fathers

In *Flags of Our Fathers,* the island of Iwo Jima, with its tunnels, its underground blockhouses, its concealed trapdoors and hidden gun emplacements is a fascinatingly mysterious zone of sudden appearances and disappearances, and a confusing space of unlocatable sounds, invisible enemies, and secret passages. Underground bunkers and tunnels honeycomb the island, with hidden trapdoors providing secret points of access to the surface. Eyewitness descriptions of the battle here describe how Japanese soldiers suddenly materialized, usually in the dark, seemingly from nowhere; American soldiers suddenly disappeared into the tunnels, as a trapdoor opened up beneath them while they huddled in their foxholes. Japanese troops moved freely just beneath the feet of the American soldiers. As one writer says, "This was surely one of the strangest battlefields in history, with one side fighting wholly above ground and the other operating almost wholly within it . . . The

strangest thing of all was that the two contestants sometimes made troop movements simultaneously in the same territory, one maneuvering on the surface and the other using tunnels beneath."[6]

The island of Iwo Jima has often been compared to a haunted zone, a place where the dead have palpable dominion and presence. Many texts refer to the "ghosts of Iwo Jima" and to the sacred status of the place, a status that Eastwood's quiet opening shots of the relics of the battlefield in *Letters from Iwo Jima* seem to reinforce. The most powerful impression of haunting in *Flags of Our Fathers,* however, comes from the famous photograph itself, a photograph whose effect on the lives of the main characters forms the subject of the film. Far from recording a searing moment of surpassing heroism, the photograph is a kind of double, a "second take" that acquires a life of its own, supplanting and erasing the event it is supposed to represent. Like the picture of Dorian Gray, the doubled image of the flag-raising, the uncanny aura that seems to surround it, destabilizes a concrete instance in time and brings "a new plot into what it is presenting."[7]

Flags of Our Fathers, with ambivalence and doubling built into the film's title, delineates the effects of false celebrity on soldiers whose actual experiences on Iwo Jima—of loss, dread, and guilt—have been supplanted by an image that now defines them. The photograph, as in ancient superstition, has somehow stolen the soul of the original event. Moreover, one of the participants in the second flag-raising has been misidentified. As Doc, the Navy corpsman, says to the Treasury Secretary organizing a reenactment of the event in the United States, "where do we imagine Hank was standing? Seein' as how he wasn't there it'll be pretty hard to leave a space for him."

The original flag-raising on March 23, 1945 was a celebrated event, cheered by all the soldiers within eyesight and on board the battleships anchored near the shore. A photograph was taken of the event, but it never received much attention. A couple of hours later, the first flag was replaced by a second, larger flag after one of the officers on the beach heard that the Secretary of the Navy had requested the original flag as a souvenir. Wanting to keep the first flag for the Marines, the officer had a second flag sent up the mountain. The second flag-raising was nearly missed by the photographers; the famous photograph by Joe Rosenthal of the Associated Press was taken on the spur of the moment, without

framing or set-up, and captured a purely workmanlike effort by the soldiers to raise the heavy pole. Although the replacement flag-raising was considered an insignificant event compared to the first, the photograph it produced became one of the most famous photographs in history.[8]

The strange doubleness that issues from the photograph—two flags, two images, two groups of flag-raisers—pushes the phantasmatic quality of photography to the surface of the film-text. The photograph of the second flag-raising, apparently grounded in the real and taken under combat conditions, is nevertheless riddled with uncertainty and doubt; it immediately takes on the unreal aspect of the replica. Rather than a recording of a punctual moment in time, it becomes a kind of instant monument. Its aura of singularity almost immediately gives way to the logic of seriality, as the photograph is reproduced in newspapers, posters, postage stamps, paintings, sculptures, and even in ice cream molds.[9] As the image proliferates, its connection to reality, to the actual event, disappears. It's "realism" begins to be questioned, as a rumor begins to circulate shortly thereafter that it was a staged event, a reenactment. And the three participating soldiers who survived Iwo Jima are subjected to the same hollowing out of the real.

Just as the photograph quickly becomes a monument to official nationalism rather than a punctual recording of an instant in time, the corporeal bodies of the soldiers, both the living and the dead, are also claimed, taken over, and "possessed" by nationalism. They are vested with an honorific, "heroes of Iwo Jima" that follows them everywhere. The aura of singularity—and the film stresses the individuality of the characters—is lost as the soldiers become part of a series, part of a bank of images exploited for national purposes, reproduced in whatever medium, and replaced when something or someone newly compelling comes along. Ira and Doc especially are aware that they have become symbols, grafted into a national narrative that has little to do with the grim work they performed on Iwo Jima. The loss of the real extends to their dead comrades, underscored by the substitution of one soldier for another in the official accounts. Throughout the film, they attempt to reclaim the meaning of their colleagues' sacrifice, to reframe the photograph in the actual experience of loss, returning again and again through memory, nightmares, and in the case of Ira, traumatized behavior, to the scenes that have been erased from the story.

Flags of Our Fathers juxtaposes three different time periods, cutting back and forth from the present period of James Bradley's research into his father's wartime experiences, specifically, into the question of why he never talked about Iwo Jima, to the narrative of the soldiers' training and the battle for the island in 1945, and the huge public relations campaign, the 7th War Bond Drive, which followed the publication of the photograph. The cutting from one temporal frame to another is sudden, jagged, and disorienting, creating an almost Eisensteinian impression of shock as the sensations of battle give way to scenes of celebrity photo ops with the three main characters during the Bond Drive. Rapid-fire and close-up shots of mortars exploding on the beach, followed by images of hand-to-hand combat and frightening nighttime guerrilla attacks shrouded in darkness and fog are juxtaposed with aggressively staged reenactments and celebrity appearances in America, as if the frenzy of battle and what Leo Braudy calls the "frenzy of renown" were at the same time radically dissonant and on some level oddly comparable.[10]

Replica, Effigy, and Aura

The film's counter-narrative of the flag-raising revolves around a particularly over-the-top staged reenactment at Soldier Field in Chicago. The three surviving soldiers, Doc, Ira, and Renne, have been recruited to tour the United States to raise money for the war effort by reenacting the event, speaking to groups of donors, and participating in staged meetings with the mothers of the soldiers from the photograph who were killed on Iwo Jima. At the center of the war bond tour is the reenactment in Soldier Field. The three men must scale a cheap papier-

mâché structure made to look like a volcanic hill and then plant a flag at the top. As they scale the structure, two of the soldiers, Doc and Ira, are drawn back to Iwo Jima in memory sequences that detail the deaths of their comrades. The deaths of the four other flag-raisers— Mike, Hank (a member of the original flag-raising team but not the second one), Harlan, and Franklin—are rendered as subjective flashbacks in the course of raising the flag at Soldier Field. The transition between the present and the past is marked at times by Doc's direct gaze into the camera, at other times by tight shots of hands and feet. Sounds of rocket fire, grenade explosions, scenes of mortal wounding and death, are intercut with fireworks, smoke, and amplified sound effects, over-arched by stadium lighting. The sound and light effects of the spectacle at Soldier Field, witnessed and cheered by more than 50,000 people, provokes an involuntary "witnessing again" for Ira and Doc. Far from honoring the soldiers, living and dead, who fought at Iwo Jima, the reenactment raises the ghosts of the past. The papier-mâché mountain becomes a haunted zone, an in-between place where the manufactured heroism and pasteboard setting commemorating the dead are unhap-pily populated by the presence of their spectral doubles.

To a certain extent, the surviving soldiers are traumatized as much by the image that follows them as by their actual experiences on Iwo

Jima. The image becomes a repository of a false history that haunts their daily lives, that hollows out their actual history, sapping its reality from within. The photograph appears in different forms throughout the film, like a traumatic memory whose themes are repeated and varied throughout waking life. The image appears in huge murals as a backdrop to the three men's celebrity appearances in the U.S. It pops up on posters throughout the cities they visit, including the outside wall of the bar that will not serve Ira because he is an American Indian. It appears as an enormous sculpture in Times Square, as a small serving of sculpted ice cream at a State Dinner, in paintings copied from the photograph, in postage stamps, in the Marine Corps War Memorial, and in sad recreations of various kinds, such as the one at Soldier Field. The reenactments turn the soldiers into living effigies as they traverse the country. At the end of the film, Ira, working in the dusty Arizona fields as a laborer, is approached by a suburban family on vacation and is asked to pose for a photograph. Ira dutifully takes out a tiny American flag, holds it up for the camera's viewfinder, and reenacts, in a dignified but still degrading way, what has become, unwittingly, the signature moment of his life.

A Machine for Raising Ghosts

The memories of Doc and Ira revolve around two events that rise to the level of traumatic memories over the course of the film. Doc has "lost" Iggy when he set out from their foxhole alone to help another soldier. When he returns, Iggy is gone. Doc reacts frantically, certain that he has returned to the right foxhole, and finally discovers a hidden trapdoor built into the base of the foxhole. Doc later finds Iggy's corpse, grossly mutilated in a tunnel. Iggy has been pulled into the earth from this secret trapdoor, tortured, and killed. It seems the memory haunts Doc throughout his life, for the film opens with the elderly Doc, collapsing on the stairs, and crying out "Where is he? Where is he?" For his part, Ira circles back, again and again, to memories of Mike, his sergeant and a man he calls a "real hero." One of these memories, however, features Mike savagely bayoneting, over and over again, a Japanese soldier he has already killed. But the repeated memory that brings Ira to the brink is the memory of his own bayoneting of a Japanese soldier in hand to hand combat, an event he cannot leave behind. The heartbreak, loss,

and guilt conveyed in these scenes demystifies the triumphalism of the official photograph.

Benedict Anderson has written about the logic of official nationalism's monuments, the repeatable, substitutable logic of images, of heroes, of national figures. Describing the "nonchalant substitutability of effigies" at the Washington Mall and Mount Rushmore, for example, he writes, "It is here that one starts to realize the singularity of late official nationalism's human images, which is that they can never, as such, be singular . . . this means that heroic national monuments do not have auras, such as one senses in the originality of: *Las Meninas*—under any, even unnatural lighting—the Wailing Wall, or Angkor Wat . . . the fact that national hero monuments are auraless also means that they circulate extremely easily through different media—stamps, t-shirts, postcards, wallpapers, posters, videotapes, place mats, and so on—without anyone feeling profaned."[11]

"Film does not capture and reproduce the real, so much as it already haunts reality, sapping its apparent solidity from within." The cinema, as Steven Shaviro continues, is "a machine for raising ghosts."[12] *Flags of Our Fathers* raises the ghosts enclosed and displaced in the photograph, bringing them back to momentary visibility, staging their presence, and marking the way they haunt the corporeal world.

Photography here reveals itself as a medium in the occult sense, a medium that saps the reality of the event while uncannily calling it forth, calling out to the living to witness again and again the ghostly remnant of an occurrence that has been detached from the real and grafted onto another kind of narrative. By employing the medium of photography to restore the singularity of events on Iwo Jima, this Eastwood film uses the image to break the spell of the image, to reframe the moment when the dead were "simultaneously forgotten, replicated, sequestered, serialized, and unknown."[13]

Letters from Iwo Jima

The second film in Eastwood's World War II diptych, *Letters from Iwo Jima,* immediately sets itself apart from all previous war films by focusing on the question of suicide. Nearly taboo in western culture and rarely represented in American films, suicide occupies a space in the U.S. imagination that is deeply other. In U.S. war films, suicide has conventionally served to mark the enemy; the perceived fanaticism of kamikaze pilots in World War II films or the blind frenzy of suicide bombers in films about contemporary Arab and Islamic conflicts define them as pathological agents of cultures that are essentially unknowable and incomprehensible. In the few films in which suicide is represented as occurring in the U.S. military context, the act is portrayed as an anomaly, the lethal end product of abuse or torture as in *Full Metal Jacket, The Deer Hunter,* or more complexly, *Courage Under Fire.* The collective suicides of Japanese soldiers during World War II, which involved, in the case of kamikaze pilots, young men from the highest and most educated echelons of society, have remained indelibly "other." As one writer says, "To knowingly and voluntarily sacrifice one's life for the sake of a perceived greater good challenges the sanctity of individual choice and right to self-determination deeply cherished in liberal, Enlightenment social thought."[14]

The reenactments of honor suicide in *Letters from Iwo Jima* serve, however, as the dramatic center of the film and as the rhetorical frame for exploring the culture and psychology of self-sacrifice. Extraordinarily intense, the three suicide scenes are exemplary studies in what Bela Balasz called the "micro-dramas" of the human face and body in film. Ranging from an almost convulsive physical struggle—the agony

of the self fighting against the self—to what seems like a serene sense of acceptance, *Letters from Iwo Jima* contests the stereotypical view of Japanese honor suicide, using suicide as an internal frame to bring issues of history, ideology, and cultural difference into close, microscopic view. In so doing, *Letters from Iwo Jima* quietly and sympathetically moves what is ordinarily seen as the absolute otherness of Japanese wartime behavior into a larger frame of reference.

As one commentator writes, "The Japanese military tradition had a distinctive, almost unique element. Where German soldiers were told to *kill,* Japanese soldiers were told to *die.*"[15] This tradition, however, was not blindly followed or fanatically observed: in many cases, soldiers were opposed to the practice but seemed to reproduce it in their actions. As Emiko Ohnuki-Tierney writes about kamikaze pilots, "At some point these young men became patriotic, but what was their *patria*? Was it their homeland, Japan? . . . Was it the emperor for whom they sacrificed their lives? Or was it their family, lovers, friends? . . . some defied outright the emperor-centred ideology. Others tried to accept it without success." The commanding officer of the Japanese forces on Iwo Jima, General Tadamichi Kuribayashi forbade honor suicide and banzai suicide charges, hoping to hold out for as long as possible in a war of attrition that would inflict heavy casualties and that might delay the seemingly inevitable American invasion of the Japanese homeland. Nevertheless, he committed his troops to a last, all out attack, and probably ended his own life.[16] The film poses the issue of honor suicide as a question, and provides three culminating dramatic scenes that highlight the gulf between nationalist ideology and stereotype and the exquisitely individual character of self-sacrifice.

The ethic of self-sacrifice was aggressively promoted by the military government, but it was rooted in traditions and distinctive symbolic codes that were intrinsic to Japanese cultural identity and community. Ohnuki-Tierney writes that the practice of self-sacrifice in the military can be traced, paradoxically, to the Japanese embrace of Confucianism, a philosophy centered on the individual and on humanistic self-cultivation. Confucianism formed the basis for ideals of loyalty, and beyond that, sacrifice, which paved the way for Japan to become "a modern military nation for which individual sacrifice was essential."[17] The Japanese military government appropriated a number of

other traditions and distinctive symbolic codes as well, including patterns of filial devotion, the cherry blossom ritual, and the samurai code of "Bushido," converting long-standing cultural practices and social rituals to the expression of a militaristic ideology.

Wartime Japan can thus be understood as a crystallized expression of what Walter Benjamin calls the "aestheticization of politics"—the conversion of social rituals, artifacts, and symbolic codes to a message of collective loyalty to a political system, similar to Hitler's dramatic translation of German folk rituals and aesthetic traditions into the mythology of the Third Reich, and Mussolini's appropriation of ancient Roman symbolism to Fascist iconography. In imperial Japan, the artifacts, rituals, behavior and symbols peculiar to the Japanese community—Confucianism, the cherry blossom ritual, devotion to family, and reverence for ancestors, among others—were channeled into emperor worship and a particularly lethal form of loyalty to the "ultimate family," the nation-state. Far from acting out of fanaticism or mindless adherence to the cult of the emperor, many of the kamikaze pilots of World War II, Ohnuki-Tierney writes, were highly critical of the ideology of the General Imperial Command, but found they had no choice but to reproduce it in their actions. *Letters from Iwo Jima,* like its counterpart *Flags of Our Fathers,* traces the distance between the motivations and psychology of the individual soldiers and national myths of honor and heroism.

The Samurai Code

One of the most resonant cultural traditions depicted in the film is the samurai code of Bushido, the "warrior way." The code of Bushido is evoked again and again by the officers serving under Kuribayashi, many of whom proclaim their adherence to it even as they disobey Kuribayashi's orders. Condensed into the belief that a soldier's duty was to die, a belief asserted by the officers at numerous points in the film, the repurposed samurai code is depicted as a form of political beguilement. A kind of hypnosis or trance seems to overcome many of the officers at the first manifestation of possible setback or defeat. The officers seem to be possessed by a deeply pathological sense of national duty. Calling the self-annihilation of soldiers on Iwo Jima a "corruption of the code of Bushido," James Bradley writes: "A traditional samurai might

expect to die in combat and be honored for it. He might kill himself to atone for a moral mistake or a failure of courage. But suicide as an expression of ultimate sacrifice for one's country was not a traditional samurai value. This was a construct of a deranged military establishment cynically bent on extracting the maximum utility from its *issen gorin*."[18] One of the officers begs Kuribayashi, several times, to be allowed to commit suicide. Another, in what becomes an almost comic routine, straps a couple of land mines onto his chest and tries to find an American tank to roll over him. A third presides over the collective honor suicide of soldiers under his command, essentially shaming them into self-annihilation. Kuribayashi's biggest challenge in the film appears to be overcoming the allure of honor suicide among the officers, some of whom disobey his direct orders to fight to the death, insisting on sacrificing their men by making suicidal banzai charges or by blowing themselves up with grenades.

Counterbalancing the officers in the film, who appear to be programmed to sacrifice themselves as well as their men, is the character of Saigo, a young conscript who has promised his wife and unborn child that he will return. Present at each of the three suicide scenes, he is spared from certain death each time.[19] Saigo's determination to stay alive becomes a kind of quest in the film, a seemingly impossible outcome given the destructive forces unleashed from within the Japanese military establishment as well as from the American attack. His transit through the tunnels, caves, and the nightmarish landscape of the battlefield, and his ultimate arrival at the side of Kuribayashi, provides a powerful rooting interest for the audience. Saigo's success, against all odds, in staying alive provides the film's dramatic resolution.

"Thou Shalt Die Like Beautiful Falling Cherry Petals"

The first, collective suicide in the caves conveys the soldiers' deaths as a struggle, a convulsive, physical battle of the self against the self. Unlike most war films, *Letters from Iwo Jima* has almost no scenes of muscular combat; instead, the combat is waged internally. In this scene, an officer who has been portrayed throughout the film as a cruel martinet, a young man poorly equipped to lead, both intellectually and morally, decides to disobey General Kuribayashi's orders to retreat and orders his men to "die with honor." "Men, we are honorable soldiers of the

Emperor. Don't ever forget that. To die with honor, this is our fate, to find our place at Yasukuni Shrine." Each soldier draws a grenade, struggles to fight back an overwhelming sense of fear and sorrow, and then blows himself up. The cave, shown previously in monochrome, in the colors of pewter and charcoal, suddenly erupts into a sickening orange-red as the bodies of the soldiers burst open. Here, the characters' figure behavior, the micro-drama of the human face, and the expressive use of close-up filming reveal the competing emotions of the soldiers with extraordinary power. Struggling against themselves, the bodies of each of the soldiers seems to be "possessed" by some kind of diabolical force. The powerful sense of identification and empathy that the collective suicide elicits in *Letters from Iwo Jima*, as the camera observes each soldier's internal agony in extended psychological

close-up, is countered by an equally strong sense, underscored by the figure behavior, lighting and sound, of suicide as profoundly "other," as transgression, as taboo.

The primal violence of honor suicide comes through as much through the figure behavior of the characters as through the act itself. The soldiers' physically struggle to pull the pins on the grenades and then to hold the grenades to their stomachs. The scene creates a powerful impression that there is an external being moving the limbs of the characters, a being controlling their arms and their hands, forcing them to activate the grenades and overpowering their will to survive. The desperate struggle the soldiers wage with themselves as they attempt to resist the invisible double that is directing their limbs and insisting on their self-destruction is palpable and explicit: each character seems to wage combat, a battle of wills, against an opponent who forces their arms to move according to its own desires. Perhaps the most moving of these suicides in the caves is that of Saigo's friend. As the officer intones the words of sacrifice, "To die with honor. This is our fate. To find our place at Yasukuni Shrine," the camera cuts to a close-up of the man holding family pictures. Weeping, struggling with emotion, his body seemingly unable to complete the act, he is barely able to pull the pin and force the grenade against his body. Finally, he slumps against the cave wall in a kind of visible gesture of surrender. As the grenade explodes against his chest, the camera pans along a wisp of smoke to a close-up of his bloodied hand holding the spattered photographs of his wife and children.

Here I would like to depart from the historical context and explanations for honor suicide on Iwo Jima and draw on another vocabulary to describe the effect of these scenes. In this first collective suicide, the struggle of the soldiers to complete the act recalls various films of demonic possession. I am thinking in particular of the several film versions of Dr. Jekyll and Mr. Hyde, in which a physical struggle takes place, a struggle for dominance over the body and the will, a muscular struggle against a stronger opponent. The idea of a physical, mortal struggle, of the self against the self, imbues these scenes as well. An alter-ego, an anti-self, seems to possess the characters. Although the soldiers were earlier seen criticizing the plan that they should all die on the island, they nevertheless perform their roles as "honorable"

soldiers. As Ohnuki-Tierney says, the soldiers "reproduced in action the emperor-centred ideology while not embracing it and sometimes even while defying it."[20]

In this regard, the film intersects thematically with *Flags of Our Fathers*. On the American side of the battle, the soldiers who were lionized throughout the United States for raising the second flag "reproduce in action" the myth of heroism, although they reject the myth and at times openly defy it. In *Flags of Our Fathers,* a specifically American form of spectral possession is crystallized in the Iwo Jima photograph. The power of the media to create a second, shadow self that overwhelms the living, a kind of second life that hollows out the real, is condensed in the famous photograph and its cultural after effects. *Letters from Iwo Jima* depicts a similar kind of spectral possession in the way the cult of the emperor overcomes the soldiers' instinctive desire to live. Using an emotionally charged repertoire of symbols and images, the militaristic Japanese government managed to convert certain traditional, familial, and ancestral symbols to emblems of heroic sacrifice for the nation.

One of these converted symbols was the cherry blossom tree, which is the most significant feature of Yakusuna Shrine, and is cited in the patriotic suicide speech given by the officer in the scene described previously. Long a symbol of the nation of Japan, and a carrier of numerous

messages and meanings—death and rebirth, relations between men and women, the sexual allure of the geisha, shifts in social identity, the "anti-self"—the cherry blossom ritual was used by the military government to aestheticize the soldiers' sacrifice for the emperor. It became the master trope of Japan's imperialism. As one writer says, "The symbol of cherry blossom came to represent the 'Japanese soul'—an exclusive spiritual property of the Japanese that endowed young men with a noble character, enabling them to face death without fear—'Thou shalt die like beautiful falling cherry petals for the emperor.'"[21] In *Flags of Our Fathers,* the three remaining soldiers find themselves transformed into living symbols whose role is to represent—and honor—all the soldiers lost in the war. In *Letters from Iwo Jima,* the soldiers become symbolic of Japan, its nobility and fearlessness, but only if they die. And a solider's death is deemed especially symbolic if it comes at their own hands.

The Face of the Other

The second suicide scene involving the cavalry officer Baron Nishi, is filmed in a way that ennobles the character; his figure behavior, the micro-poetics of his facial expressions, and the staging of the scene dignify the act in a style that directly contrasts with the gruesome collective suicide earlier in the film. Once again, Saigo is present, and serves as he did at the first suicide scene as a mute witness. Nishi is portrayed as a cultured, sophisticated man, the scion of an old and wealthy family, who had spent time in America. A famous equestrian, he won a gold medal at the Los Angeles Olympics of 1932. According to the author Richard Wheeler, Nishi did not believe in honor suicide, or in the practice of Bushido—fighting to the death—finding it to be a senseless holdover from feudal times, when face-to-face battle and hand-to-hand combat were the norm. In the extended battle on Iwo Jima, by contrast, the antagonists were largely invisible to each other. As Leo Braudy writes, "the central revelation [of the two films] is that neither side really knows much of the human nature of the other. In such a war, the ancient honor of hand-to-hand fighting with an enemy you may actually know is lost."[22]

In what can be read as a challenge to the code of the Japanese military, Nishi goes to great lengths to save the life of a wounded American

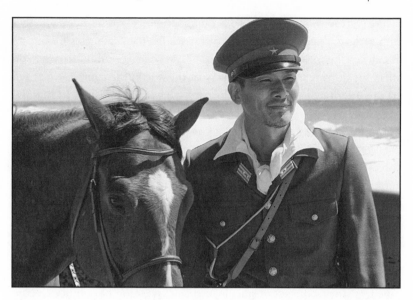

soldier they have captured, treating his wounds and drawing him into conversation, essentially making him visible to the Japanese soldiers under his command. Nishi's compassionate act reveals the humanity of one side to another. In the course of this "face-to-face encounter" with the other, the soldiers, on both sides, hear what the philosopher Emmanuel Levinas names the "call of the other."[23] Another code comes into prominence, one that works against the imperial narrative, a code that is distilled in a letter the American soldier Sam has received from his mother, "Do what is right, because it is right."[24]

Soon after, Nishi's headquarters are attacked. Rushing to the mouth of the cave with his rifle, the first to arrive at the defense, he is severely wounded, his eyes burned by explosives. Blinded, he tells his medic to "go help the others. I'm useless now." He removes a silk scarf from his neck and ties it around his eyes. After determining that his men can no longer hold the position, Nishi orders his lieutenant, Okubo, to take command of the troop and make their way north. He will stay behind: "I'm a one-man show from here on out."

In his farewell address, Nishi tells his soldiers to "do what is right, because it is right," quoting the letter from Sam's mother. His soldiers stand at attention and salute. Nishi, standing erect, dressed in a gleaming

white shirt with the white scarf around his eyes, claps his heels together and returns the salute. He then dismisses his men. He asks Okubo to hand him his rifle, and softly says, "I am sorry, Okubo." As the soldiers file outside to make their way to the north, the camera cuts back to the interior of the cave. In close-up, we see Nishi's bare foot, moving slowly up the stock of the rifle to locate the trigger. The camera continues tracking upward, as he grasps the charm on a necklace, and then removes the scarf. In a continuous vertical movement, the camera looks into his damaged eyes, and continues moving upward, to the blue mouth of the cave. The film then cuts to the outside of the cave, and fixes on Okubo as a single shot is heard and smoke wafts from the cave entrance.[25]

Nishi's calm, almost spiritual facial expression, the striking effect of the soft white shirt and scarf he wears, and the sensual camera movement that follows the movement of his foot up the stock of the rifle transforms the act of suicide into an expression of nobility. In contrast to the horror evoked by the grenade suicides, Nishi's self-extinction is staged almost as a kind of transcendence; the light shining on his face, the slow vertical lift of the camera, the deep blue frame provided by the mouth of the cave—the visual cues suggest the iconography of a Medieval or Renaissance painting. Another striking contrast with the first suicide scene is found in the differences between the two farewell speeches. Nishi asks his men to "do what is right, because it is right." Missing from the speech is any reference to the emperor, honor or duty. Instead, these basic, direct sentences address the soldiers at a personal level.

At this point, the meaning of honor suicide takes on a different coloration. The face-to-face encounter with the other that immediately precedes the act shifts the message from rigid adherence to the military honor code to an individual, ethical response. In Levinas's words, "the original meaning or impact of ethics (and accordingly the meaning of every human action), does not have its origin in myself, but in "The Other."[26] "We understand that the face is not something seen, observed, registered, deciphered or understood, but rather somebody responded to. I can only and only I can respond to the injunction of a face."[27] Nishi's compassionate treatment of Sam in the scene just prior, frames the suicide in terms of the call from the other, underscored by

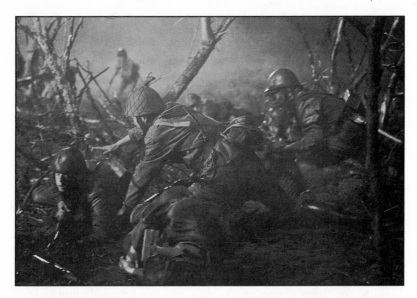

the "letter from Iwo Jima" he has just read aloud. His ethical, empathetic response to Sam, his face-to-face encounter with the other, refutes the doctrine that in war, "there are no others, only enemies."[28]

"This is Still Japan"

Each of the visualized suicides are in some form a response to a call; each is portrayed as a recoded enactment of the imperial military code, a rewriting of the code of military honor that brings a number of new and surprising messages to the foreground. In the grisly grenade suicides in the caves, for example, the soldiers are seemingly possessed by the power of ideology, forcibly moved by a false sense of obligation to commit an atrocity against themselves. The first suicide evokes the radical "otherness" of the act of self-annihilation. The suicide of Baron Nishi, in contrast, unfolds as an ennobling gesture, one that brings to the surface connections between self and other, the points of common humanity linking the Japanese and the Americans. His self-sacrifice is visualized in a way that invites the audience to consider the act sympathetically, to identify with the character and to sense the symbolic meaning of the act. The suicide of Kuribayashi moves along a similar line, an expression of closure that serves to expand the symbolic horizons of the film.

In his cave headquarters as the siege of the island is coming to an end, Kuribayashi tells Saigo, "I promised to fight to the death for my family, but the thought of my family makes it difficult to keep that promise." Just after he says these words, a radio broadcast comes over the air, a broadcast featuring the children of Nagano, Kuribayasi's home town, singing a song of thanks to him and his soldiers. Lyrics such as "Imperial country, Imperial land," and "pride, honor at any price," stand out as motifs, along with the refrain "Iwo Jima," but the beauty of the children's voices, and the lilting melody, carry a powerful emotional charge. The camera cuts among Kuribayashi, Saigo, and Fujita, the adjutant to Kuribayashi, as each is nearly overcome by emotion. The radio broadcast condenses themes of family, empire, pride, and peace and makes explicit the government's use of the imagery of family love to foster a sense of the "national family" and love of the emperor. Despite this explicit ideological meaning, it creates a strong acoustic bond, a close sonic connection to memories of home and family.

Kuribayashi immediately sets about ordering a general attack. He asks Saigo to do him a favor, to stay behind to burn his military chest and all his documents. Kuribayashi addresses his soldiers for the last time, and tells them "to be proud to die for your country. I will always be in front of you." He then draws his sword out of its scabbard, and leads the men in a nighttime attack on American lines.[29] Crosscut with the final attack are scenes of Saigo burning Kuribayashi's military documents and burying the pouch containing the letters written by the soldiers that were never delivered to the Japanese homeland.

Kuribayashi, leading the attack, is severely wounded, and pulled away from the battle by his lieutenant, Fujita. As night gives way to day, he is dragged down a dark sand hill by Fujita, with black dust pluming up behind. The desolate landscape, featureless except for the sand and empty sky, has an abstract Zen-like quality, unmarked by craters, trenches or corpses. Kuribayashi orders his lieutenant to stop, saying "No more. No more. Thank you, Fujita." He then tells him to take his samurai sword and behead him, in ritual Japanese fashion.

Kuribayashi pulls himself up on his hands and knees, tells Fujita that this is an order, and prepares himself for death. Just before he administers the blow, Fujita is shot from behind by a lone GI up on the ridge. Kuribayashi's facial expressions give an impression of being

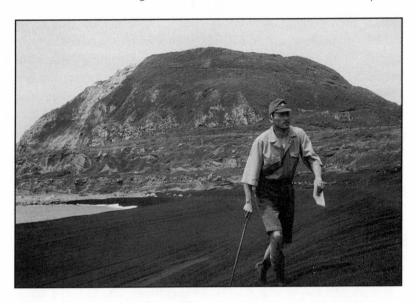

tricked by some extraordinary fate. In his written instructions to his soldiers, the historical Kuribayashi had said that "yours not to die a noble and heroic death; yours to live the most excruciating life."[30] It seems his words are now coming back to haunt him. Just then Saigo appears, shovel in hand. Kuribayashi asks one final favor, to bury him where he cannot be found. Looking out to sea, he then asks if this is still Japanese soil. Saigo assures him it is, and Kuribayashi takes the pistol he had been given by the American officer at a dinner in his honor, cocks it quickly, and shoots himself in the chest.

Saigo watches over Kuribayashi in a way that situates his suicide on the farside of military tradition, drawing instead on the imagery of family, home, and the passing of one generation into another. The continuity symbolized by the film's closing moments—the rising sun, the survival of Japan, the youthfulness of Saigo—translates Kuribayashi's death into a semaphore of positive emotion. Instead of focusing on the face of Kuribayashi, the camera concentrates on Saigo, whose quiet, unflinching demeanor underlines the dignity of the event.

The coda of the film returns us to the cave headquarters of Kuribayashi, where the pouch of letters buried fifty years before has been discovered. As the bag containing the letters is lifted from the shallow hole, the camera cuts to a low angle position, as if it was in the hole

looking up, assuming the point of view of the letters, or of someone buried with the letters. As the handwritten texts spill from the bag, the camera follows them as they float to the ground, and the "voices" of the letters are heard, voices that multiply and blend into one another. Here, ghosts long buried seem to be released. A film that had been almost exclusively focused on the question, "How will they die?" now brings the dead back to life in the form of letters to the people the soldiers loved.

The dead here, as in *Flags of Our Fathers,* seem to call to the living. The haunted letters of Iwo Jima, spilling out of the bag at the end of the film with the voices of the soldiers intoning the words, words never delivered "in time," and now overlapping, as if rushing to be heard, reaching from decades past to the current generation.

Chion's concept of the acousmetre, the disembodied, phantom voice that haunts the image track can be enlisted here. Although we see characters throughout the film writing letters, and hear the letters of Kuribayashi and Saigo as they give subjective audition to the lines they are writing, the role of the letters as a repository for the voices of the dead is only manifest in the final images. The film's final shots come with particular force, as if the unseen letters, collected and buried, were speaking all along, speaking through the visuals, imbuing the echo chamber of the caves and tunnels with their phantom presence. The flood of voices that suffuses the sound track suggests a resurrection, almost as if the characters we have seen and followed throughout the narrative were ghosts or puppets enlisted by the film's voices, the ghostly voices sealed in the letters in the ground.

Conclusion

In dramatizing the battle of Iwo Jima from both sides of the conflict, the two films, *Flags of Our Fathers* and *Letters from Iwo Jima,* confront the viewer with an unfamiliar set of demands. The doubled narratives of enemy combatants, with soldiers from both sides portrayed with equal sympathy and conviction, force the viewer to constantly check the impulse to "take sides" in the depiction of battle. The films remind us that the basic semantic "deep structure" of the war film—the agonistic conflict of nations—centers on the individual soldier enacting two competing roles, performing both as a "killing machine"

and as the embodiment of a national ideal. Acts that would otherwise be condemned—the release of violence and aggression, the suspension of civilized norms, the conversion of the soldier's body into a killing machine—are, in war, celebrated as an ideal form of heroic citizenship. Both films emphasize the gap between the reality of combat and the rhetoric of heroism and honor. Both *Flags of Our Fathers* and *Letters from Iwo Jima* draw in careful psychological shadings the cost this contradiction exacts on the individual soldiers. The motifs of haunting and doubling, of replication and erasure, of celebrity and oblivion that are so prominent in these films dramatize the way nationalist ideology hollows out the lives of the soldiers, making effigies out of the living and the dead alike.

At the same time, both films also hold out the prospect of what Benedict Anderson, with sincere but guarded feeling, calls "the Goodness of nations." With his customary irony occasionally giving way to earnestness, Anderson locates three sites of "guaranteed national Goodness:" the Unborn, for whom we sacrifice, preserve, conserve, and try to fashion a better world; the National Dead, whose sacrifice for nation is always noble, no matter the battle or the cost to the other side; and the Living, for whom the nation holds out the strongest possibility of fraternity. Although the nation may be imperfect or even Wrong, he writes, it almost always deserves "another chance." "And do not most of us want, against the odds, to give our nations another chance?"[31]

The theme comes through most strongly in the closing moments of each film. In *Flags of Our Fathers*, the final sequence consists of the flag-raising team on Iwo Jima running into the ocean to take a swim, a scene filmed in color and overflowing with spontaneous pleasure. The scene is rendered as the memory sequence of Doc Bradley on his deathbed. And the final scene of *Letters from Iwo Jima* depicts the spilling out of the long-buried letters, discovered after fifty years of oblivion and finally given audition. As the letters tumble to the floor of the cave, they speak of love and desire, not of obligation and sacrifice. The swimming in the surf, the voices that are finally heard, these are the ghosts of the unbounded life that the past, non-monumental and non-heroic, can sometimes convey to the present and the future.

9 | Trauma and History in *United 93* and *World Trade Center*

Simultaneously disruptive and conservative, the narratives of *United 93* and *World Trade Center* occupy an odd netherworld of historical representation—challenging in terms of subject matter, but narrowly circumscribed in their approach. Shaped by the cultural barriers erected around the memory of 9/11, both films are scrupulous in their pursuit of authenticity, and yet focus on such a narrow slice of history that they seem to deflect historical understanding as well as any larger sense of "coming to terms." While not rising to the level of prohibition that surrounded Holocaust representation before *Schindler's List,* the idea that it is still "too soon" to represent 9/11 has permeated much of U.S. culture, a perception that apparently influenced the filmmakers to rigorously delimit their works. As the critic and essayist Frank Rich has commented, however, perhaps it is already "too late"; the event has begun to fade from memory, the culturally therapeutic value of representing the event may no longer hold, and geopolitical realities in Iraq and Afghanistan may have superseded the event itself.[1]

Both *United 93* and *World Trade Center* have been approvingly characterized as politically neutral acts of memorial representation and as straightforward narratives of self-sacrifice and collective determination. Both films perform a certain kind of cultural work, reframing historical trauma as a narrative of heroic agency. Radically different in their visual styles and in the particular elements of the events that they

190

portray, these two subdued and tightly focused works each follow a narrative arc that emphasizes human agency and collective heroic action in the face of overwhelming catastrophe. Sensitive to the demand that representations of 9/11 have a special connection to "discourses of responsibility," the films rehearse a pattern that has emerged as a culturally dominant formula, underscoring the theme of heroism in a much larger landscape of victimization. Nowhere in *United 93* or *World Trade Center* are the compound contexts, the traumatic cultural and social effects, the devastating losses or the profound alterations of national life that characterize 9/11 registered; instead, linear narrative patterning and classical limitations of character, place, and time impose a rigorous and singular structure. Adherence to the "discourses of responsibility" seems, in both works, to have led to a determined refusal to acknowledge the radical alteration of national life wrought by 9/11.

The Hitchcockian Blot

Rather than observing the "discourses of responsibility," limitations of form and content of this sort might be read as a symptom of cultural repression, the "too soon" or "too late" suggesting the skewed temporality of trauma. Understood in terms of the ongoing historical narrative of the United States, 9/11 has begun to seem like a prohibited zone, an event that cannot be assimilated beyond a few singular strands, the isolated bits that confirm a national story of heroism and providential guidance. An unstated consensus seems to be emerging that 9/11 should be considered a hallowed event in that "graven images" should not be made of it, suggesting that just beneath this veneer lurks a sense of fear and dread. The refusal of several CBS affiliates to air a documentary on 9/11 at the five year anniversary mark, ostensibly because of the strong language used by the firefighters and other rescuers is a symptom of this tendency, which has become more pronounced over time: the same documentary had been aired twice before on CBS.

In psychoanalysis, a distinction is made between "acting out" and "working through," a distinction that the historian Dominick LaCapra has applied to historical narratives dealing with the Holocaust. Seen as initial dramatic responses to 9/11, the two films' insistence on the literal, narrow representation of events can be understood as an example of "acting out," the recreation of the traumatic event in a form

that is largely depleted of context or temporal extension. LaCapra describes "acting out" as a melancholy possession of the subject by the past. "Working through," by contrast, suggests a breaking out; without freeing oneself from trauma, the subject attains a "measure of critical purchase on problems."[2] Despite their emphasis on agency and positive action, *World Trade Center* and *United 93* seem closer to the spirit of melancholy possession than they do to the spirit of attaining a "measure of critical purchase."

Although these works carefully screen out the most catastrophic images and effects of 9/11, they still manifest a disturbing intensity of affect. A sense of adrenalized stasis dominates the tone especially of *United 93*, a mood compounded by both films' focus on the profound disconnection, claustrophobia, and sense of helplessness suffered by the characters. Both films emphasize an inability to communicate, numbing isolation, and an almost literal experience of paralysis. Despite the traditional plotting of these works, the traumatic nature of the events of 9/11 is conveyed through their visual and acoustic design. As in melodrama, the tensions in the narrative are in effect somatized, displaced into the body of the film-text.

E. Ann Kaplan and Ban Wang describe cinematic attempts to render historical trauma as a somewhat paradoxical endeavor. Trauma, they point out, is often considered the ultimate limit of representation, the collapse of symbolic systems, what is left after the destruction of the capacity to signify. "The traumatic experience has affect only, not meaning . . . the affect is too much to be registered cognitively in the brain."[3] In these definitions, the traumatic event is so profoundly disturbing to the victim that it cannot be communicated; its symptoms emerge only in the form of nightmares, hallucinations, incoherent speech or phobias. When applied to wide-scale historical events, however, this type of clinical description, based as it is on individual cases, short-circuits both historical analysis and narrative representation. Although many cultural critics have adopted this asymbolic model based on individual, clinical cases—trauma as resisting symbolization—it clearly falls short of providing a discursive paradigm for dealing with the overwhelmingly catastrophic occurrences of the twentieth and twenty-first centuries, which have increasingly consisted of traumatic historical events. Recent history is more and more a series of shocks on an unprecedented

scale with events that confound existing forms of historical explanation and require a new representational vocabulary.

Calling for a revision of the asymbolic clinical model, Kaplan and Wang make the striking point that "history has shown that intensely traumatic events have spawned more narratives and images, rather than less."[4] Contemporary theorists, such as Hayden White and Thomas Elsaesser have written extensively about the obsessive, traumatic nature of twentieth and twenty-first century historical events. Central to this analysis is the fact that the extreme, compound nature of "modernist" events is reinforced by the media: the continuous video replays, the endlessly repeating loops of disasters such as the collapse of the World Trade Center, the obsessive coverage of the Katrina storm and flood, and the space shuttle disasters speak not to the collapse of signifying capacity but rather to the deep connection between saturation media coverage and cultural trauma. The attack on the World Trade Center, as one critic has said, was "the most widely observed breaking news event in human history, seen that day in still photos, on the internet or on television by an estimated two billion people, nearly a third of the human race."[5]

Despite the extreme, explosive nature of modernist historical events, amplified as they are by the media, historians have tried to situate them into existing historical paradigms. For some progressive historians, for example, 9/11 precipitated a reframing of the narrative of the American nation, provoking a new consideration of U.S. history in relation to the rest of the world. Such a focus changes the look of American history, forcing a different, more global perspective on the past. The Revolutionary War from this perspective seems like a small incident in a centuries-long global competition among colonial powers vying for dominance. Similarly, the traditional emphasis of late-twentieth century American history on the Cold War has begun to give way in importance to postcolonial and neocolonial frameworks. And the history of ethnic migrations, and in particular, the history of Muslims in America, has begun to displace the traditional focus on superpower politics.

But other historians, from a very different perspective, situate the event in terms of American exceptionalism. A doctrine that had been largely discredited by the rise of social histories in the last decade, American exceptionalism has returned as a powerful paradigm among

neoconservatives. In this view, the United States is understood to be unique among the nations of the world, a viewpoint that emphasizes the special role America plays in the world, "what makes it different from others." In this understanding, the underlying ethical vision of the American story, its central theme, is made visible by its opposition to competing large-scale ideologies. The value of the civilization represented by the United States has, since 9/11, become increasingly clear to those who hold to the exceptionalist viewpoint. In particular, contemporary struggles against Islamic fundamentalism have been compared to the struggle against fascism and the Cold War. As one historian writes, "the massive conflict with fascism and then the cold war focused attention on what is our civilization, why it is different from others. With that came a certain sense of heightened attachment to our civilization and a desire to defend and protect it."[6]

Another framework for understanding 9/11 is the literary-cultural analysis offered by Susan Faludi, who considers 9/11 in terms of the long-forgotten nightmares of the seventeenth and eighteenth century settlers. Comparing the cultural response to 9/11 to the earliest traumatic events in American history, she argues that 9/11 recalls the underlying trauma at the core of American history: the frequent and devastating attacks by Native Americans on colonial settlements during the seventeenth and eighteenth centuries. "Essential to our understanding of what that attack . . . [9/11] . . . means to our national psyche is a recognition that it did happen before, over and over . . . And its happening was instrumental to the American character. The nation that recently imagined itself so impervious to attack at home was gestated in a time when such attacks were the prevailing reality of American life."[7] Colonial settlers were oppressed and haunted by fears of Indian attack; one in ten male settlers were killed in hostile attacks, and among the large numbers of young women and female children abducted by the Indians, a full 60 percent were never recovered. Richard Slotkin writes that early American settlers dwelled "in an atmosphere of terror," colonists wandered around in an "Indian-haunted dreamland." As Faludi writes, "Our original 'war on terrorism' bequeathed us a heritage that haunts our reaction to crises" like 9/11. The result was a narrative rewriting of fear and terror, the intentional creation of a myth of national invincibility, written in the heroic frontier literature that followed, a

literature that reinstated the agency and the virility of the frontier male in the face of the original homeland terroristic threats. In this literary reframing of frontier terror, as historian Roy Harvey Pearce wrote in 1947, the "captivity narrative"—the narratives of women who had escaped Indian captivity, usually on their own and then wrote about their experiences—was rewritten into the "rescue fantasy" of Western literature, with white male settlers playing a heroic role. The captivity narrative was "refashioned into America's 'terroristic vehicle,' our verbal armor against our oldest national nightmare."[8]

In all three of these accounts, the experience of the historical trauma of 9/11 is represented in terms of an older, existing cultural narrative, one that is configured as a variant of postcolonialism, American exceptionalism or the imaginative mythology of the frontier. In all three, the traumatic event of 9/11 is situated within a familiar mise-en-scene. A very different take on the experience of the World Trade Center disaster comes from Slavoj Žižek, who links it to the twentieth century's passion for the real, the fullest possible rendering of moments that break through the predictable ordinariness of daily life. "In contrast to the nineteenth-century [with its utopian projects] . . . the twentieth-century aimed at delivering the thing itself . . . The ultimate and defining moment of the twentieth-century was the direct experience of the Real as opposed to everyday social reality—the Real in its extreme violence as the price to be paid for peeling off the deceptive layers of reality."[9] The collapse of the World Trade Center towers, he writes, can be seen as the climactic conclusion of twentieth-century art's 'passion for the Real,' or as Karl Heinz Stockhausen has said about the attacks on the towers, "the ultimate work of art." "The 'terrorists' themselves did not do it primarily to provoke real material damage, but *for the spectacular effect of it* . . . we were all forced to experience what the 'compulsion to repeat' and *jouissance* beyond the pleasure principle are: we wanted to see it again and again."[10]

Žižek's provocative assertions convey a powerful sense of the enabling relationship between trauma and contemporary media forms, a point that is not addressed by any of the other historical metanarratives that have emerged after 9/11. In another striking analogy, Žižek compares the planes hitting the towers, particularly the second plane, recorded for all time flying with wings seemingly outstretched for the

camera, to the famous scene in Hitchcock's *The Birds,* when Melanie, flush with flirtatious triumph, is suddenly attacked by a gull as she traverses Bodega Bay. The gull enters our perspective as a blot, unseen and unnoticed by Melanie, who is attacked in the middle of a brilliant, cloudless day. "Was not the plane which hit the WTC tower literally the ultimate Hitchcockian blot, the anamorphic stain which denaturalized the idyllic New York landscape?"[11]

Both *United 93* and *World Trade Center* convey a sense of the dread and insecurity haunting the American social landscape. As in Hitchcock, where everyday life is frequently pictured as a "haunted dreamland"—the tone of these films communicates a sense of anxiety, a sense of unease that also finds expression in films like *The Birds, Vertigo, North by Northwest,* and others. Even the famous motifs of these films can now seem newly unsettling, like a dream scene whose meaning has suddenly become clear—the attack by a seemingly innocuous airplane in *North by Northwest*; the "birds'-eye" view of the flaming wreckage after the attack on the gas station in *The Birds*; the bodies falling out of the tower in *Vertigo.* The haunted imaginary of 9/11 is replete with images that are already part of the haunted dreamland of American culture, already pre-scripted in the cinema.

National Crisis: *United 93*

The opening scenes of *United 93* superimpose what has come to be known as the "sounds of terror" over images of daily American life. The first shot of the film, after the logo sequence has unfolded in silence, is a dark screen with the sound of a man praying, intoning the "Adon," or Muslim prayer. A close-up of a man's hands holding the Koran follows. The location is a comfortable American hotel room. Another hijacker walks in and says, "It's time," in Arabic. The film then cuts to a silent image in which the title of the film appears. A helicopter shot of New York City follows, with the sound of the prayer continuing over the gliding overhead image of city traffic. The film alternates shots of predawn New York with shots of the hijackers praying, conducting purifying rituals, making last minute preparations, and hastening to leave. As the kneeling hijackers bow to finish the prayer, sunrise breaks over the city. The ominous effect created by the slow and deliberate pacing, the sound of the prayer, and the long drawn out electronic chords of

the soundtrack provide an image of a metropolis that is both poetically beautiful and doomed. The opening recalls the tones of a horror film, where the monstrous and the mundane are commingled. The lines of traffic in downtown New York, the trip by train to the airport with "God Bless America" plastered onto an industrial container, the waiting at the gate area in the airport—the mundane details of national life acquire an ominous aura and meaning, as if they were emptied of their usual content and converted to an expression of foreboding. Corey Creekmur describes the "call to prayer," heard in numerous Iraq films, as a conventionalized sound of terror, a signifier of dread, of unthinking repetition and the threat of violence.[12] Here, the prayer itself, the "Adon," seems to communicate threat, an alien presence within the familiar, comfortable zone of an American city and an American hotel room, almost as if a kind of social and political boundary were being crossed and transgressed in the overlay of sound and image.

The contemporary nation, as Benedict Anderson famously describes it, is organized in forms of simultaneity and parallelism, a multiplicity of parallel lives moving in synchrony through the administered time of the workday and the calendar. "Homogeneous empty time" is a phrase he borrows from Walter Benjamin to describe the temporality of the modern nation. The very different temporality of the terrorists, signaled by the haunting sounds of the prayer, unmoored from its source and seemingly ubiquitous, explodes into this measured, orchestrated parallelism, imposing what Benjamin calls "Messianic time" into the culture of America. In contrast to the parallelism and simultaneity of modern Western life, the temporality of the terrorists is organized around an endpoint of destruction, structured around a teleological

moment to be realized at the instant of impact. Their time introduces absolute negativity into the administered world of goods and services and pulls the modern nation into a zone of incomprehension and panicked anxiety.

As the hijacking of Flight 93 unfolds, the film depicts the complete collapse of communications among the official organs of civilian and military control. The vast networked culture of military aerial surveillance, civilian flight control, and government agencies such as the FAA are depicted as incapable of sorting through the mass of conflicting reports and unable to respond. Too much information, too many flight plans to consider, too many unknowns in an environment that cannot operate with unknowns—the agencies charged with traffic and surveillance are studies in purposeless, almost random motion, the officials pausing only in horrified silence as the second plane crashes into the tower, visible on the TV sets of the control rooms and through the window of the New York control tower. Attempts to understand the timetables of the airlines and the flight paths of the planes are met with confusion; the coordination among different civilian and military agencies is hopelessly ineffective. The many overlapping sectors of authority create a sense of paralysis. Despite the fact that the names of most all the agencies depicted in the film contain the word "control," including

the National Air Traffic Control Center, and the Air Traffic Control towers in New York, Boston, and Cleveland, the film depicts the unprecedented event of a multiple hijacking as a plunge into administrative chaos and confusion.

The passengers on United Flight 93, by contrast, are portrayed as effective tacticians. They quietly identify specific individuals who have the expertise and physical strength to mount a counterattack. An amateur pilot of small planes among the passengers volunteers to try to land the jet; a former air traffic controller offers to talk the amateur pilot through the landing; a black belt in the martial arts will lead the counterattack. As the film unfolds, the stunned passengers emerge from a condition of atomized inertia to become an effective collective unit dedicated to survival. Violence has a face here, and so does heroic agency. As the passengers begin to coordinate their plan of action, their steadiness and concentrated determination are set against the increasing agitation of the civilian and military officers and personnel on the ground.

The stylistic feature of *United 93* that has received the most critical attention is the handheld camera, which conveys an extraordinary quality of immediacy and urgency. As the film progresses, the camerawork becomes increasingly jagged, with the speed and intensity of movement, the fragmentary split-second images, and the whip pans of the camera creating a tachycardic rhythm that pummels the audience. In the opening shots of the film however, a stately and smooth rhythm dominates, as the film provides still shots of the hijackers as they pray in the predawn light, beautiful helicopter shots of New York, and long, stationary shots of mundane details such as the fueling of the airplane. The steady increase in speed and rhythm is all the more effective for its gradual introduction.

The other major stylistic trope of *United 93* is its powerful use of parallel editing. Cutting among the interiors of the plane, the National Air Traffic Control Center in Herndon, Virginia, the air traffic control towers in New York, Boston, Cleveland, and the Northeast Air Defense Sector (NEADS), the film presents a powerful study of what Eisenstein might call polyphonic montage, the simultaneous advance of multiple strands of the story, orchestrated in the form of controlled and graduated shocks to the audience. Early in his theater career, Eisenstein

advocated placing firecrackers under the seats of the audience; later, he refined the technique of shocking and moving the audience through the orchestration of color, music, rhythm, and lighting. In *United 93*, the intercutting is full of contrasting visual tones, the red gloom of the control tower in Boston, the green hue of the control room at the NEADS, the soft white of the National Air Traffic Control Center, the wide windows of the New York control tower looking across the water onto the smoking towers, and the white fluorescence of the interior of the plane itself. The technique of parallel editing here renders in a detailed way activities in six different locations, each distinctively colored and clearly defined. The six locations depict a world of interiors, a high-tech universe dedicated to rational understanding, assessment, and control. Paul Greengrass, the film's director, calls air traffic control a "beautifully calibrated machine . . . our modern life is essentially about systems." Each of these "control" spaces, however, is plunged into near panic as the morning advances and reports of hijacked planes keep coming in, a total of 29 reported hijackings in the course of the day. As the film progresses, the use of long shots and even medium shots diminish: crosscutting is reduced to close-ups of one location cut directly into close-ups from another location, heightening the tension.

Rigorously focused on the real time unfolding of the hijacking, the film, as the director Paul Greengrass says, is focused on the present and on the future: "we are all on United 93 . . . This is where we are today . . . [these are] images of that day, but also images of our tomorrow." "National crisis" are the last words heard from the ground, as Ben Sliney, the director of National Air Traffic Control shuts down and grounds all flights in the United States and all flights entering from other countries. The scenes that follow are limited to the struggle on board the flight, which is rendered as an extraordinary melee, in which adrenaline and dread are equally mixed. The sudden blackout at the end of the film is softened only by the continuation of the orchestral score for a few moments, concluding with a single electronic chord. The closing of the film thus matches the opening, which began in darkness with the sound of one hijacker praying.

The sudden, devastating end of the film can be compared to the endings of World War I films. As Pierre Sorlin writes about films set during World War I, they typically end with a vision of complete devastation, delivered without comment by the filmmakers: "the emptiness of the end overwhelms the spectator: makes them feel as if they have been caught up in some vast, impersonal, meaningless disaster . . . no

one has been spared. It is like a world's end: no story can be told, there is not the possibility even of a history."[13]

A Day in the Life: *World Trade Center*

While *United 93* begins with prayer, ritual ablutions, and an overall sacramental tone that establishes a deeply tragic mood, *World Trade Center* begins prosaically, opening as a kind of "day in the life" of a city, conveying the typical morning routines of an ordinary working morning in New York. In the first scenes of the film, we see the five police officers who will comprise the rescue team moving along separate pathways into the city. The twin towers are depicted from all vantage points, initially from the George Washington Bridge against the "dawn's early light," and then from New Jersey, Staten Island, and uptown Manhattan, viewed in closer and closer shots from all radial points of the city. The film's opening has something of a "city film" aspect, reminiscent of Ruttman's *Berlin: Symphony of a Great City* or Vertov's *Man with a Movie Camera*. The predawn transportation by car, train, and ferry; the early morning labor of workers in the meat-packing district; the daily routines of morning dogwalkers; and above all, the catalogue of familiar New York sites—the Empire State Building, the Chrysler Building, and the Statue of Liberty are rendered from a ground level or sea level point of view. Like Vertov and Ruttman, Oliver Stone draws a familiar portrait of the city, picturing it as a place that is both ordinary and beautiful—a snapshot of a world about to change.

The initial shots of the film sketch the domestic life of John McLoughlin, the leader of the eventual rescue team and one of two main characters, in a way that hints at vague marital dissatisfaction, as his wife Donna pretends to be asleep when he shuts the alarm off at 3:29 A.M. despite her eyes being wide open. He dresses and peeks affectionately and solicitously into his kids' bedrooms. None of the other characters are shown in their homes, but are rather first seen in transit as they make their way into the city. All the parallel structures cementing the "imagined community" of nation together—the newspaper, the radio, the transit schedule, all the social connectors that foster a sense of community among millions of disparate people—are evoked here. Will Jimeno listens to the car radio broadcasting the time and the traffic

report and sings along with a country song whose lyrics, "looking for the promise of the promised land" still seem innocent; another character reads the newspaper chronicle of the Yankees' exploits the night before, telling the man next to him on the train that he "was there" for Jeter's home run; a fourth member of the group who will form the doomed rescue party watches the approach to New York as the Staten Island ferry he's on moves on schedule into the city. When the characters arrive at the Port Authority station house, a mood of shared good humor and easy camaraderie suffuses the group. The orders of the day are given, the policemen move out to their assigned beats in the terminals and ports of the city, and what looks like a predictably routine workday begins.

In *World Trade Center* the attack is rendered from the ground level perspective of the police officers. Jimeno senses the low trajectory of the incoming plane as a shadow momentarily darkens the street; McLoughlin feels the impact through the walls of the precinct building as a deep rumble briefly causes the ground and the foundation to shudder. Unlike the depiction of the attack on the towers in *United 93*, which details the near panic in the air traffic control room, there is no warning or foreknowledge in *World Trade Center*. The knowledge that an airplane has crashed into one of the towers comes only after

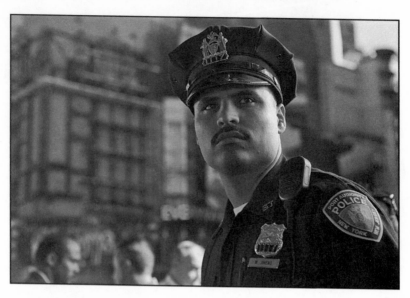

the fact, in fragments, with no authoritative source of information to clarify the confusing and partial reports that the policemen begin picking up from their cellphones, radios, and dispatchers. As they marshal together and commandeer a city bus to transport them en masse to the towers, the group is unaware, except for one man on a cellphone, that a second plane has crashed into the World Trade Center. Called on to clarify the situation, McLoughlin mistakenly insists that there has been only one plane.

When the Port Authority police arrive at the World Trade Center site, they appear stunned by the rain of white paper from countless office file cabinets, by the almost slow motion transit of ashen-faced and bloodied office workers walking slowly away from the site, and by the shocking image of a man jumping from the burning tower. A high heeled shoe lying on the ground, a businessman fainting on the sidewalk, a car crushed by fallen debris—the images of the disaster are prosaic, for the most part, but powerfully evocative. Almost a century ago, the Surrealist Louis Aragon described the power of cinema to evoke fascination, focusing especially on the power of film to transform "really common objects," such as corned beef and tins of polish, a newspaper and a packet of cigarettes: "Those letters advertising a make of soap are the equivalent of characters on an obelisk or the inscriptions in a book of spells: they describe the fate of an era."[14] *World Trade Center* evokes

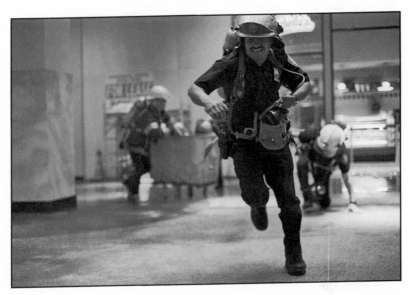

something of the strange silence and the "magnification of objects" that the Surrealists prized. As the rescue workers pass through the doomed retail arcades of Tower 1, with the shop windows advertising Victoria's Secret, J. Crew, Johnston and Murphy, and Express, the signs on the windows seem to describe "the fate of an era." In the words of Aragon, "On the screen, objects that were a few moments ago sticks of furniture or books of cloakroom tickets are transformed to the point where they take on menacing or enigmatic meanings."

Alone for a brief period in the retail arcade, Jimeno is approached by another rescue worker: a black policeman, bloody and dazed. He slowly walks toward Jimeno and in a kind of spectral voice, tells Jimeno that "it's going to be a long day," and that "there are a lot of good men up there." The man then walks away toward a white scrim of plastic sheeting. The appearance by this liminal figure, who possesses a kind of ghostly, otherworldly aspect, introduces the next section of the story, which will center on the nightmarish entrapment of two of the policemen and the anxious waiting of their families.

In Dreams

In contrast to the nervous, "verite" style of *United 93*, *World Trade Center* maintains a minimalist, nearly abstract visual approach, especially

the sequences set in what Oliver Stone calls the "hole." There are nine sequences set in the "hole," the extraordinarily lifelike set built to imitate the pit in which McLoughlin and Jimeno are trapped. The scenes under the pile are compositions in black, grey, and white, as if they were drawings in charcoal. The static aspect of these scenes—both men are pinned down and unable to move—at times seem like something out of the avant-garde plays of Samuel Beckett, where forms of emptiness, nothingness, and the utter absence of events express the profound isolation of the characters. Here, in long sequences underground, we see only the lips of the characters moving, scenes that are extended to the point of discomfort on the part of the viewer. In contrast, the extraordinarily bright and vivid portrayals of their two wives anxiously awaiting some kind of reliable information and the even more day-glo dreams of the two firefighters, are like being plunged into a painting by Van Gogh, unfathomably beautiful and colored so intensely that they seem enameled.

In its deliberate, dreamlike rendering, the film presents a kind of "synthetic critique" of daily life. When Donna in her Long Island home must step around the big hole in the flooring of her new kitchen, a remodeling job that her husband McLoughlin has not completed; when Alison walks out into her New Jersey neighborhood at night to see the flickering blue light of every television set illuminating every crowded little house on the block; and when the congregations of the lost and desperate are seen gathered together in the hospital lobby, waiting for the injured office workers and first responders who will never arrive, the film succeeds in defamiliarizing the everyday. A stop light that will not turn green, a trip to the well-stocked drugstore, a deserted street: these become the raw materials of a twenty-first-century wasteland.

The working class and suburban milieu of the film have been covered by Oliver Stone before, particularly in *Born on the Fourth of July*. *World Trade Center* captures the clutter, warmth, and ragged edges of contemporary suburban life, of lives unfolding at the beginning of the twenty-first century. Concentrating on the perspective of the two policemen and their families, the film holds to a narrow, circumscribed view. Memory serves as the rhetorical device linking the men to their families. McLoughlin's memory scenes of Donna, for example, seamlessly flow into real life sequences; Jimeno's memory scenes of Alison similarly lead directly to sequences depicting her in the real world. The

women, particularly, Donna, also project remembered scenes with their husbands onto the mise-en-scene of their daily lives. In both cases, the characters' memory passages fix on intimate moments: the agitation and noise of ordinary life are filtered from the quiet emotion and soft coloration of love scenes. Stone describes the film as a love story, a "double love story." But as the dreams and memory scenes give way to real-life scenes depicting the almost overpowering anxiety of the characters, the tensions and stresses of family life become revealing mini-dramas, portraits of personal lives under extraordinary stress. The attacks of 9/11 bring all the fissures and fault lines of family life to the fore.

Exile on Mainstreet

The more explicit political and ideological messages of the film coalesce around the character of Karnes, the ex-GI who rescues McLoughlin

and Jimeno. Karnes's storyline shifts the genre focus of the text, casting the film into a completely different register, one defined by codes of action and behavior that seem almost like fossilized remnants of earlier periods. In the portrayal of Karnes, the film condenses references to earlier genre forms, bringing into view deeply embedded cultural scripts, almost atavistic patterns of narrative agency that have been preserved in cultural memory and revived in the aftermath of 9/11.

Introduced while he is watching the attacks on television, Karnes's first words are, "I don't know if any of you know it yet, but we're at war." The next sequence depicts him in church, a sequence introduced by a shot depicting a Bible open to "the Revelation to John," and a placard suggesting the reading for the day from Pentecost. Karnes gazes at the large church crucifix hanging over the altar and tells his pastor that he is going to join the rescue operation. "God gave me a gift. To be able to help people. To defend our country. And I feel Him calling on me now for this mission." He gets a military haircut and appears clothed in his old Marine uniform at the World Trade Center site. Filmed from a low camera angle, Karnes stands out in the grim surroundings; unlike all the other characters in the film, Karnes seems confident, assured, and almost serene. Walking into the smoking ruin, he encounters a firefighter who tells him that all the rescuers are being withdrawn until the pile stabilizes. Looking away into the distance, he responds, "It's like God made a curtain with the smoke, shielding us from what we're not yet ready to see." The firefighter looks at him oddly, watches him as he walks into the ruins, and makes a vaguely sarcastic comment.

Karnes emanates a singleness of purpose that borders on obsession. With eyes constantly looking toward some imaginary horizon, he resembles the Moses of DeMille's *The Ten Commandments* after his vision of the Burning Bush. Although the song Jimeno had been singing in the opening of the film, "The Promised Land," had earlier seemed naïve and slightly ironic, it now seems prophetic, as the film offers in Karnes a figure who combines the motifs of Old Testament implacability and New World conviction. Stone gives the character a dark, obscure past and a vague, undefined present. Karnes is apparently unburdened by family, free of occupational obligations, and bereft of any human attachments other than to his pastor. Like Moses, or like Ethan Edwards in *The Searchers,* Karnes is certain he will succeed; Ethan's

statement, "As sure as the turnin' of the earth, we'll find 'em" is a line that could easily be rewritten for Karnes in *World Trade Center*. The recoding of the helpless terror of 9/11 into an effective myth of male agency brings Karnes into a long line of American cinematic heroes, whose mysterious pasts and uncertain futures are redeemed by the clarity of a singular quest.

Benedict Anderson writes that exile is frequently the genesis of nationalism, that national sentiment and identification comes most clearly into focus under the condition of exile. Karnes might be seen as a character in exile, one whose absolute identification with the military, God, and country can only be realized once the homeland has been made strange, unheimlich, no longer familiar. Karnes, like his cinematic predecessors, literally enters the wasteland to rescue the two trapped police officers, and in the symbolic logic of the film, restores to the narrative of 9/11 the promise of regeneration.

As his search progresses into the night, he comes upon another ex-Marine and they agree to coordinate their searches. Karnes tells him: "If someone says stop you don't stop. You don't hear 'em. There's no going back." The bluish tints of the lighting, smoke, fire, twisted metal, and uniforms of the men convert the imagery of the pile to a war landscape, a zone already haunted by the ghosts of those who have perished. The rescue mission here shades into a military action, one that has a particular resonance to the Gulf War where the military was told to stop— and did turn back. The single mindedness of Karnes and the constant referencing of God and war pulls the film into the gravitational field of earlier cultural texts such as the western and the war film. The rescue of Jimeno and McLoughlin, from this perspective, becomes not a closure but a preamble to a much larger cultural remaking, one dominated by the fantasy of America as a once and future promised land, whose refashioning will be conducted with boots on the ground.

The Places of Memory

World Trade Center builds on the symbolic aura associated with the specific site of the attacks, the "ground zero" location that has been recreated in the film to breathtaking effect. As Pierre Nora characterizes it, the places of memory must be endowed with a "symbolic aura" that resonates in the public imagination. Memory, as he puts it, clings

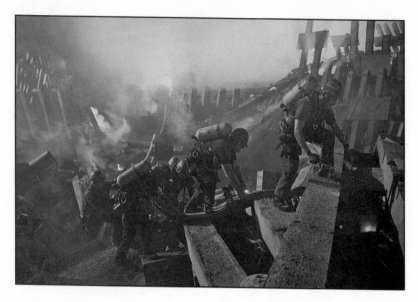

to places just as history clings to events. In its concentrated attention to place rather than event, *World Trade Center* focuses on a specific site, the symbolic center where the memory of 9/11 is concentrated. The film expresses the audience's emotional relationship to place, condensed in the ruins of ground zero and extending outwards to Trinity Church and the streets and neighborhoods of New York and New Jersey. It reenacts the past in terms of place, instantiating Nora's description of the "places of memory."

The sense of collective renewal projected in the closing scenes of the film, as the two trapped policemen are lifted from the pile and reunited with their families, competes with the sense of "unfinished business" that clings to Karnes as he walks away, having completed only the first part of his mission. Where the theory of traumatic representation gives priority to the past dominating the present, *World Trade Center* shifts the perspective, suggesting that the past will now define the future. The traumatic events of 9/11, the film suggests, resonate not simply in the neighborhoods and in the political precincts of America, but in a more fundamental way in the renovating of certain cultural scripts that had almost become obsolete. A filmmaker who had earlier worked to dismantle the disfiguring mythologies of masculinity inherited by the Vietnam generation now portrays a hero haunted by the past but compelled

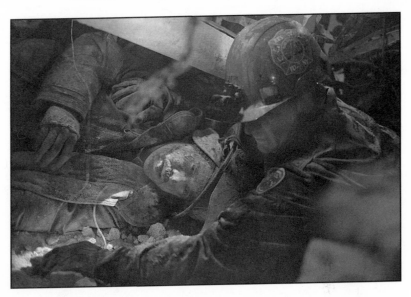

by it. Rehearsing the trajectories both of Moses and Ethan Edwards, Karnes will move his "mission" into the desert; and like these figures, he will wander there for years.

Rather than evoking the memory of place, *United 93,* by contrast, attempts to break down the defenses of the audience in order to prevent the traumatic events of 9/11 from being relegated to memory. The film tries to recreate the event as rigorously as possible, partly in order to hold it as an immediate perception. As Cathy Caruth has written, it functions like "a voice that cries out from the wound."[15] Rather than working to "explode" the conventions of the historical film, *United 93* draws them into a single, almost unbearably concentrated expression. The sense of entrapment, the accelerated and chaotic camera movements, the jagged cutting, all contribute to an extraordinary sense of realism that aims to break down the protective defenses of the audience in order to register a traumatic historical event that is not of the past, but exists in the present. As Greengrass says in his commentary track for *United 93*: "this is where we are today."

From this perspective, *World Trade Center* and *United 93* seem to define starkly different approaches to representing the historical event of 9/11. The question I have been pursuing throughout this chapter is the role of film in articulating the shift in historical consciousness that

9/11 has produced. Both films insist that 9/11 marks a fundamental dividing point. The traumatic historical film, as represented by *United 93* and *World Trade Center*, provides a limited but useful sense of the power of visual representations to preserve the memory of trauma by "acting out." Whether films and other modes of visual media can also contribute to a "working through" of traumatic historical experience remains an open question. However, as the essayist Frank Rich has said, it may already be "too late." And, as he further writes, these films may soon come to seem escapist in comparison with geo-political reality as it unfolds in the future.

Notes

Preface to the Revised Edition

1. Homi K. Bhabha, *The Location of Culture* (London: Routledge, 1994): 148.

2. Alfred W. Crosby Jr., *The Columbian Exchange: Biological and Cultural Consequences of 1492* (Westport: Praeger, 2003). Quoted in Charles C. Mann, "America, Found and Lost," *National Geographic*, May 2007: 37.

3. Tom Conley, *Cartographic Cinema* (Minneapolis: University of Minnesota Press, 2007).

4. This estimate comes from David Friend, "The Man in the Window," *Vanity Fair,* September 2006: 286.

Introduction

1. Jacques Rancière, "Interview: The Image of Brotherhood," trans. Kari Hanet, *Edinburgh '77 Magazine*, no. 2 (1977): 26–31. Kaja Silverman expands on Rancière's concept of the dominant fiction in *Male Subjectivity at the Margins* (New York: Routledge, 1992): see especially 15–121.

2. Rancière, "The Image of Brotherhood."

3. Timothy Brennan, "The National Longing for Form," in *Nation and Narration*, ed. Homi K. Bhabha (London: Routledge, 1990): 49. See also Benedict Anderson, *Imagined Communities: Reflections on the Origin and Spread of Nationalism* (London: Verso, 1991).

4. Rancière, "The Image of Brotherhood."

5. See Roy Harvey Pearce, *Savagism and Civilization: A Study of the Indian and the American Mind* (Berkeley: University of California Press, 1988): 49.

6. The concept of nation as an "imagined community" has been set forth by Anderson in *Imagined Communities*. The phrase "deep, horizontal comradeship" comes from Ellis Cashmore, *Dictionary of Race and Race Relations* (London: Routledge, 1984).

7. Virginia Wright Wexman, *Creating the Couple: Love, Marriage, and Hollywood Performance* (Princeton, N.J.: Princeton University Press, 1993): 72.

8. Cornel West characterizes competing forms of identity in terms of "identity from above" and "identity from below" in "A Matter of Life and Death," *October* 61 (Summer 1992): 20–23.

9. Michael Kammen, *The Mystic Chords of Memory: The Transformation of Tradition in American Culture* (New York: Knopf, 1991): 299.

10. Ibid.

11. Ibid., 688.

12. Examples include the advent of the History Channel on cable and the success of Ken Burns's documentaries on public television.

13. George Lipsitz, *Time Passages: Collective Memory and American Popular Culture* (Minneapolis: University of Minnesota Press, 1990): 4.

14. Ibid., 36.

15. Caryn James, "These Are Works of Art, Not Children's Schoolbooks," *New York Times*, May 21, 1995: 18.

16. Ibid.

17. Victor Turner, "Social Dramas and Stories about Them," *Critical Inquiry* 7 (1980): 168.

18. Nathan Huggins, "The Deforming Mirror of Truth: Slavery and the Master Narrative of American History," *Radical History Review* (Winter 1991): 37.

19. The phrase "fissures and faultlines" comes from Wimal Dissanayake, "Nationhood, History, and Cinema: Reflections on the Asian Scene," in *Colonialism and Nationalism in Asian Cinema*, ed. Wimal Dissanayake (Bloomington: Indiana University Press, 1994).

20. Although Hollywood defines itself purely as an entertainment industry, in contrast to the film industries of countries such as France, Canada, and Australia, which serve a semiofficial role as the "cultural flagships" of their nations, the Hollywood cinema, taken as a whole, can be seen to express both the mythic and the prosaic dimensions of nation. Although no single film or genre could be said to capture all the tributaries of national life, the Hollywood genre system as a whole functions as a kind of vast *speculum mundi* that defines what passes as social reality in the United States. As Fredric Jameson writes: "The reality socially constructed by Hollywood 'realism' is a map whose coordinates are parcelled out among the specific genres, to whose distinct registers are assigned its various dimensions or specialized segments. The 'world' is then not what is represented in the romantic comedy or in film noir: but it is what is somehow governed by all of them together—the musical, the gangster cycles, 'screwball comedy,' melodrama. . . . The unreal is then what falls outside of the system as a whole and finds no place in it." Fredric Jameson, *Signatures of the Visible* (New York: Routledge, 1990): 175–76. Although Jameson does not refer specifically to the concept of national identity and restricts his description to the classic period of the Hollywood studio system, the model he sets forth can, I believe, be adapted to the question of the American cinema's role in constructing concepts of nation. If, as Brennan describes it in "The National Longing for Form," the nation is an "imaginary construct" that depends for its existence on an "apparatus of cultural fictions," that apparatus in the present-day United States is centered in the Hollywood cinema.

21. See Annette Hamilton, "Fear and Desire: Aborigines, Asians, and the National Imaginary," *Australian Cultural History* 9 (1990): 18.

22. For discussion of the concept of "genre memory," see Gary Saul Morson and Caryl Emerson, *Mikhail Bakhtin: The Creation of a Prosaics* (Stanford, Calif.: Stanford University Press, 1990).

23. In *Imagined Communities*, Anderson argues that the realist novel, which rose to prominence in tandem with the rise of the nation-state, is the most exemplary manifestation of national self-consciousness, for it resembles in its form and structure the multiplicity and simultaneity of national life. With its mixture of idioms, its composite structure, and its use of temporal parallelism as a way of linking a multitude of unrelated actions, the realist novel provided people with an image of nation as a "solid community" moving simultaneously up or down through history, of parallel lives moving along parallel pathways, a structure that "allowed people to imagine the special community that is the nation" (25).

24. Anthony D. Smith, "War and Ethnicity: The Role of Warfare in the Formation,

Self-Images, and Cohesion of Ethnic Communities," *Ethnic and Racial Studies* 4, no. 4 (1981): 391.

25. Morson and Emerson, *Mikhail Bakhtin*, 290, 292, 278, 293, 297.

26. Smith, "War and Ethnicity," 391.

27. Michael Ignatieff, *Blood and Belonging: Journeys into the New Nationalism* (New York: Farrar, Straus & Giroux, 1993): 6.

28. See ibid. and Anthony D. Smith, *National Identity* (Reno: University of Nevada Press, 1991).

29. Ignatieff, *Blood and Belonging*, 5, 9.

30. Smith, *National Identity*, 15.

31. The concept of polycentric or pluralistic nationalism is developed in Yael Tamir, *Liberal Nationalism* (Princeton, N.J.: Princeton University Press, 1993). She derives the phrase "polycentric nationalism" from Anthony D. Smith, *Theories of Nationalism* (London: Duckworth, 1983).

32. Ignatieff, *Blood and Belonging*, 248.

33. John D. Kelly, "Diaspora and World War, Blood and Nation in Fiji and Hawaii," *Public Culture* 7, no. 3 (1995): 489.

34. Ibid., 495.

35. Homi K. Bhabha, "DissemiNation: Time, Narrative, and the Margins of the Modern Nation," in *Nation and Narration*, ed. Homi K. Bhabha (London: Routledge, 1990): 318.

36. Michael Ignatieff, "The State of Belonging," *Time*, February 27, 1995: 56.

37. Dissanayake, "Nationhood, History, and Cinema," xvi.

38. Iain Chambers, *Border Dialogues: Journeys in Postmodernism* (London: Routledge, 1990): 47.

39. Graeme Turner, "The End of the National Project? Australian Cinema in the 1990's," in *Colonialism and Nationalism in the Asian Cinema*, ed. Wimal Dissanayake (Bloomington: Indiana University Press, 1994): 214.

40. Ignatieff, *Blood and Belonging*, 249.

41. This passage combines phrases from Peter H. Wood, "Response to Nathan Huggins's 'The Deforming Mirror of Truth,'" *Radical History Review* (Winter 1991): 53; and Huggins, "The Deforming Mirror," 45, 39.

42. Hamilton, "Fear and Desire."

43. Susan Jeffords, *The Remasculinization of America: Gender and the Vietnam War* (Bloomington: Indiana University Press, 1989).

44. Hayden White, "The Fact of Modernism: The Fading of the Historical Event," in *The Persistence of History: Cinema, Television, and the Modern Event*, ed. Vivian Sobchack (New York: Routledge, 1995).

1. Race and Nation in *Glory*

1. Michael Ignatieff, *Blood and Belonging: Journeys into the New Nationalism* (New York: Farrar, Straus & Giroux, 1993).

2. Cornel West, "A Matter of Life and Death," *October* 61 (Summer 1992): 20–23.

3. Paul Gilroy, *There Ain't No Black in the Union Jack* (London: Hutchinson, 1987): 52.

4. Peter Dimock, "Towards a Social Narrative of Loss," *Radical History Review* (Winter 1991): 54–56.

5. Richard Dyer, "White," in *The Matter of Images: Essays on Representations* (London: Routledge, 1993): 145.

6. Ibid., 141.

7. Ibid., 144.

8. Edward Zwick, the director of *Glory*, is probably best known as the cocreator of the TV series *thirtysomething*. In an interview in *Film Comment*, he describes the "anachronistic" scene in which Trip and Shaw converse about their parallel purposes as containing "a certain degree of liberal fantasy." See Armond White, "Fighting Black," *Film Comment* (January–February 1990): 26.

9. Frederick Douglass, *The Life and Writing of Frederick Douglass*, vol. 3 (New York: International, 1953): "The iron gate of our prison stands half open . . . one gallant rush . . . will fling it wide" (123).

10. Gary Scharnhorst, "From Soldier to Saint: Robert Gould Shaw and the Rhetoric of Racial Justice," *Civil War History* 34, no. 4 (1988): 308–22.

11. Ibid., 317–18.

12. See Peter Burchard, *One Gallant Rush* (New York: St. Martin's, 1965): on Douglass's sons, see 84, 139; on Charlotte Forten, see 116–17, 145–46. In the film, the black woman standing near Shaw in the Port Royal scene is, according to the screenwriter, Kevin Jarre, meant to represent Charlotte Forten.

13. Nathan Huggins, "The Deforming Mirror of Truth: Slavery and the Master Narrative of American History," *Radical History Review* (Winter 1991): 37.

14. Frederick Douglass, *My Bondage and My Freedom*, ed. William L. Andrews (Urbana: University of Illinois Press, 1987): 218–19.

15. Huggins, "The Deforming Mirror," 25.

16. Ibid., 38.

17. Frantz Fanon, *The Wretched of the Earth* (New York: Grove Weidenfeld, 1968): 51–53.

18. Homi K. Bhabha, "A Question of Survival: Nations and Psychic States," in *Psychoanalysis and Cultural Theory: Thresholds*, ed. James Donald (London: Macmillan, 1991): 98–99.

19. Ibid., 99.

20. Douglass, *My Bondage*, 218–19.

21. Huggins, "The Deforming Mirror," 31.

22. Frederick Douglass, *Narrative of the Life of Frederick Douglass, American Slave, as Written by Himself*, ed. Houston A. Baker Jr. (New York: Penguin American Library, 1982): 72; quoted in Stephanie A. Smith, "Heart Attacks: Frederick Douglass's Strategic Sentimentality," *Criticism* 34, no. 2 (1992): 197.

23. Mikhail Bakhtin, quoted in Gary Saul Morson and Caryl Emerson, *Mikhail Bakhtin: Creation of a Prosaics* (Stanford, Calif.: Stanford University Press, 1990): 411.

24. See White, "Fighting Black."

25. See Lawrence W. Levine, "Slave Songs and Slave Consciousness: An Exploration of Forgotten Sources," in *Anonymous Americans: Explorations in Nineteenth-Century Social History*, ed. Tamara K. Hareven (Englewood Cliffs, N.J.: Prentice Hall, 1971): 99–130.

26. Gilroy, *There Ain't No Black*, 159.

27. Levine, "Slave Songs," 120.

28. Stuart Hall, "Minimal Selves," in *Identity: The Real Me* (London: ICA, 1987): 45.

29. Gilroy, *There Ain't No Black*, 236.

30. Huggins, "The Deforming Mirror," 38.

31. Gilroy, *There Ain't No Black*, 26.

32. Raymond Williams, *Towards 2000* (Harmondsworth: Penguin, 1983); quoted in ibid., 50.

33. Variations of this phrase appear in Huggins, "The Deforming Mirror," and the separate "Responses" of Peter H. Wood, Peter Dimock, and Barbara Clark Smith, *Radical History Review* (Winter 1991): 25–59.

2. Native America, *Thunderheart,* and the National Imaginary

1. Edward H. Spicer, "The Nations of a State," *Boundary 2* 19, no. 3 (1992): 26–48.

2. The quoted phrases are from ibid.

3. Annette Hamilton, "Fear and Desire: Aborigines, Asians, and the National Imaginary," *Australian Cultural History* 9 (1990): 14–35.

4. Nicholas Colchester, "Goodbye, Nation-State. Hello . . . What?" *New York Times*, July 17, 1994: 17.

5. Hamilton, "Fear and Desire," 16.

6. Ibid., 23.

7. Michael P. Rogin, *Ronald Reagan, the Movie, and Other Episodes in Political Demonology* (Berkeley: University of California Press, 1987): 141, 138, 146. See generally Rogin's chapter titled "Liberal Society and the Indian Question," 134–68.

8. Lauren Berlant, *The Anatomy of National Fantasy: Hawthorne, Utopia, and Everyday Life* (Chicago: University of Chicago Press, 1991): 217.

9. Arnold Krupat, "Postcoloniality and Native American Literature," *Yale Journal of Criticism* 7, no. 1 (1994): 175.

10. Ward Churchill, *Fantasies of the Master Race: Literature, Cinema and the Colonization of American Indians* (Monroe, Maine: Common Courage, 1992): 242–43.

11. Gary Saul Morson and Caryl Emerson, *Mikhail Bakhtin: The Creation of a Prosaics* (Stanford, Calif.: Stanford University Press, 1990): 290–92.

12. Hamilton, "Fear and Desire," 18.

13. Benedict Anderson, *Imagined Communities: Reflections on the Origin and Spread of Nationalism* (London: Verso, 1991): 26, 25; see generally 9–36.

14. Fernand Braudel, "History and the Social Sciences: The Long Duree," in *On History*, trans. Sarah Matthews (Chicago: University of Chicago Press, 1980): 26–27.

15. Elaine A. Jahner, "Transitional Narratives and Cultural Continuity," *Boundary 2* 19, no. 3 (1992): 169; see also Anderson, *Imagined Communities*, 9–36.

16. The concept of heterochrony is discussed at length in Morson and Emerson, *Mikhail Bakhtin*.

17. Krupat, "Postcoloniality," 175.

18. Roy Harvey Pearce, *Savagism and Civilization: A Study of the Indian and the American Mind* (Berkeley: University of California Press, 1988): 49.

19. Edward Said, "Identity, Negation, and Violence," *New Left Review* 171 (1988): 58; quoted in Krupat, "Postcoloniality," 175.

20 Krupat, "Postcoloniality," 175.

21. Anthony D. Smith, "War and Ethnicity: The Role of Warfare in the Formation, Self-Images, and Cohesion of Ethnic Communities," *Ethnic and Racial Studies* 4, no. 4 (1981): 391.

22. The plot of the film is closely based on a series of incidents that occurred on and near the Pine Ridge Reservation in the mid-1970s, the site of a growing activist movement led by traditional Lakotas trying to regain control of tribal lands. The corrupt tribal government of Richard Wilson, installed by the federal authorities, tried to suppress this move-

ment through a campaign of terror waged by Wilson's private army, widely known by the acronym GOON (Guardians of the Oglala Nation). In order to deal with GOON violence, and to prevent the illegal transfer of uranium-rich reservation land to the federal government, traditionalists on the Pine Ridge Reservation asked for help from AIM (the American Indian Movement). AIM's physical intervention led to the seventy-one-day siege of Wounded Knee in 1973. With international attention now focused on U.S.-Indian relations, the state sought to contain the situation, fighting what Ward Churchill calls a "veritable counterinsurgency war against AIM and the traditional Oglalas of Pine Ridge" (167) that lasted for three years. Sixty AIM members and supporters perished at the hands of Wilson's private army, which was supplied with guns and ammunition by the federal government, and hundreds more were assaulted and harassed. In 1975, an armed confrontation took place between AIM members and the FBI. Thinking they were being attacked by GOON or vigilantes, two members of AIM shot back at and killed two FBI agents, an incident covered in Apted's companion documentary to *Thunderheart*, *Incident at Oglala*. Jim Vander Wall explains that although the deaths of the two FBI agents were an "unintended consequence," the FBI provoked this firefight in order to justify a "massive paramilitary assault on AIM" (296–97). More than 180 FBI agents descended on Pine Ridge the next day, and, over the next three months, terrorized the population with massive force, including "Huey" helicopters, armored personnel carriers, M-79 grenade launchers, and fixed-wing aircraft. The chairman of the U.S. Civil Rights Commission would later characterize this operation as "an overreaction which takes on aspects of a vendetta . . . a full-scale military type invasion" (letter from Arthur J. Fleming to U.S. Attorney General Edward S. Levi, July 22, 1975, quoted in Vander Wall, 297). The summary I have given here is adapted from Jim Vander Wall, "A Warrior Caged: The Continuing Struggle of Leonard Peltier," and Ward Churchill, "The Earth Is Our Mother," both in *The State of Native America: Genocide, Colonization, and Resistance*, ed. M. Annette Jaimes (Boston: South End, 1992).

23. Smith, "War and Ethnicity," 382.

24. Jimmie Durham, "Cowboys and . . . Notes on Art, Literature, and American Indians in the Modern American Mind," in *The State of Native America: Genocide, Colonization, and Resistance*, ed. M. Annette Jaimes (Boston: South End, 1992): 429.

25. Morson and Emerson, *Mikhail Bakhtin*, 280, 292, 293.

26. Virginia Wright Wexman, *Creating the Couple: Love, Marriage, and Hollywood Performance* (Princeton, N.J.: Princeton University Press, 1993): 75, 76; see in general Wexman's chapter titled "Star and Genre: John Wayne, the Western, and the American Dream of the Family on the Land," 67–129.

27. Smith, "War and Ethnicity," 377, 378.

28. These phrases are found in Hamilton, "Fear and Desire," 16, 23, 18.

29. Ross Gibson, *South of the West: Postcolonialism and the Narrative Construction of Australia* (Bloomington: Indiana University Press, 1992): 12.

30. Wexman, *Creating the Couple*, 77–78.

31. Ibid., 78, 110.

32. Gibson, *South of the West*, 17.

33. Smith, "War and Ethnicity," 391.

34. Richard Slotkin, *Regeneration through Violence: The Mythology of the American Frontier, 1600–1860* (Middletown, Conn.: Wesleyan University Press, 1973). Slotkin argues that the figure of the frontier hunter, who roamed freely over the land rather than cultivating or taking possession of it, became the prototype for the cowboy hero of American myth. The frontiersman, who dominated and subdued the world of nature, was purified by acts of violence, "regenerated" through his violent encounters with game and through his domination of racial others.

35. Robert Stam, Robert Burgoyne, and Sandy Flitterman-Lewis, *New Vocabularies in Film Semiotics* (London: Routledge, 1992): 219.

36. Michael J. Shapiro, "Moral Geographies and the Ethics of Post-Sovereignty," *Public Culture* 6, no. 3 (1994): 485.

37. Walter Benn Michaels, "The Vanishing American," *American Literary History* 2, no. 2 (1990): 233.

3. National Identity, Gender Identity, and the Rescue Fantasy in *Born on the Fourth of July*

1. Susan Jeffords, *The Remasculinization of America: Gender and the Vietnam War* (Bloomington: Indiana University Press, 1989).

2. Stephanie A. Smith, "Heart Attacks: Frederick Douglass's Strategic Sentimentality," *Criticism* 34, no. 2 (1992): 193.

3. Sigmund Freud, "A Special Type of Object Choice Made by Men," in *The Standard Edition of the Complete Psychological Works of Sigmund Freud*, vol. 2, ed. J. Strachey (London: Hogarth, 1962): 163–76.

4. These phrases are from Frederick Douglass, as quoted in Smith, "Heart Attacks."

5. In a recent article, Michael Selig draws attention to numerous analyses based on this premise. See Michael Selig, "Genre, Gender, and the Discourse of War: The A/historical and Vietnam Films," *Screen* 34, no. 1 (1993): 1–18.

6. Laura Mulvey, "Notes on Sirk and Melodrama," in *Home Is Where the Heart Is: Studies in Melodrama and the Woman's Film*, ed. Christine Gledhill (Bloomington: Indiana University Press, 1987): 72.

7. Freud, in "A Special Type of Object Choice," 173, uses these words to describe the emotions associated with the "rescue fantasy." This is in sharp contrast with Selig's statement: "The reconstitution of a heroic male subject, a prerequisite for which is the devaluation and abuse of the feminine" and "their almost always violent repressions of the feminine." "Genre, Gender, and the Discourse of War," 3.

8. See Jean Bethke Elshtain, *Women and War* (New York: Basic Books, 1987). Elshtain asks whether the "current accessibility of the 'Vietnam experience' in and through the language of victimization, estrangement, therapy, and healing will, over time, narrow the gender gap" (220). To which Jeffords replies: "Not moving toward a narrowing of the gender gap . . . the new masculine affirms itself as incorporating, not accepting, the feminine." *The Remasculinization*, 138.

9. Jeffords, *The Remasculinization*, 53.

10. Ibid., 21.

11. Ibid., xiii.

12. Several critics have objected to the characterization of the Vietnam film as a genre, including Linda Dittmar and Gene Michaud, "Introduction—America's Vietnam War Films: Marching toward Denial," in *From Hanoi to Hollywood: The Vietnam War in American Film*, ed. Linda Dittmar and Gene Michaud (New Brunswick, N.J.: Rutgers University Press, 1990): 1–15.

13. George Lipsitz, *Time Passages: Collective Memory and American Popular Culture* (Minneapolis: University of Minnesota Press, 1990): 15.

14. David Grimstead, "Melodrama as Echo of the Historically Voiceless," in *Anonymous Americans: Explorations in Nineteenth Century Social History*, ed. Tamara Hareven (Englewood Cliffs, N.J.: Prentice Hall, 1971): 80, 88.

15. Frank Rahill, *The World of Melodrama* (Philadelphia: University of Pennsylva-

nia Press, 1967); cited in Christine Gledhill, "The Melodramatic Field: An Investigation," in *Home Is Where the Heart Is: Studies in Melodrama and the Woman's Film*, ed. Christine Gledhill (London: British Film Institute, 1987): 25.

16. Robert Stam, Robert Burgoyne, and Sandy Flitterman-Lewis, *New Vocabularies in Film Semiotics: Structuralism, Poststructuralism and Beyond* (London: Routledge, 1992): 219.

17. Gary Saul Morson and Caryl Emerson, *Mikhail Bakhtin: The Creation of a Prosaics* (Stanford, Calif.: Stanford University Press, 1990): 290–92.

18. Ibid., 278.

19. Ibid., 293, 297.

20. Although the historical film has often been denigrated precisely for its melodramatic tendencies—its assimilation of history to "the whole panoply of domestic conflicts" so that "history is shut into that order" (Stephen Heath, "Contexts," *Edinburgh '77 Magazine*, no. 2 [1977]: 42), its inability to depict "social or historical happenings without centering those events around the lives of a few individuals" (David Bordwell, Janet Staiger, and Kristin Thompson, *The Classical Hollywood Cinema: Film Style and Mode of Production to 1960* [Routledge & Kegan Paul, 1985]: 13)—these tendencies are not fatal failings in my view, but rather powerful strategies for questioning an American master narrative that relies for its effectiveness on its reproduction and consolidation in the structures of the family. If the family serves, in the present, as the main conduit of national and political identity, then a genre form traditionally centered on the domestic sphere would seem to be the appropriate vehicle for its analysis and critique.

21. Christine Gledhill, "Between Melodrama and Realism: Anthony Asquith's *Underground* and King Vidor's *The Crowd*," in *Classical Hollywood Narrative: The Paradigm Wars*, ed. Jane M. Gaines (Durham, N.C.: Duke University Press, 1992): 145.

22. Fredric Jameson, "Nostalgia for the Present," in *Postmodernism; or, The Cultural Logic of Late Capitalism* (Durham, N.C.: Duke University Press, 1991): 280.

23. Thomas Elsaesser, "Tales of Sound and Fury," in *Home Is Where the Heart Is: Studies in Melodrama and the Woman's Film*, ed. Christine Gledhill (Bloomington: Indiana University Press, 1987): 61.

24. Gledhill, "Between Melodrama and Realism," 146–47.

25. Elsaesser, "Tales of Sound and Fury," 55.

26. See Smith, "Heart Attacks."

27. P. N. Medvedev, *The Informal Method in Literary Scholarship: A Critical Introduction to Sociological Poetics*, trans. Albert J. Wehrle (Cambridge: Harvard University Press, 1985): 136; quoted in Morson and Emerson, *Mikhail Bakhtin*, 277.

28. Geoffrey Nowell-Smith, "Minnelli and Melodrama," in *Home Is Where the Heart Is: Studies in Melodrama and the Woman's Film*, ed. Christine Gledhill (Bloomington: Indiana University Press, 1987): 72.

29. Aristotle, quoted in ibid.

30. Susan Jeffords, "Can Masculinity Be Terminated?" in *Screening the Male: Exploring Masculinities in Hollywood Cinema*, ed. Steven Cohan and Ina Rae Hark (London: Routledge, 1993): 245–62.

31. Smith, "Heart Attacks," 209.

32. Richard Slotkin, *Regeneration through Violence: The Mythology of the American Frontier, 1600–1860* (Middletown, Conn.: Wesleyan University Press, 1973).

33. Jeffords, "Can Masculinity Be Terminated?" 259.

34. Ina Rae Hark, "Animals or Roman," in *Screening the Male: Exploring Masculinities in Hollywood Cinema*, ed. Steven Cohan and Ina Rae Hark (London: Routledge, 1993): 153.

35. See Steve Neale, "Aspects of Ideology and Narrative Form in the American War Film," *Screen* 32, no. 1 (1991): 35–57.

36. Slotkin, *Regeneration through Violence*, 5.

37. Paul Willeman, "Anthony Mann: Looking at the Male," *Framework* 15–17 (1981): 16.

38. Scott Benjamin King, "Sonny's Virtues: The Gender Negotiations of *Miami Vice*," *Screen* 31, no. 3 (1990): 292.

39. Steve Neale, "Masculinity as Spectacle," in *Screening the Male: Exploring Masculinities in Hollywood Cinema*, ed. Steven Cohan and Ina Rae Hark (London: Routledge, 1993): 14–15.

40. Hark, "Animals or Roman," 161.

41. Jeffords, "Can Masculinity Be Terminated?" 257–58.

42. For an extended discussion of the use of feminine "types" as images of the national character in the nineteenth century, see Martha Banta, *Imaging American Women: Ideas and Ideals in Cultural History* (New York: Columbia University Press, 1987).

43. As noted previously, the phrases "blood-seeker" and "milk-giver" are from Frederick Douglass, quoted in Smith, "Heart Attacks."

44. Freud, "A Special Type of Object Choice."

45. See Michael Clark, "Remembering Vietnam," in *The Vietnam War and American Culture*, ed. John Carlos Rowe and Rick Berg (New York: Columbia University Press, 1991): 177–207.

46. Rick Berg and John Carlos Rowe, "The Vietnam War and American Memory," in *The Vietnam War and American Culture*, ed. John Carlos Rowe and Rick Berg (New York: Columbia University Press, 1991): 6, 5.

47. Ibid., 6.

48. Ibid.

49. Ibid., 9.

50. Frederick Douglass, *My Bondage and My Freedom*, ed. William Andrews (Urbana: University of Illinois Press, 1987): 225.

51. Berg and Rowe, "The Vietnam War," 4.

52. Clark, "Remembering Vietnam," 204.

53. Miriam Hansen, "The Hieroglyph and the Whore: D. W. Griffith's *Intolerance*," in *Classical Hollywood Narrative: The Paradigm Wars*, ed. Jane M. Gaines (Durham, N.C.: Duke University Press, 1992): 195.

54. Freud, "A Special Type of Object Choice," 173.

55. Ibid.

56. Ibid.

57. Clark, "Remembering Vietnam," 205.

58. Ibid., 203.

59. Freud, "A Special Type of Object Choice," 173.

60. Ibid.

61. Hansen, "The Hieroglyph," 191.

4. Modernism and the Narrative of Nation in *JFK*

1. Oliver Stone and Zachary Sklar, *JFK: The Book of the Film: A Documented Screenplay* (New York: Applause, 1992) contains an extraordinary collection of reviews, commentaries, editorials, and responses constituting several hundred pages, as well as Oliver Stone's and Zachary Sklar's research notes for the film. In addition, *Cineaste* (19,

no. 1 [1992]) has published a special issue on *JFK*, and the April 1992 issue of *American Historical Review* includes a substantial special section on the film. Marjorie Garber, Jann Matlock, and Rebecca Walkowitz's edited collection *Media Spectacles* (New York: Routledge, 1993) contains several chapters that deal with the controversy and debate surrounding *JFK*.

2. Hayden White provides a particularly sophisticated treatment of these issues in relation to *JFK* in "The Fact of Modernism: The Fading of the Historical Event," in *The Persistence of History: Cinema, Television, and the Modern Event*, ed. Vivian Sobchack (New York: Routledge, 1995).

3. Benedict Anderson introduces the term "unisonance" in connection with the singing of the national anthem and the impression of social parallelism and simultaneity it fosters. See *Imagined Communities: Reflections on the Origin and Spread of Nationalism* (London: Verso, 1991): 145.

4. The relation between nationalism and narrative form has been addressed by a number of writers. See, for example, Homi K. Bhabha, "DissemiNation: Time, Narrative, and the Margins of the Modern Nation," and Timothy Brennan, "The National Longing for Form," both in *Nation and Narration*, ed. Homi K. Bhabha (London: Routledge, 1990); William Rowe and Vivian Schelling, *Memory and Modernity: Popular Culture in Latin America* (London: Verso, 1991); Partha Chatterjee, *Nationalist Thought and the Colonial World: A Derivative Discourse* (Minneapolis: University of Minnesota Press, 1993); and Anderson, *Imagined Communities*.

5. Anderson, *Imagined Communities*, 26. The phrase "homogeneous, empty time" comes from Walter Benjamin, *Illuminations* (New York: Schocken, 1969): 261.

6. Anderson, *Imagined Communities*, 25.

7. Ibid.

8. White, "The Fact of Modernism."

9. The phrase "anticipation within retroversion" comes from Mieke Bal, *Narratology: Introduction to the Theory of Narrative* (Toronto: University of Toronto Press, 1985): 67.

10. Brennan, "The National Longing for Form," 49.

11. Renata Wasserman, "Mario Vargas Llosa, Euclides da Cunha, and the Strategy of Intertextuality," *PMLA* (May 1993): 464.

12. See Ann Laura Stoller, "In Cold Blood: Hierarchies of Credibility and the Politics of Colonial Narratives," *Representations* 37 (Winter 1992). The phrase "epistemic murk" comes from Michael Taussig, "Culture of Terror, Space of Death: Roger Casement's Putumayo Report and the Explanation of Torture," *Comparative Studies in Society and History* 26, no. 3 (1984).

13. Homi K. Bhabha, "A Question of Survival: Nations and Psychic States," in *Psychoanalysis and Cultural Theory: Thresholds*, ed. James Donald (London: Macmillan, 1991): 98. Bhabha here explores the limits of Anderson's concept of the unisonance of the imagined community, drawing on competing models of national consciousness as defined by Edward Said and Frantz Fanon.

14. Anderson, *Imagined Communities*, 11. See also Brennan, "The National Longing for Form," 50.

15. The iconography of D.C. monuments has been utilized in other film texts in relation to conspiracy in ways that contrast with *JFK*. In *Mr. Smith Goes to Washington*, for example, the montage elicits a sense of democracy as transparent; in *All the President's Men*, by contrast, the official spaces of Washington are represented as signs that must be deciphered for their underlying, conspiratorial connections. But where *All the President's Men* presents conspiracy as a temporary aberration that can be purged

through the apparatus of "the system" itself, *JFK* narrates a secret history that "de-realizes" the dominant historical narrative.

16. In the script of the film, this scene is handled differently. Rather than a black man and his young son at Kennedy's tomb, the script has Garrison flashing back to documentary images of Dachau, with piles of bodies being bulldozed into a ditch. In the logic of the film, this change underlines the message of the importance of national community, associated with the images of Lincoln and Kennedy. It asserts, under the banner of the national, a sense of black and white having a common story and sharing the same fate.

17. Bhabha, "DissemiNation," 297.

18. Rowe and Schelling, *Memory and Modernity*, 204.

19. Ibid., 213.

20. See Dipesh Chakrabarty, "Postcoloniality and the Artifice of History: Who Speaks for 'Indian' Pasts?" *Representations* 37 (Winter 1992). In his concluding paragraphs, Chakrabarty expresses well the dominance of national narratives over other, possible narratives of social connection, and stresses the role of historical writing in furthering this condition.

5. Prosthetic Memory/National Memory: *Forrest Gump*

1. See Michael Kammen, *The Mystic Chords of Memory: The Transformation of Tradition in American Culture* (New York: Knopf, 1991).

2. Thomas Elsaesser, "Subject Positions, Speaking Positions: From *Holocaust, Our Hitler,* and *Heimat* to *Shoah* and *Schindler's List,*" in *The Persistence of History: Cinema, Television, and the Modern Event,* ed. Vivian Sobchack (New York: Routledge, 1995): 146.

3. See Walter Benjamin, "The Work of Art in the Age of Mechanical Reproduction," in *Film Theory and Criticism,* ed. Gerald Mast, Marshall Cohen, and Leo Braudy (New York: Oxford University Press, 1994): 665–81.

4. Alison Landsberg, "Prosthetic Memory: The Logics and Politics of Memory in Modern American Culture" (Ph.D. diss., University of Chicago, 1996), abstract: 1.

5. Alison Landsberg, "Prosthetic Memory: *Total Recall* and *Blade Runner,*" *Body and Society* 1, nos. 3–4 (1995): 180.

6. Landsberg, "Prosthetic Memory" (diss.), 1.

7. Elsaesser, "Subject Positions," 146.

8. Letter to the editor, *New York Times,* May 10, 1996.

9. Landsberg, "Prosthetic Memory" (diss.), 1.

10. Tom Conley, letter to author, October 15, 1995.

11. See Benedict Anderson, *Imagined Communities: Reflections on the Origin and Spread of Nationalism* (London: Verso, 1991); and Gopal Balakrishnan, "The National Imagination," *New Left Review* 211 (May–June 1995): 56–69.

12. Vivian Sobchack, "Introduction: History Happens," in *The Persistence of History: Cinema, Television, and the Modern Event,* ed. Vivian Sobchack (New York: Routledge, 1995): 2, 3.

13. See Rick Perlstein, "Who Owns the Sixties?" *Lingua Franca* (May/June 1996): 30–37.

6. The Columbian Exchange: Pocahontas and *The New World*

1. Alfred W. Crosby Jr., *The Columbian Exchange: Biological and Cultural Consequences of 1492* (Westport, Conn.: Praeger, 2003): 3.

2. Charles C. Mann, "America, Found and Lost" *National Geographic,* May 2007: 37.

3. Robert A. Rosenstone, *History on Film/Film On History* (Harlow, England: Longman/Pearson, 2006): 154–64.

4. Paul Ricouer, *The Reality of the Historical Past* (Milwaukee: Marquette University Press, 1984): 1–24.

5. Ibid., 7.

6. The documentary on the production of *The New World* included on the DVD makes the point that the gestures and whoops of the Native American actors are totemic animal gestures: they "bring a totemic animal into their moves, into the sounds they make; they bring the body language of the Indians into it, to speak in a language of memory."

7. Ricouer, *Historical Past,* 16.

8. Benedict Anderson, *The Specter of Comparisons: Nationalism, Southeast Asia, and the World* (London: Verso, 1998): 2.

9. Tom Conley, *Cartographic Cinema* (Minneapolis: University of Minnesota Press, 2007): 1–3.

10. Crosby, *The Columbian Exchange,* 3.

11. Crosby, *The Columbian Exchange,* quoted in Mann, "America, Found and Lost," 37.

12. Robert Desnos, "Eroticism" in *The Shadow and Its Shadow: Surrealist Writings on Cinema,* ed. Paul Hammond (London: British Film Institute, 1978): 122.

13. Conley, *Cartographic Cinema,* 5.

14. Juri Tynianov, "On the Foundations of Cinema," in *Russian Formalist Film Theory,* ed. Herbert Eagle (Ann Arbor: Michigan Slavic Publications, 1981): 93.

15. Conley, *Cartographic Cinema,* 4.

16. Homer, *The Odyssey,* Trans. Robert Fitzgerald (New York: Farrar, Straus, and Giroux, 1998): 1.

17. Mann, "America, Found and Lost," 45.

18. "A World Transformed," *National Geographic,* May 2007, map supplement.

19. Quoted in Mann, "America, Found and Lost," 39. The original text is from Jamestown president, George Percy.

20. Mann, "America, Found and Lost," 39.

21. Alfred W. Crosby Jr., *Ecological Imperialism: The Biological Expansion of Europe, 900–1900* (Cambridge: Cambridge University Press, second edition 2004): 299.

22. Donald Young quoted in Mann, "America, Found and Lost," 38.

23. Ross Gibson, *South of the West: Postcolonialism and the Narrative Construction of Australia* (Bloomington: Indiana University Press, 1992): 12.

24. Mann, "America, Found and Lost,"37.

25. All quotes in this paragraph are found in Mann, "America, Found and Lost," 34, 45, 37.

26. Finding the landscape inhospitable, the English colonists transformed the landscape into something familiar. Rather than learning from the Indians, and incorporating their techniques of agriculture, hunting, and fishing, the colonists brought in foreign plants, animals, and agricultural practices that transformed the land. As Charles C. Mann writes in "America, Found and Lost" (37), "The colonists did not come to

the Americas alone. Instead they were accompanied by a great parade of insects, plants, mammals, and microorganisms. Some of the effects were almost invisible; others were enormous." Although the biological and historical impact of these changes was monumental, the film maintains a close psychological focus, treating the historical period from the "inside" of historical events.

27. Anderson, *The Specter of Comparison*, 45

28. Mann, "America, Found and Lost," 34.

29. Crosby, *Ecological Imperialism*, xviii. Crosby writes, "Europe's first off-shore farm was the whole New World."

30. Ibid., xix.

31. Crosby, *The Columbian Exchange*, 37. Crosby elaborates this point in the following quote: "The fatal diseases of the Old World killed more effectively in the New, and the comparatively benign diseases of the Old World turned killer in the New."

32. Ibid., xxii.

33. Mann, "America, Found and Lost," 53.

34. Crosby, *The Columbian Exchange*, 31.

35. Leanne DuBois quoted in Mann, "America, Found and Lost," 45.

36. The unfenced animals were allowed to graze wherever they wanted; unlike the Europeans, the Indians did not fence in their planted fields. The colonists' animals devoured Indian harvests, trampled the earth into a rock-hard surface, and rooted out the vegetables that the Indians depended on during hard times.

37. Crosby, *Ecological Imperialism*, 44.

7. Homeland or Promised Land? The Ethnic Construction of Nation in *Gangs of New York*

1. Homi K. Bhabha, *The Location of Culture* (London: Routledge, 1994): 148.

2. The Nativist movement, represented by Bill Cutting in the film, formed a political party called the Know Nothings: the first major anti-immigration party in America. Although the party claimed a number of adherents, and had a highly vocal minority, it was not able to pass legislation barring or restricting immigration. Both Washington and Jefferson had embraced the immigration of Europeans, with Washington welcoming "opulent Europeans" to America. Despite winning control of the state government in Massachusetts in 1854, the Know Nothing party declined in influence from that point forward. Their major issue was the rising number of Catholic immigrants to the United States; they warned that this "monster was only waiting for the hour to approach to plant its flag of tyranny, persecution, and oppression among us."

3. The nation as "imagined community," a description coined by Benedict Anderson, has been widely adopted and has been extraordinarily influential. Anthony D. Smith, among others, has linked Anderson's concept to what he calls a "constructivist" concept of nation formation, as opposed to a "primordialist" approach, or his own concept of the genesis of nations, "ethno-symbolic." For Smith, see *The Nation in History: Historiographic Debates about Ethnicity and Nationalism* (Hanover: University Press of New England, 2000). For Anderson's widely influential approach, see *Imagined Communities: Reflections on the Origin and Spread of Nationalism* (London: Verso, 1991). Also, see Anderson, *The Spectre of Comparisons* (London: Verso, 1998).

4. The Old Brewery was described in contemporary accounts by the Reverend Matthew Hale Smith: "It is a region of wickedness, filth and woe . . . Lodging houses are under ground, foul and slimy, without ventilation, and often without windows, and

overrun with rats and every species of vermin. Bunks filled with decayed rags make the beds . . . Rooms are rented from two to ten dollars a month, into which no human being would put a dog. Children are born in sorrow, and raised in reeking vice and bestiality, that no heathen degradation can exceed. The degraded women who tramp the streets in the viler parts of the city, who fill the low dance houses and drinking saloons, graduate in this vile locality." From Daniel Stashower, *The Beautiful Cigar Girl: Mary Rogers, Edgar Allan Poe, and The Invention of Murder* (London: Penguin, 2006): 14.

5. Ibid., 30. While the Irish spoke English, thus easing the process of assimilation, they were devoutly Catholic, which at the time was considered a major threat to the status quo. Both Catholicism and Judaism were tolerated, however, in a nation founded in large part on antagonism towards the concept of state-ordered religion.

6. Anthony D. Smith, *Myths and Memories of the Nation* (Oxford: Oxford University Press, 1999): 151.

7. Ibid., 156.

8. Ibid., 153.

9. See Louis DiSipio and Rodolfo O. de la Garza, *Remaking America: Immigration and Immigration Policy* (Boulder: Westview Press, 1998): 24–25. Political leaders in the first decades of existence of the United States generally supported unlimited immigration of white Europeans to the United States; one of the articles of complaint against King George in the Declaration of Independence was the fact that he inhibited migration. As the authors write, "Washington spoke of welcoming not only the 'opulent and respected stranger' but also the 'oppressed and persecuted of all Nations and Religions.'"

10. In 1912, George Santayana famously described the myth of Americaness in a way that anticipates Homi K. Bhaba's more recent description of national identity as a performative act, one not inherited or conferred, but enacted in the daily lives of a nation's citizens. "As it happens, the symbolic American can be made largely adequate to the facts; because if there are immense differences between them—for some Americans are black—yet there is a great uniformity in their environment, customs, temper and thoughts. They have all been uprooted from several souls and ancestries and plunged together into one vortex, whirling irresistibly in a space otherwise quite empty. To be an American is itself almost a moral condition, an education, and a career." See George Santayana, "Materialism and Idealism in American Life," in *Character and Opinion in the United States* (New York: Scribner, 1924). See also Alison Landsberg, "The Prosthetic Imagination: Immigration Narratives and the 'Melting Down' of Difference," in *Prosthetic Memory* (New York: Columbia University Press, 2004): 49–80.

11. Smith, *The Nation in History*, 65.

12. Ibid., 75. This "ethnosymbolic" concept of nationalism is set against the arguments of "constructionists" like Eric Hobsbawm and Benedict Anderson, who understand nationalism as a relatively recent phenomenon created by states for political and economic purposes, and against "primordialists," such as Hugh Seton-Watson and Adrian Hastings who see nationalism as a holdover from earlier ethnic forms of identification. Smith compellingly describes nationalism as a structure of belonging that builds on earlier forms of ethnic identification, marshalling the energy of the symbols, imagery, and myths of the past for the purposes of building a national sense of affiliation.

13. Homi K. Bhabha, *Location of Culture*.

14. Iver Bernstein, *The New York City Draft Riots* (Oxford: Oxford University Press, 1990): 5–11.

15. For a full analysis of the Draft Riots, see Ibid.

16. Smith, *Myths and Memories of the Nation*.

8. Haunting in the War Film: *Flags of Our Fathers* and *Letters from Iwo Jima*

1. Michel Chion, *Audio-Vision: Sound on Screen*, trans. and ed. Claudia Gorbman (New York: Columbia University Press, 1994).

2. Michel Chion, *The Voice in Cinema*, trans. and ed. Claudia Gorbman (New York: Columbia University Press, 1999).

3. See "Trivia for *All Quiet on the Western Front* (1930)," the Internet Movie Database, http://www.imdb.com/title/tt0020629/trivia (accessed September 20, 2006). The translations of these three texts are explained in detail in Tysen D. Dauer and Nadja Kramer, "Classical Philology Gone Wild: The Use of Classical Texts in the Film *All Quiet on the Western Front*," *Graduate Studies and Research Journal* 7 (2007), Minnesota State University, Mankato. The first quotation in Greek comes from *The Odyssey*, and describes Odysseus, "Tell me Muse, of the man of many ways, who was driven far . . ." The second, from Ovid's *Remedies of Love*, reads "Fight the disease at the start, for once the symptoms develop/Medicine comes too late."

4. Pierre Sorlin, "Cinema and the Memory of the Great War," in *The First World War and Popular Cinema*, ed. Michael Paris (Edinburgh: Edinburgh University Press, 1999): 5–28.

5. Sigmund Freud, "The Uncanny," in *Studies in Parapsychology* (New York: Collier Books, 1963): 19–62.

6. Richard Wheeler, *Iwo* (Annapolis: Naval Institute Press, 1994): 188.

7. Oscar Wilde, "De Profundis." The complete quote is instructive: "It makes me feel as if you yourself had been merely a puppet worked by some secret and unseen hand to bring terrible events to terrible issue. But puppets themselves have passions. They will bring a new plot into what they are presenting, and twist the ordered issue of vicissitude to suit some whim or appetite of their own."

8. See Wheeler, *Iwo*.

9. See Benedict Anderson, *The Spectre of Comparisons* (London: Verso, 1998): 46–57.

10. Also see Leo Braudy, "Review of *Flags of Our Fathers* and *Letters from Iwo Jima*," *Film Quarterly* 60, no. 4 (Summer 2007): 16–23.

11. Anderson, *The Spectre of Comparisons*, 49.

12. Steven Shaviro, "Response to 'Untimely Bodies: Toward a Comparative Film Theory of Human Figures, Temporalities, and Visibilities,'" (paper presented at the Society for Cinema and Media Studies Conference, March 9, 2008, Philadelphia, Pa).

13. Anderson, *The Spectre of Comparisons*, 56.

14. Amy Borovoy, "Review of Emiko Ohnuki-Tierney, *Kamikaze Diaries: Reflections of Japanese Student Soldiers*," *American Anthropologist* 109, no. 4 (December 2007): 774.

15. Emiko Ohnuki-Tierney, *Kamikaze Diaries: Reflections of Japanese Student Soldiers* (Chicago: University of Chicago Press, 2006): 4.

16. By continuing the battle as long as possible, driving up casualties on the U.S. side, Kuribayashi hoped to blunt the United States' enthusiasm for an all-out invasion of Japan and perhaps create more favorable conditions for surrender. Kuribayashi knew that the island of Iwo Jima was certain to fall, and that he and most of his men would be killed. He also knew that Japan had no chance of winning the war. James Bradley, the author of *Flags of Our Fathers*, theorizes that Kuribayashi also knew the influence of American public opinion, and that the American public would not support an extended bloodbath on Iwo Jima. "Americans have always taken casualties very seriously. When

the number of casualties is too high, public opinion will boil up and condemn an operation as a failure . . . Kuribayashi had lived in America . . . he hoped American public opinion would shift toward wanting to bring the war with Japan to a rapid end." Quoted in Kumiko Kakehashi, *So Sad To Fall in Battle: An Account of War* (New York: Ballantine Books, 2007): 47.

17. Emiko Ohnuki-Tierney, "Betrayal by Idealism and Aesthetics," 16.

18. James Bradley, *Flags of Our Fathers* (New York: Bantam, 2006): 315.

19. Nevertheless, the film establishes a connection between the positive filial emotion displayed by Kuribayashi and Saigo and the repurposed "warrior way" that emphasized dying as the ultimate expression of love for the nation. As one historian says, "the most striking feature of Japanese history is this readiness to stake one's life for the sake of parent or child." The traditional Japanese bond of family love was redirected in wartime Japan into a larger collective identification with the nation: the nation was imaged as a kind of ultimate family. The intimate family of the soldiers was best honored by sacrificing their lives for the "national family," of which the emperor was the symbol: "The Meiji government had institutionalized the family as the foundational unit of the nation-state . . . Loyalty to [the emperor] was a 'natural' manifestation of love of family." The collective suicides enacted by the Japanese soldiers on Iwo Jima might thus be understood as a form of misrecognition of nation and emperor that was carefully cultivated by the state. See Amy Borovoy, *American Anthropologist.*

20. Ohnuki-Tierney, "Betrayal by Idealism and Aesthetics," 17.

21. Ibid., 19.

22. Braudy, "Review," 17.

23. Emmanuel Levinas, *Totality and Infinity: An Essay on Exteriority,* trans. Alphonso Lingis (Pittsburgh: Duquesne University Press, 1969).

24. Anne Gjelsvik, "Care or Glory: Picturing a New War Hero in *Flags of Our Fathers,*" (paper delivered at the Eastwood Conference, University of Southern Denmark, May 2008).

25. Although Nishi's suicide is depicted as an individual choice, the use of a rifle to commit suicide was one of the first lessons a soldier learned in the Japanese army. Ohnuki-Tierney writes that "each new conscript was trained to use his toe to pull the trigger while pointing the gun precisely at a certain point under his chin so that the bullet would kill him instantly. He was supposed to use this technique if he was captured in a cave or in a trench surrounded by the enemy . . . one must never be captured by the enemy" (from Ohnuki-Tierney, *Kamikaze Diaries,* 5).

26. Emmanuel Levinas, *Humanism of the Other* (Urbana, Ill.: University of Illinois Press, 2006): 29–31.

27. Levinas, *Totality and Infinity,* 206.

28. This phrase comes from Gil Andujar, *The Jew, The Arab: A History of the Enemy* (Stanford: Stanford University Press, 2003): 4.

29. Here Kuribayashi broke significantly with convention. One writer suggests that Kuribayashi held off committing his troops to a final banzai charge so as not to dignify the senseless loss of life. Instead, the final all out attack on Iwo Jima was a well-organized, stealthy operation that caused panic on the American side over three hours of intense fighting. Kuribayashi's attack "was not a banzai charge, but an excellent plan aiming to cause maximum confusion and destruction" (Kakehashi, 195). Also, Kuribayashi was in the lead: "There is no other example in the history of the Japanese army where a division commander led the charge himself. This all-out attack is highly unusual." Customarily, the commanding officer would send his men on a banzai charge and commit hari-kari behind the lines. See Kakehashi, *So Sad to Fall in Battle,* 48, 157–58, and Wheeler, *Iwo,* 30–43.

30. Kakehashi, *So Sad to Fall in Battle*, 157.

31. Anderson, *The Spectre of Comparisons*, 365.

9. Trauma and History in *United 93* and *World Trade Center*

1. Frank Rich, "Too Soon? It's Too Late for 'United 93'" *New York Times*, May 7, 2006.

2. Dominick LaCapra, *Representing the Holocaust* (Ithaca: Cornell University Press, 1994): 209.

3. E. Ann Kaplan and Ban Wang, "Introduction: From Traumatic Paralysis to the Force Field of Modernity," in *Trauma and Cinema: Cross-Cultural Explorations* (Seattle: University of Washington Press, 2004): 5.

4. Ibid., 12.

5. David Friend, "The Man in the Window," *Vanity Fair*, September 2006: 286.

6. Stephan Thernstrom quoted in Janny Scott, "9/11 Leaves Its Mark on History Classes," *The New York Times*, September 6, 2006.

7. Susan Faludi, "America's Guardian Myths," *The New York Times* (September 7, 2007): A29.

8. Ibid.

9. Slavoj Žižek, *Welcome to the Desert of the Real!* (London: Verso, 2002): 5–6.

10. Ibid.

11. Ibid., 15.

12. Corey K. Creekmur, "The Sound of the 'War on Terror'" in *Reframing 9/11: Film, Popular Culture, and the "War on Terror,"* ed. Jeff Birkenstein, Anna Froula, and Karen Randell (New York: Continuum, forthcoming 2010).

13. Pierre Sorlin, "Cinema and the Memory of the Great War," in *The First World War and Popular Cinema*, ed. Michael Paris (New Brunswick, N.J.: Rutgers University Press, 2000).

14. See Louis Aragon, "On Décor," in *The Shadow and Its Shadow: Surrealist Writings on the Cinema*, ed. Paul Hammond (London: British Film Institute, 1978): 29–31.

15. Cathy Caruth, *Unclaimed Experience: Trauma, Narrative, and History* (Baltimore: Johns Hopkins University Press, 1996): 2.

Index

109, 144, 154, 156, 159, 161, 162,
216n10
Clark, Michael, 80, 84, 221n45, 221n52,
221n57
Colchester, Nicholas, 217n4
Collingwood, R.G., 122
Columbian Exchange, the, x, 120, 121,
123, 136, 141, 142, 213n2, 224n1,
224nn10–11, 225n31, 225n34
Conley, Tom, xi, xv, 108, 123–25, 213n3,
223n10, 224n9
Conscription Act, xi, 161
Courage Under Fire, 175
Creekmur, Corey, 197, 229n12
Crosby, Alfred Jr., x, 120, 123, 124,
133, 140, 141, 142, 213n2, 224n1,
224nn10–11, 224n21, 225n29,
225n31, 225n34, 225n37

Dances with Wolves, 39
Dead Rabbits, the, xi, 148, 157, 159
Deer Hunter, The, 175
Desnos, Robert, 124, 224n12
Dimock, Peter, 17, 215n4, 217n33
Dissanayake, Wimal, 214n19, 215n37,
215n39
Dittmar, Linda, 219n12
Dominant fiction, 1–3, 15, 17, 36, 121,
213n1
Douglass, Frederick, 23, 24, 25, 29, 30,
67, 68–69, 79, 156, 216n9, 216n12,
216n14, 216n20, 216n22, 219n2,
219n4, 221n43
Draft Riots, 144, 161, 226nn14–15
Durham, Jimmie, 47, 218n24
Dyer, Richard, 18–19, 20, 216n5

ecology, xi, xiii, 51, 121, 123, 124, 136,
224n21, 225n29, 225n37
Eisenstein, Sergei, 146, 147, 171, 199
Elsaesser, Thomas, 65, 66, 104, 106,
220n23, 220n25, 223n2
Elshtain, Jean Bethke, 219n8
emancipation, 16, 18, 36, 153, 156, 161
Emancipation Proclamation, xi
Emerson, Caryl, 8, 214n22, 215n25,
216n23, 217n11, 217n16, 218n25,
220n17
Emerson, Ralph Waldo, 22, 23
ethnicity: and nationalism, 7, 9–11, 16,

46, 55, 153, 155, 160, 225n3; and
identification, xi, xiii, 9, 11, 13,
16, 40, 46, 49, 50, 54, 144, 145,
155–56, 160, 226n12; ethnic con-
flict; ix, xi, 9–10, 15, 143–44, 148,
151–52, 154, 160–62, 214n24,
217n21; and race, ix, 2–3, 6, 15, 16,
144, 214n24, 217n21; and commu-
nity, 7, 40, 46, 49–50, 52, 155, 157,
214n24, 217n21

Faludi, Susan, 194, 229n7
Fanon, Frantz, 27, 216n17, 222n13
Fitzcarraldo, 133
Five Hundred Nations, 39
Five Points, the, 144, 146, 148–51, 153,
154, 156, 157, 160, 161
Flitterman-Lewis, Sandy, 219n35
Forten, Charlotte, 25, 216n12
Freud, Sigmund, 10, 14, 57, 70, 77,
81–82, 86, 122, 219n3, 219n7,
221n44, 221n54, 221n59, 227n5
Full Metal Jacket, 110, 175

Genre memory, 7, 8, 13, 41, 47–48, 61,
214n22
Geronimo, 39
Gibson, Ross, 50, 218n29, 218n32,
224n23
Gilroy, Paul, 17, 32, 34, 215n3, 216n26,
216n29, 216n31
Gjelsvik, Anne, 228n24
Gledhill, Christine, 63, 219n6, 220n15,
220n21, 220nn23–24, 220n28
Greengrass, Paul, 200, 201, 211
Grimstead, David, 60, 219n14

Hall, Stuart, 33–34, 216n28
Hamilton, Annette, 38–40, 42, 214n21,
215n42, 217n3, 217n5, 217n12,
218n28
Hansen, Miriam, 86, 221n53
Hari-kari, 228n29
Hark, Ina Rae, 220n30, 220n34,
221nn39–40
Hell's Angels, 166
Hitchcock, Alfred, 191, 196
Holocaust, the, 105, 190, 191, 223n2,
229n2

Robert Burgoyne is professor and chair of film studies at the University of St. Andrews. His recent work includes *The Hollywood Historical Film* and *The Epic Film in World Culture*. His writing has been translated into Portuguese, Chinese, Italian, Spanish, Japanese, and Korean.